BREAKING
VAN GOGH

BREAKING VAN GOGH

Saint-Rémy, Forgery,
and the $95 Million Fake at the Met

JAMES OTTAR GRUNDVIG

Skyhorse Publishing

Skyhorse Publishing books may be purchased in bulk at special discounts for sales promotion, corporate gifts, fund-raising, or educational purposes. Special editions can also be created to specifications. For details, contact the Special Sales Department, Skyhorse Publishing, 307 West 36th Street, 11th Floor, New York, NY 10018 or info@skyhorsepublishing.com.

Skyhorse® and Skyhorse Publishing® are registered trademarks of Skyhorse Publishing, Inc.®, a Delaware corporation.

Visit our website at www.skyhorsepublishing.com.

10 9 8 7 6 5 4 3 2

Library of Congress Cataloging-in-Publication Data is available on file.

Cover design by Rain Saukas

Print ISBN: 978-1-5107-0780-1
Ebook ISBN: 978-1-5107-0781-8

Printed in the United States of America

Dedicated to my mother,
"Bebe"
Gudrun Odfjell-Grundvig
(1921–2015)

CONTENTS

INTRODUCTION

In June 2013, while conducting research for a *Huffington Post* article on fake Jackson Pollock paintings sold to wealthy investors, I asked nineteenth-century American art expert Alexander Boyle one question: "Are there any fake van Gogh paintings?" Without hesitation, Boyle replied, "Sure, there's one hanging in the Met." Struck by the idea that one of the most iconic van Gogh works, *Wheat Field with Cypresses*, could be a fake, I began looking for more information. In the process, I would learn that there were claims of other fake van Goghs on the market. In the 1990s, they would lead to what would become known as the "van Gogh Fakes Controversy." Art journalists, art historians, and a few art experts made accusations, many of them about several paintings, but no absolute proof was provided for any of these.

While writing about technology, from big data and cloud computing to social media and mobile apps for multiple media outlets, I saw how recent advances enabled one to go online and compare the Metropolitan Museum of Art's version with another painting of the same landscape, *A Wheatfield, with Cypresses*, that hangs in Gallery 45 of the National Gallery in London. For instance, as Alex Boyle

pointed out to me, the London painting has "cracking" in the pale blue sky that resembles a dried riverbed during drought, while the Met's canvas shows no such imperfections, like a woman wearing makeup.

Like Pollock, Vincent van Gogh added his own unique signatures to his artwork. For one, he used three custom-made pigments, colors that were unique only to him. He also used a custom-made asymmetrical weave count, in which there were twelve threads on the horizontal axis and thirteen threads on the vertical axis per square centimeter—these custom canvases were ordered and delivered to Vincent during his stay at the Saint-Rémy asylum in the South of France. Recently, an x-ray of a purported van Gogh led to the painting being labeled a fake when it was discovered that the canvas had a square weave count (twelve by twelve threads per cm). And then there are the actual *signatures*—those found in over 820 letters that Vincent wrote and that still survive. Over a thirty-five-year period after the artist's death, his sister-in-law Johanna van Gogh-Bonger archived and translated those letters into four languages. Today the van Gogh letters exist online, in an easy-to-use, dynamic database that can be searched by keyword, date, and location. The letter database is run by the Van Gogh Museum in Amsterdam, Netherlands, which claims to be the final arbiter of the paintings' attributions and authenticity, as well as the translations of the original letters.

Because of my background in construction—civil engineering sector—where I had worked with materials that degraded (concrete) and fatigued (steel), I first delved into the material characteristics of the artworks and studied environmental stresses from the way Vincent's paintings were dried, stretched, handled, rolled, shipped to his brother Theo in Paris, and stored in a "haphazard" manner, as Vincent recalled in his letters. Those material characteristics are what drew me to *Wheat Field with Cypresses*. After I reviewed troves of van Gogh letters and read what the artist saw, felt, and thought 125 years ago, I was sold on turning this story into a full-length book.

Ultimately, to determine whether a van Gogh is a fake, one should first separate the paintings by time and place. Over Vincent's short ten-year career as an artist, his drawings and paintings evolved in terms of unique brushwork—he dabbled in Pointillism, but his thick impasto was a signature that belonged strictly to him. When he arrived in Paris, he found his place among the Impressionist peers, from Gauguin and Monet to Pissarro and Cézanne. He was influenced not only by the rich colors and techniques of the artists, but also their drive to not replicate what was in front of them, like a photograph, but rather to draw out the natural symbolic meaning of what they saw and felt at that moment in time.

It was when he went to the South of France to pursue his dream of establishing an artist colony (which never came to fruition) in Arles in 1888—and then, after a mental breakdown, checked himself into the Saint-Rémy asylum—that van Gogh was swept away by the bright southern sunlight and colors (*Irises, Sunflowers*) and magnificent nature (*Wheat Fields* and *Cypresses*) that spoke to him in a way that city life could not. At the Saint-Paul monastery-turned-hospital, in his most troubled mental and emotional state, his nadir, he produced what are unequivocally his greatest artworks.

During his stay at the asylum, painting was part of Vincent's therapy, and those years in Provence would become the most productive of his career. It was during this time that he went on to produce many of his masterpieces, including *Starry Night, Irises, Sunflowers,* and *Bedroom.* It was also during these years that Vincent devised a way to package his paintings to reduce shipping costs. He would stack five to six paintings on top of one another, roll them with the painted side facing outward, bind them tight together with a string (contributing to the disintegration of the impasto), place the rolls in wooden crates, and send the crates on the "goods" train from Arles to Paris in an overnight journey. One or more of Vincent's letters accompanied the rolled paintings in the trip north to his brother Theo in Paris, who stored them in his small apartment and, when

there was no longer room, leased storage space from a local paint shop. A decade later, to make up for the poor storage conditions, one of the paintings (the *Sunflowers*) was taken to a restorer, who also had a reputation as a copyist and a forger. Shortly after that, the same restorer bought eight van Goghs, including *A Wheatfield, with Cypresses* (the version that is now in London's National Gallery). The story soon got more complex.

As I was learning the details of *Wheat Field with Cypresses*, the Pollock story took a back seat to van Gogh. I reached out to the Met to get the museum's side—could they tell me more about the painting's provenance?—and spoke to one of its curators and van Gogh experts. In my quest for answers, I emailed a dozen questions to the Met, but my request to examine the painting's "condition report" was denied. I would ask in different ways, including going to the museum in person, but was denied access each and every time. Even after I published (in the *Huffington Post*) a 2,600-word article on the subject, "Hacking van Gogh: Is the Master's 'Fingerprint' Missing from a Met Painting?" on July 10, 2013, the Met still rejected my request to make the condition report available to the public.

By the end of July 2013, I reached out to my longtime editor, Stephen Gregory, the publisher of the English version of the *Epoch Times*. He wrote a Freedom of Information Act (FOIA) letter to the Met requesting the condition report. Yet again, the Met summarily rejected the query on behalf of the press and general public, claiming that it was not quite a public institution, despite its 1870 charter stating the contrary.

Why am I trying to show that the Met's *Wheat Field with Cypresses* is a fake without access to the condition report? Well, why would the museum hide such a report from the public? The more the Met said "No," the more determined I became to find the answers. When I came across a 1982 *New York Times* article on the Met's rebuffing the late Morley Safer and CBS's *60 Minutes* inquiries into examining

and testing a different suspect painting the Met bought in 1960, I knew I was in good company.

In investigating the Metropolitan Museum's *Wheat Field with Cypresses*, I would learn that the history of the ownership of the painting was in many ways just as interesting as the question of whether the artwork is authentic or not; that the van Gogh paintings from the South of France did suffer from the telltale stress cracking and "impacted" impasto brushstrokes; and that van Gogh was not only a great artist, but also a very literate writer, who was self-critical, thoughtful, and sensitive, able to see life in everything nature had to present to him.

It was this last point—the story of a poor artist who painted the "peasant genre" and died destitute, having sold only one of his nearly nine hundred paintings during his life—that drove me to investigate further. Van Gogh is arguably the most iconic artist of the past two hundred years. Sadly, his early death, with his brother Theo dying six months later, gave other artists of lesser ability ample space and time to copy, forge, and sell knockoff paintings at the turn of the twentieth century.

Breaking van Gogh is divided into three main parts (followed by a concluding section that brings my questions into the contemporary context—the Age of Transparency). The first covers the times and circumstances in which two van Gogh paintings shattered auction records by a magnitude of ten. It also describes the time that the son of a German-Swiss arms dealer, who had made his fortune over the misfortune of dead and wounded soldiers on both sides of the World War II conflict, saw that his father's company was going to be in the red for the first time in its sixty-two years of business. Did the financial threat influence the decision of the second-generation arms dealer to sell one of the few paintings he had inherited? This part will trace the story of how *Wheat Field with Cypresses* first made its way from Dieter Bührle into the 1990 *Passionate Eye* exhibition at the National Gallery of Art in Washington, DC, was then purchased for the collection of

Walter Annenberg, and finally ended up at the Metropolitan Museum of Art, where it resides to this day.

The second part of *Breaking van Gogh* takes the reader on a tour of Vincent van Gogh's years in the South of France, through his mental "attacks" and declining health to the iconic works painted in those years, which include the three versions of the *Wheat Field with Cypresses* landscape: the Met's First version, purportedly painted in June 1889, and two subsequent versions, the Small version and the Final version (September 1889), the Final version having resided in London's National Gallery since 1960 with a slightly different title—*A Wheatfield, with Cypresses.*

The third section of the book delves into the colorful and magnetic owners of the Met's First *Wheat Field with Cypresses* in the nineteenth and twentieth centuries, connecting the Post-Impressionist era at the turn of the century to the modern-day "Fakes Controversy." Some of those owners include members of the von Mendelssohn family (descendants of the German composer Felix Mendelssohn) and Emil Georg Bührle, an arms dealer to the Nazis, among others.

This book sets out to answer the question of authenticity of the First *Wheat Field with Cypresses* painting. To do so in the absence of the condition report, it examines the physical characteristics of the different versions, as well as the paper trail that was the basis of the Met's attribution and provenance. Do the written historical documents authenticate the First version? Is the First version's history different from what the Met has long claimed? The book will also examine the relevant van Gogh letters, as well as the inventory list, compiled by Andries Bonger (brother to Theo's widow, Johanna van Gogh-Bonger) after the deaths of Vincent and Theo, to point to some curious absences and omissions in these crucial primary sources.

Finally, *Breaking van Gogh* will take the reader through the history of ownership and the telltale signs of van Gogh's authentic

works. By looking at the technical characteristics of the painting, the written historical records, the convoluted history of the painting, and its journey through one of the most turbulent periods in history, I will ask and attempt to answer the question of whether the Met's *Wheat Field with Cypresses* would be more accurately described as a *van Nogh*.

I
THE ART BOOM RISES

1

House of Bührle

Dieter Bührle, a Swiss arms manufacturer, drove along the river toward Lake Zurich to his father's mansion on Zollikerstrasse. He adjusted his thick Coke-bottle glasses and looked in the rear-view mirror. He didn't like what he saw—the gray receding hairline appeared to have crept further up the crown of his head, and the worry lines on his forehead aged him. He practiced smiling and frowning, glancing at those lines while keeping one eye on the road.

Friday, December 12, 1986.

On past Friday afternoons before the annual Oerlikon-Bührle Group board meeting, he recalled being more relaxed, often celebrating a good year of profits and growth with drinks and an early dinner with colleagues or his bankers in town. Not that year. Stressed by the news he would have to deliver to his sister Hortense and the rest of the board the next day, he grimaced and tried to take his mind off business.

Visiting his late father's private art collection, one of the largest in Europe in the twentieth century, would bring some respite from the bad business year. It had worked in the past—when he was a child and teenager, and later a college graduate—to take a private

tour of the colorful Impressionist paintings of Vincent van Gogh and Paul Gauguin, Edgar Degas and Henry Matisse, and numerous other European masters. Thinking about those paintings brought him joy, even though he wasn't an art expert or enthusiast like his father. Somehow, it even gave him hope that he would come out of the Saturday board meeting having tendered his resignation and the board having rejected it.

A historical landmark, the Zollikerstrasse mansion was built in 1886. Emil Georg Bührle bought it in 1937, the year he and his children became Swiss citizens, having emigrated from neighboring Germany. This was also the year when he began to buy and collect art from the French Impressionist school. Emil was rich. He had arrived. And the drums of World War II would make him wealthier. Another world war was great for business at Oerlikon-Bührle, armaments manufacturer.

Bührle's company sold anti-aircraft, anti-ship, and anti-submarine guns, 20mm cannons, and the components of new missile-guided systems to the Nazis and Allies in both theaters of the war, the Atlantic and the Pacific. Oerlikon-Bührle supplied industrial arms to the British Royal Navy, fitted its weapons on the frigates and destroyers of the US Navy Pacific Fleet in 1942, and fed the Nazi war machine to the very end, when the Nazis looted billions of dollars in art for barter to purchase more weapons and munitions.

The war was great for business and even better for Bührle's ability to buy European Impressionist and Post-Impressionist art. By the time he died in 1956, there were more than 150 artworks in his collection. Thanks to the war, he had become the richest man in Europe: he bought more than three-quarters of his collection in the last decade of his life.

During the war, he would buy art with suspect and sometimes unknown provenance, which would lead Emil Bührle into trouble

as accusations began appearing after the war. The industrialist had to perfect a delicate balancing act to erase his ties with the Nazis, including Hermann Göring.

Thirteen paintings in Bührle's collection that were acquired during the war would eventually be clawed back by the US OSS (Office of Strategic Services), the predecessor of the CIA, which pressured the Swiss government to help recover art stolen by the Nazis and return it to its rightful owners in 1945. Ever the art collector, Bührle would buy back nine of those thirteen paintings from the original owners at better-than-market rates—in cash. As his wealth grew, he outbid and outmaneuvered most American museums, including the Metropolitan Museum of Art in New York, for works such as Marc Chagall's *Russian Wedding* and Pablo Picasso's *Still Life with Flowers and Lemons.*

Emil's sudden death in 1956 from a heart attack left his son Dieter wounded, cast into an emotional fog, and in charge of the Oerlikon-Bührle empire. The Bührle empire was making the next generation of missile-guided systems for the United States, Canada, England, the European allied nations, and later NATO. Not unlike his father, Dieter found ways to work with countries sanctioned by the Allies, from Iran to apartheid South Africa, among other rogue regimes. In 1970, such back-channel dealings had landed him in trouble with Swiss authorities.

Now, in 1986, arriving at the foundation's house, Dieter drove into the gated driveway and parked in the back of the three-story red brick mansion with its A-frame roof with dormers, ivy that climbed up the walls and brick columns by the front door, and cypress trees that stood tall behind a wrought-iron fence with hedges around the perimeter of the property. It was the cypress trees, imported from Italy and planted on the mansion yard, that reminded Dieter and his sister of the van Gogh paintings in their father's art collection, seven of them the artist's masterpieces, including *Sower with Setting Sun* and *Blossoming Chestnut Branches.*

A villa attached to his father's old house stored more than one hundred works of art—three-fifths of Emil's collection—Dutch Masters, Impressionists, Post-Impressionists, and Cubist painters. Emil's widow and children owned the rest of the paintings.

This trip to his father's mansion, in peace and solitude, served two purposes. The visit would relax his frown lines and lower his blood pressure, getting his mind off business; more importantly, it would also give him an opportunity to pick out a painting or two that he could sell if his business went further south and there were no new contracts. Maintaining the lifestyle of wealth with a summer home in Italy and a ski chalet in the Swiss Alps was paramount to his well-being.

He entered the villa and it was as though he stepped into a time portal that took him back to his teenage years. He inhaled the familiar musty odors that were embedded in the carpets and wallpaper of the house. Even though the house and villa were touched up in 1960 and then totally renovated in 1976—twenty years after his father's death—his memory still saw the home where all those bright French paintings hung side by side, covering the dining-room wall. In his head, he still heard the stern footsteps and deep voice of his domineering father, a robust man, who conducted business with an iron fist but also had a warm side, a passion for the arts that dated back to his school days before World War II.

The evidence of his father's passion was right there on the walls—paintings by Cézanne, Chagall, van Gogh, Gauguin, Renoir, Picasso, Goya, Manet, and Monet, among others. That was why, on February 24, 1960, Dieter, his sister Hortense, and their mother Charlotte Bührle-Schalk had established the Foundation E. G. Bührle Collection. They decided that the villa would be a museum, open to the public one day a week. They wanted to establish Emil's legacy and share his love for art with the public.

Making his way to the Impressionism gallery, Dieter approached a van Gogh masterpiece, *Wheat Field with Cypresses*. Seeing the

landscape artwork—painted by Vincent van Gogh during his troubled but artistically liberating stay at the Saint-Rémy asylum in southern France in 1889, a year before his untimely death—transported Dieter back to 1951, the year his father purchased the painting from a German-born arachnid specialist named Peter Witt. Dieter recalled being there when an intermediary, an art broker, entered the house and the two men sat down for coffee discussing market prices for Impressionists, the Saint-Rémy masterpiece, and other paintings that were available for Emil to purchase. What they didn't talk about was the war.

Since Dieter's current concerns had more to do with finances than with art, he wondered about the painting's value going into 1987. He knew it had to be in the low millions, but how much? Was *Wheat Field with Cypresses* worth $3 million? Might it be worth as much as $5 million? How much could it fetch at an auction? He didn't know if there had been a large sale in the art auction market on French Impressionism, so he was unsure of the painting's potential value in the marketplace.

As he looked over the clouds that swept from left to right in the painting's pale blue sky, with shafts of sun and shadow dancing across the low-range gray mountains in the background and a breeze blowing through the wheat and the cluster of cypresses in the foreground, Dieter understood that this painting could be his meal ticket, his insurance policy in case Oerlikon-Bührle imploded.

He made a vow to himself: after the start of the New Year, he would get the masterpiece appraised.

2

Cold War, Hot Art

Dieter Bührle arrived the next day at the Tudor-style office at the Bucheggplatz tram station in Zurich, Switzerland. The reclusive businessman, who had spent more than half his life in his father's shadow, carried troubling news in his briefcase. Feeling frost redden his cheeks, he eyed the opaque sunlight trapped behind an overcast sky and wondered what he was going to tell the board, on which his sister Hortense Anda-Bührle sat as a director.

Oerlikon-Bührle Group, a holding company that oversaw military arms manufacturing, Bally Shoes, and industrial coating systems, was in the red and hemorrhaging money from three speculative defense projects that struggled to find traction. The Reagan-era arms didn't produce the windfall in military contracts Dieter had envisioned, nor did the strong Japanese yen help manufacturers in the West—most tools and arms factories in the United States were up for sale.

Where were the wars? he wondered, straightening the knot in his scarlet tie. Were the only conflicts fueled by terrorist bombings and hijackings? Had the 1980s become the decade of transition and short-lived skirmishes?

Despite being an old professional, whose father served in World War I, made weapons for the rearmament of Germany in the 1920s, and then sold weapons to the Nazis and Allies during World War II, Dieter had failed to see the signs of the Cold War receding, of power in flux. How could he not see? Perhaps it was because Russia was still a nuclear-armed superpower threat.

Dieter didn't let the bad news overwhelm him—he had trekked through deeper financial valleys before and always found a way out. Yet he couldn't brush off the losses, as the numbers would be exposed in the financial statements. They wouldn't lie. He also knew they wouldn't be released to the public for another month—not until January 1987. That gave him time to dance like a Russian bear: spin, maneuver, manipulate, strategize, and build a winning story. Before any of that could happen, however, he had to address the first loss in the company since his father Emil Georg Bührle took over as managing director in 1924.

The company had been in the black for a span of sixty-two years, since Dieter was three years old. Dieter Bührle reminded himself of that fact while striving to steer the company back to profitability. He would conduct this meeting in his usual stoic, businesslike manner. He would weather the storm, as long as he laid out a clear path and upbeat message with strong business prospects to come in the New Year.

Focus on the near-term success, he thought as he strolled up the sidewalk, watching the icy vapor of his breath dissipate in the cold air.

The quiet on that cold, gray Saturday morning served him well. So did the empty roads with low-rise office buildings, tucked in a bowl of crags and trees, the stillness broken by the infrequent rumble of a tram arriving at the station. Dieter liked the silence. Board meetings on Saturdays meant no phone calls, no faxes, no media to ask probing questions, and no inquiries from the worldwide 30,000-plus Oerlikon employees of the publicly traded company his father had built from the ashes of a dying German tool manufacturer.

Dieter knew he could contain the bad news until good news arose in the spring. The only issue he had to contend with was that there would be no dividends for the investors for Christmas. His chief of finance, Ernst Winkler, who was in charge of the company's pension fund, had alluded to that cold reality.

Dieter entered the office, placing his cashmere overcoat, scarf, and gloves on an Italian leather sofa in the lobby, and headed to the conference room to start the meeting. The graying, chubby-faced chief executive officer, wearing a three-piece wool suit, sat down at the head of the table, as he was also the chairman of the board. Seated across from him was his sixty-year-old younger sister Hortense; a cunning Italian businessman with a round face from the Contraves Group, Marco Genoni, the CEO of Oerlikon Aerospace, Inc., a Canadian arms concern; and an engineer named Michael Funk, who was being groomed as Dieter's replacement to lead the conglomerate within a year. Also present were four other board members, including Ernst Winkler.

As Dieter read through the meeting minutes, he dispensed with pleasantries and small talk. He broke the bad news without emotion. Oerlikon-Bührle Group was not, as he had suggested in September, in the black, but deep in the red. He eyed Ernst as he read the words *250 million francs in losses.* The huge losses came from several business units, but mostly from the military arms manufacturing division.

Two hundred and fifty million francs swept through the board like a cold breeze. Looks of disbelief, slackened jaws, and gasps ran around the table. It was a shock to the directors, especially after the company had delivered a modest profit of 37 million Swiss francs in 1985. Without reacting to or making eye contact with any of the board members, Dieter handed out copies of Oerlikon-Bührle's financial statements, pointing out that:

The main culprits were the armament division, which was 200 million francs in the red as against the 100 million that had been

expected and the Contraves division, which was faced with a 50 million franc deficit as against an anticipated 50 million profit.[1]

Dieter had obfuscated the bad news earlier that fall by explaining that profits would be smaller, not that the company was bleeding money. Before he got to the question-and-answer phase of the meeting, he flipped the minutes over, letting the board members know he was going to speak off the record. Dieter leaned forward, tapping his index finger on the table. He looked around at the board members and said, "This has been a tough year for us. Yes, we overpaid for the land in Canada to build Oerlikon Aerospace's new manufacturing plant. It was an expensive transaction, but it's the cost of doing business."

"We began the bidding process for the ADATS [Air Defense Antitank System] project almost a year ago, and had to surpass six other Canadian firms aiming to secure the same multimillion-dollar contract," Michael Funk interjected.

"Will the project be a success?" Hortense asked, adjusting her shoulder-length, dyed brown hair.

"Of course," Dieter replied with a look of reassurance. "Our man in Canada, André Bissonnette, will be elected to be a senator in the prime minister's cabinet at the start of the year. But we want to keep that quiet, keep that ace card in our back pocket."

Dieter's right-hand man, Michael Funk, nodded in agreement.

"What does that mean for Oerlikon-Bührle?" Hortense asked.

"The future is promising. The new facility is on schedule to open next autumn," Dieter answered. "Once the Americans see us deliver the ADATS guided-missile system to the Canadians, our orders will go through the roof."

"What are the risks?" his sister asked.

"Hortense, there are political risks. But they are behind us. Once the plant is operational, Oerlikon-Bührle will do what we do best—build."

"How much profit did André Bissonnette make?" she asked, continuing to press.

"One-point-six million dollars," he replied.

"Actually, it was Bissonnette's wife, Anita Laflamme, whose name was on the deed of sale. The property was flipped three times in eleven days before we executed the purchase," Funk clarified. "We closed on the land last April."

Hortense made a face as she ran the numbers through her head. Bribing officials, this time Canadian, had always been part of Dieter's world, just like it was the norm during her father's era. Grease the palms with under-the-table money, and be first in line on many projects and contracts. She remembered that her brother had been tried and convicted in Switzerland in 1970 for breaking several international and Swiss laws by illegally selling arms to apartheid South Africa, and to Mideastern enemies of Israel and the United States, by using false sales certificates from a French shell corporation. So bribing Canada to secure the ADATS contract was a coup that locked out competitors, at a time when no other country was buying the anti-tank missile system. Had Dieter not won the Canadian bid, the financial statements would have bled red for years to come.

Hortense understood and accepted that the Swiss muscle—cash—was needed to make the deal work. As her father was fond of saying, *if you can't be good, be careful.* In other words, don't get caught.

Satisfied with the explanations on the Canadian land deal, Hortense turned the minutes back over and asked about the accounting issues, with losses not only on the anti-tank ADATS battery, but also Seaguard and the old R&D weapon Escorter, an experiment that was finally shelved after a costly thirteen-year run, having attracted few buyers.

"After the worst-case projection," Dieter said, "you get into the whole matter of write-offs and the liquidation of reserves—and these are major changes."[2] Taking a one-time loss in the company's

books was one way to stem the financial bleeding ahead of questions from nosy journalists and concerned investors.

What Dieter and Michael Funk wouldn't say on the record was that the military technology division, headed by Funk, consolidated a turnover in 1985 that amounted to 1.08 billion Swiss francs. So even that year's "modest profit" of 37 million francs was suspect. Without that accounting dexterity of consolidation in a division that eliminated duplicate jobs, the profits might have turned into a loss. They'd be in trouble if a forensic accountant raked through the numbers.

Ernst Winkler then discussed the "unexpected" cost overruns for the Contraves division with its Seaguard system. "We project a 50 million francs write-off for the Seaguard," he said flatly.

Hortense pored over the balance sheets and was about to ask a question when Winkler spoke up again. He reminded the board that the step had to be taken in accordance with the company's strict regulations governing capital write-offs. "Since there are no customers, the price of the product must be set at a lower figure. And by your own admission, Dieter, there are no other customers for Seaguard at this time beyond the systems that have been installed on six Turkish frigates."[3] Hortense then also brought up Oerlikon-Bührle buying an Ohio manufacturing company, Motch, reminding her brother that the once "prize catch" had turned into a business failure after seven years.

Ernst moved on to Oerlikon-Bührle's 1978 acquisition of Bally, the struggling Swiss company, which bought leather during World War II from the Nazis, and said:

> In contrast to these indigestible chunks, the picture at Bally, the third leg of the Bührle triad, looks positively gratifying. Although the ups and downs on the currency market and the absence of American tourists have resulted in a drop in sales and earnings, they are "undramatic."[4]

"Then the problem going into 1987 is not with Bally, but the military group," Hortense stated.

"Nonsense. The military contracts are where the future lies," Dieter said, adding, "From what I know, virtually all American machine tool manufacturers are up for sale, because given their cost structure they cannot compete against the Japanese. Oerlikon Motch Corp in Cleveland, Ohio, is faced with a situation of this kind."[5]

"Will the company be showing a loss again this year?" Hortense asked.

"Things should get back to normal in 1987. We already know that we will not be running into the kind of one-time write-offs or unusual restructuring expenditures that we did this year. I am saying all this on the assumption that the dollar does not decline any further," Dieter answered.

"We should put that in the annual letter to our stockholders," Winkler said.

"And then we can return to paying a dividend?" Hortense asked.

"Sure. But remember, one military contract worth two billion francs will change everything," Dieter replied, with a bit of confidence returning.

"Dieter, don't get ahead of yourself, which is your tendency, brother. Remember our stockholders meeting earlier this year?" Hortense said.

Dieter nodded, trying to figure out where she was going with the question.

"You said you would quit the board of directors," she reminded him. "But you and Michael will stay in charge next year?"

"Let me put it this way: I have certain ambitions, too. When I leave my post, I would like the concern to be in the black again so that we can pay a dividend once more. I will let people know in plenty of time when I am ready to leave. Funk has his hands full with the military technology division as matters stand,"[6] Dieter said.

Satisfied with the board meeting in preparation for the stock-holders' letter at the end of January, Dieter ended the meeting and wished everyone a merry Christmas. He left first, grabbing his coat and scarf on the way out, still plagued by a gnawing feeling that he had better come up with a plan B for himself if things blew up and went off the rails in 1987.

The Vincent van Gogh painting he owned was looking more and more like a plan B.

3

1987 Shock and Thaw

Nineteen eighty-seven began quietly in Switzerland.
Dieter Bührle had had a more subdued family Christmas holiday than in years past. He himself did okay—the family still managed to vacation at their ski chalet in the Swiss Alps. But no dividends were paid to the investors for the first time that he could recall; that bothered him, since it left him exposed to criticism from insiders and outsiders alike.

As he was about to pack his belongings and drive his family back to Zurich, he saw the international news on TV. The Canadian prime minister, Brian Mulroney, had elected André Bissonnette as minister of transport to his cabinet. Upon hearing the news, Dieter, breathing a sigh of relief, broke out a bottle of champagne and finally decided to celebrate. He could finally exhale, knowing that an insider would soon be in place to lock up more defense contracts with Canada.

Even with this booster shot of good news, Dieter was still planning to get his van Gogh painting appraised. Given the recent developments, however, it could wait a little, at least until Oerlikon-Bührle made its financial statements public in a couple of weeks

and after he fielded questions from the press and investors on all of the recent losses the arms manufacturer suffered. Once he got that painful exercise out of the way, he would turn his focus to making sure the new plant, located in St. Jean-sur-Richelieu, southeast of Montreal and thirty-two miles north of the Vermont border, would be up and running by September.

Sipping a glass of Dom Perignon, Dieter called Marco Genoni, head of Oerlikon, a subsidiary of the Oerlikon-Bührle Group, who was vacationing in Lake Como in the Italian Alps, and shared the good news out of Canada. They raised a glass of bubbly and said *prost!* over the phone, wishing Oerlikon Aerospace great success in the new year. After they discussed Marco's trip to the project site in the coming week, Dieter called Michael Funk, who was already back in Zurich, sharing the great news on Bissonnette's appointment. "Michael, we need to find more business partners like André Bissonnette this year. I will make a trip to the US and see if old partners could provide us with access to a Washington senator," he said.

They laughed at the thought, at the opportunity to be explored and exploited, wished each other good health and better profits in the New Year, and said *prost!* again, blessing their endeavors with good luck to come in 1987.

———

Luck is a fickle and feckless lady. Just as 1987 started off with a bang of great news that their man in Canada was now an advisor in Prime Minister Brian Mulroney's cabinet, bad news drove a wedge through the hope and optimism that Dieter and his executives shared on New Year's Day. A little over two weeks into his new post, André Bissonnette was forced to resign. The deed took place at an emergency cabinet meeting on Sunday—a Sunday meeting, like Dieter's stealth board meetings held on Saturdays, was rarely a good sign, since it usually meant a scandal.

That Sunday, January 17, 1987, the politicians had their day off.

Prime Minister Brian Mulroney was caught in the hornet's nest of a land-for-money bribery case. His rivals in the Liberal Party, whom Mulroney had ousted three years earlier in the 1984 election rout, now had the upper hand, and they managed to dislodge a seventh cabinet member during Mulroney's office tenure. Being forced to axe his close friend André Bissonnette in such a publicly humiliating way, a mere couple of weeks into the new post, made the deed all the more painful. But Mulroney had no choice. New elections would come in two years' time. So there he was, seated in Parliament Hill in the nation's capital of Ottawa, Ontario, forced to clean house in a public mea culpa on January 18.

A week after the news of the scandal exploded across the media airwaves, the *New York Times* put the political paroxysm in perspective:

> In the House of Commons this week, Prime Minister Brian Mulroney, half-moon spectacles perched on his nose, spent several hours fending off attacks by opposition members aroused by a sense that his 28-month-old administration has suffered an irrecoverable blow. . . .
>
> What is known about the affair so far is that the 100-acre plot in the Quebec town changed hands three times in 11 days in January 1986, three months before Oerlikon obtained a contract valued at $440 million. . . . The land deals increased the value of the plot from $590,000 to $2.2 million, the profit going to local speculators, at least some of them known to Mr. Bissonnette.[7]

The Canadian Mounted Police launched its own investigation into the scandal. Stunned by the news as it became public in the wake of Brian Mulroney's admission of making a mistake, Dieter Bührle worked the phones. He knew it was imperative to make sure that his two main executives in the Oerlikon Aerospace business unit in Canada did not speak to the press and that any press release had to come from his office.

Dieter instructed Marco Genoni to take a vacation, lie low, and be out of sight when the heat from the probe came, as they knew it would.

Dieter Bührle gave the same instructions to Michael Funk, adding that the best way for the company to stay out of the scandal was pretend nothing had happened. "Business as usual" became Dieter's mantra. He repeated it now, and reminded them both that Oerlikon was losing money and they had to do everything in their power, legal or otherwise, to avoid the plant's construction getting shut down, hit with a work stoppage, or otherwise delayed because of court action over matters that didn't concern them. Canadian laws were friendly enough, but different from Switzerland's, so they had to tread carefully and do their research. He told his capos to identify where the pitfalls might lie for Oerlikon Aerospace in the coming month.

As far as Dieter was concerned, André Bissonnette was Brian Mulroney's problem, not that of Oerlikon-Bührle Group. He wanted to portray the company as the unaware, blameless buyers of land that seemed a bit overpriced but was critical to the long-term military contract that the company had won a year before.

As this scandal now threatened the only viable business that the military division of Oerlikon-Bührle had going for it, Dieter once again turned his attention to the van Gogh. The sooner he got the *Wheat Field with Cypresses* appraised, the better he would sleep at night. He began to make calls to a few art gallery owners he knew were familiar with his father's art collection. Time was no longer Dieter's ally.

Another issue cropped up in mid-January. Oerlikon-Bührle Group finally released its 1986 financial statements to the public and shareholders. The day after the release, the press came seeking comment about the multinational corporation's first loss in revenue and profit in more than half a century. A reporter from Zurich's *Die Weltwoche—World Week*—magazine called his office. She wanted to interview Dieter for an article and have him answer questions on the losses in the military division. Knowing that declining the interview

would make investors suspicious, Dieter agreed to the interview in his office, on his turf.

=======

The new year had started off with more than a bang for Dieter Bührle. Beyond fending off the press on his company's first loss and the political fallout from the Canadian land grab deal, he arranged for the art appraisers to come by his father's house to check on the condition of the painting and estimate its fair market value.

He also read about an upcoming March 30 auction at Christie's in London. The auction was going to feature one of Vincent van Gogh's dozen *Sunflowers* paintings.

The news was music to his financial ears. All of a sudden, Dieter didn't need the *Wheat Field with Cypresses* appraised. The Christie's auction was going to give him a free ballpark figure, an estimate of the painting's worth in the open market. He called back the appraisers and told them to sit tight until April.

Timing, not time, moved to his side.

He would be able to learn the price of one of van Gogh's masterpieces before making a public statement in Canada—not from Zurich, and without using the Bührle family name. The statement on the role Bissonnette played in the Oerlikon Aerospace land sale would come from Marco Genoni. Still, pressure was mounting on the business side with the release of the *Die Weltwoche* article, which hammered the Oerlikon-Bührle Group on its red ink and its state of affairs that had made investors worried. Would the magazine now write about the scandal that was unwinding in Canada? In that cauldron of bad news, Dieter saw that his safety net was in the Christie's spring auction.

The auction of Vincent van Gogh's *Sunflowers* was about to change Dieter's life.

=======

Dieter's art scout in London got wind of why Christie's auction house had outmaneuvered Sotheby's to secure the sale and consignment of van Gogh's *Sunflowers*:

> In the race for the Beatty van Gogh, Christie's, by whatever tactics, outsmarted and outbid Sotheby's. Apparently the trustees of the Beatty estate were particularly impressed by Christie's producing a mock-up catalogue, tasteful and scholarly. . . . Charles Roundell, Christie's main Impressionist expert, who edited the text, called upon Professor Ronald Pickvance, the world's foremost authority on van Gogh, and the Zurich art dealer Dr. Walter Feilchenfeldt for advice and assistance. Feilchenfeldt, himself a diligent investigator and well-known van Gogh scholar, was able to draw on the research of his associate Dr. Roland Dorn, an up-and-coming star in the field of van Gogh studies. Dr. Dorn's important contribution to the catalogue concerned the history of the painting, its *provenance*.[8]

Dieter wouldn't attend the auction, since he wasn't a collector or an art lover like his father, but he did make calls to colleagues and business associates in London to contact him as soon as they heard news on the sale of the painting, its price, and who won the bid. The last piece of information was critical to his plans to unload *Wheat Field with Cypresses* at a price he hoped would be above market value. He also kept track of the other factors surrounding the sale of the painting.

He learned, for instance, that Christie's sent the *Sunflowers* on a mini roadshow at Christie's sites in New York, Tokyo, and London to drive interest in the painting and drive up the price. The pre-auction roadshow worked. *Sunflowers* made the cover of the international edition of *Newsweek*. On the day of the auction, in the final Lot 43, Christie's team placed *Sunflowers* on an easel for the packed house to see. They opened the bidding at 5 million pounds. The bidding war began, and the price quickly soared in 500,000-pound

increments. The number of bidders slowly fell, and by the time *Sunflowers* reached 22.5 million pounds, the high-water mark, there was only one bidder left standing.

The final sale price, the equivalent of 36.3 million dollars, or 54.7 million Swiss francs, left Dieter astonished. He felt blood race through his veins; his face flushed. He jumped up and down, like when he played soccer in high school and his team scored a goal. Ecstatic, he phoned his art scout in London and told him to buy a copy of every UK newspaper and magazine the very next day. He needed to learn everything about how Christie's operated, as well as about van Gogh's masterpieces and the Japanese buyer who won the auction. He was especially interested in the painting's roadshow because it reminded him of a strategy he had used time and time again in the 1960s and '70s, when he visited the Saudi Kingdom, Nigeria, and South Africa and demonstrated the latest in anti-aircraft and ballistics weaponry. Nothing like a large, stylishly designed cold piece of steel, such as a cannon, or a loud and bright explosion of an artillery shell to close an arms deal with potential buyers.

His arms roadshow was a lot like Christie's roadshow for van Gogh's *Sunflowers*. Christie's had done the same thing in an effort to create buzz, stoke a bidding war. The plan worked brilliantly. Dieter would emulate that for his van Gogh masterpiece.

———

By April, pressure mounted on Oerlikon Aerospace to respond to the charges and accusations about the land sale of the plant. Recalling the interview he did with journalist Rita Flubacher for *Die Weltwoche*, Dieter picked up the February 19, 1987, issue, opened to page 21, and began to read excerpts from the article "Balance Sheet Cosmetics Are the Only Answer—Oerlikon-Bührle: Massive Losses in Military Sales; Machine Tool Sales to US Down." He looked past the title to the subheading, "International Military Sales Slowing," and read:

Nor has the defense ministry developed a particular fondness for "ADATS," the antiaircraft and antitank guided missile system mounted on armored personnel carriers.

Flubacher: It has been said that some 250 million francs have been spent on the "Escorter" so far.

Bührle: That is not an accurate figure. Depending on how the costs are figured, they range between 150 and 200 million francs. Let me emphasize that in this case—as opposed to "ADATS"— none of the development costs were capitalized.

Dieter closed the magazine and knew he had to have Marco Genoni respond to the mounting pressure on Oerlikon Aerospace in the next few days. He ordered his secretary to call the Canadian field office at the plant and get hold of Genoni. He then picked up the phone and told Marco to contact their Canadian chief counsel, John F. Lemieux, to write a press release and fax it over to Dieter at the Swiss headquarters.

When Dieter received Marco's fax an hour later and noticed the press release was loaded with lawyerspeak, he realized his mistake. It was too contrived, too corporate. He needed to humanize Marco and Oerlikon Aerospace and make them approachable, while playing up the cultural gap between the two nations separated by the Atlantic Ocean.

"Marco, what is a hole we can exploit between us Swiss and the Canucks?" Dieter asked.

Marco thought for a moment, and then replied, "Appearances. What about appearances?"

"*Ja, ja.* That's it," Dieter said. "Come up with a line or two, call back the media and give it to them as if we were victims, too, along with the Canadian taxpayers."

The fax printed out. Dieter flipped it over and read Marco's answer: "Appearances count more in Canada than they do in Switzerland. I didn't look enough at appearances."

Subtle but effective, Dieter thought, since Marco pointed out to Canadian authorities that Oerlikon Aerospace was also a victim of the scandal. They had simply misunderstood Canadian business etiquette.

Ten days after a request to respond to charges about the land sale, Marco gave the press his one-line answer, word for word—not through Oerlikon's chief counsel, but in his own humble voice. The response worked. It deflected the hot-button issue, putting the blame back on the Mulroney government.

———

Prime Minister Brian Mulroney survived the scandal, as did Dieter Bührle. In September 1987, the new Oerlikon Aerospace plant opened in a small ceremony with the Canadian government. Dieter was nowhere to be seen, nor was André Bissonnette, his liaison to the prime minister and the conduit to winning the ADATS contract.

In the meantime, Dieter's attention was diverted to New Mexico. At the US Army's Air Defense Artillery testing site in the Oscura Range, a joint venture between Martin Marietta and Oerlikon Aerospace, he was one of four military contractors competing for the right to sell the ADATS missile-guided system to the US Army. This was the billion-franc contract Dieter had hoped to land for his company to pull it out of the red.

———

In October, the ADATS contest was drawing to a close in New Mexico White Sands. Around the same time, Dieter learned that Sotheby's in New York City was going to host its own van Gogh auction in November. *Irises*, a van Gogh masterpiece painted during the artist's stay at the Saint-Rémy asylum in France, was being put up on the auction block. This time, Dieter would have people in place at the auction. He wasn't going to bid on the painting, but he needed

to learn which art experts were involved and whom in the New York and London art orbits he could hire to catalogue a book about his father's art collection, since his sister Hortense had already put together a concept roadshow to celebrate their father's centennial birthday in 1990. Dieter recalled that his sister had started inquiries a year earlier for an exhibit, a tour to honor their father. Now her queries to American museums finally made sense to him.

It was still late 1987, so Dieter and his sister would have two full years to produce the show, secure sponsors, and attract a few wealthy Americans to buy his painting. For the plan to work, he needed to do what Christie's had done six months earlier and what Sotheby's was about to do in early November: build an air of exclusivity. He needed to speak to Hortense about how to best position the exhibit to drum up auction-house style press with global impact, sex appeal, and excitement.

Who is the best art showman in America? Dieter wondered.

———

Before the month was over, however, October 19, 1987, happened.

The US stock market crashed in what would be called "Black Monday." The Dow Jones Industrial Average cratered by more than 22 percent. It was the end of a five-year bull market. It also spelled trouble for Oerlikon-Bührle's stock price and international holdings.

Dieter kept his wits about him and stayed calm. November came and proved to be a fruitful month for the skyrocketing value of van Gogh art. At the Sotheby's auction, Alan Bond, the Australian real estate and media magnate, made news and set a new world record. Bond was the last bidder to drop out of the Christie's *Sunflowers* auction when the painting was ultimately sold to the Japanese insurance conglomerate. In an unusual deal with Sotheby's, Alan Bond took out a loan from the auction house for 50 percent of the sale price of van Gogh's *Irises,* a Saint-Rémy masterpiece, like *Wheat Field.*

Van Gogh's *Irises* sold for $53.9 million to Bond. This figure represented a 33 percent increase on *Sunflowers,* and it was good news for Dieter and his *Wheat Field with Cypresses.*

To add to the good news of a new world record sale price, word came back from the US Government Accounting Office (GAO): the US Army submitted its findings on the trials and testing of the ADATS. They were good.

On November 30, a letter was sent to GAO officials, including the future Director of Homeland Security, Tom Ridge. It read:

> On November 30, 1987, the Army announced that it had selected the system produced by a Swiss firm, Oerlikon Bührle, teamed with Martin Marietta, called the Air Defense Antitank System (ADATS). Although none of the four systems tested met the Army's total requirements, the Army concluded that ADATS showed the best potential for achieving that goal. The results of the competitive test are classified.

The 1987 year-end board meeting was going to be a major improvement from the one Dieter held a year ago, when he had to announce the gut-wrenching 250 million francs in company losses. This time, the news was stellar: "The Army announced Monday that a team headed by Martin Marietta Corp. beat three other defense contractors for the right to build a $1.7 billion weapon to protect troops from enemy planes and helicopters." [9]

It was time for Dieter to expand the business and let his sister take the lead on their father's art exhibition. Things were finally looking bright.

4

The Passionate Bull's-Eye

By late spring 1987, Hortense had come up with the concept of exhibiting her father's paintings, both those in the Foundation and in the siblings' private collections. The more she tinkered with the project, the more it made sense, at this particular time, to exhibit the art collection beyond Zurich to the outside world. She knew she would need to sell the exhibit to the top museums of the world to launch a global tour. She removed an August 1959 *Studio* magazine from a plastic folder to remind her of both Emil's past and his persona.

The second paragraph read:

Bührle's name is still hardly known in Britain, and not very familiar even in his country of adoption, Switzerland, for he was an invincibly shy, retiring man, completely averse to personal publicity—but everyone who was in the last war must have heard of the weapon that made his fortune and thus enabled him to become one of the greatest Maecenas of our time—the famous Oerlikon 20 millimeter anti-aircraft gun. And thereby hangs a strange tale.[10]

From that one passage Hortense understood better than her business-minded brother that the exhibit had to overcome two big hurdles to succeed.

The first challenge was the unfamiliarity with the Bührle name outside of Zurich, with its alien sound and strange-looking letter. The second obstacle came from the legacy her father established—easily discovered by anyone who cared to look—of selling arms, ammunition, and anti-aircraft guns to Nazi Germany during World War II, as well as Dieter's shady past as a convicted criminal. Hortense knew she would have to remove Dieter's name from virtually all exhibit-related correspondence, communications, and marketing materials.

She would also have to dance the tango, if not the foxtrot, with museum directors, curators, and government officials, absorb or deflect their outsized egos, deal with foreign cultures, and steer strong personalities away from Emil and Dieter's arms-trading careers. She would have to channel people's interest to focus on the art. She would have to be nimble, resolute—and, if need be, to show a stiff German spine when negative issues of the past managed to percolate to the surface in the press and news media.

She read on: "His eminently catholic taste embraced all periods and all schools, but he never lost his juvenile passion for the French impressionists."[11] And then, "The impressionist galaxy is so sparkling that it is difficult to know where to begin—and where to stop."[12]

Hortense came away with a game plan. Through her family's global network of government officials, she would begin to make inquires with museums about hosting and sponsoring the exhibit. It would be an Impressionist roadshow commemorating the hundredth birthday of Emil G. Bührle. She would tie it to a name that would mean absolutely nothing outside of Switzerland and parts of southern Germany.

Her father was born in 1890, the same year that Vincent van Gogh died, so perhaps the exhibit should have commemorated not

Emil's birth year, but rather the premature death of Vincent van Gogh at age thirty-seven. That would have marked a solemn occasion by honoring the art master that museum curators and directors would have recognized and gravitated toward, without the controversies surrounding the Bührle name. But Hortense and Dieter needed the show for an alternate agenda: they wanted to put one of the van Gogh masterpieces up for sale without it being advertised as such, and without going through the rigorous authentication process of an auction house with outside consultants worried about broken or missing provenance. It was one thing to examine a painting in granular detail and to review its condition report; it was another to examine one hundred paintings with matching condition reports. Also, if they could drum up a private sale through the exhibit, Dieter wouldn't have to pay exorbitant brokerage fees to an auction house. Both of these potential obstacles were major turnoffs to Hortense.

She set her sights on a world tour in 1990 that would start in America—New York, Chicago, and Washington, DC—three high-profile art-loving cities. The centennial celebration would then travel to Canada, on to Asia, and back to London to conclude the tour.

Hortense moved swiftly. In June 1987, she set up the first meeting in Zurich between herself, Dieter, the Emil G. Bührle Foundation executives, and the National Gallery of Art's senior curator of paintings, Charles Moffett, along with his team.

———

After that June meeting with Charles Moffett, over dinner with Dieter at her favorite Zurich restaurant, Hortense became the face associated with Emil and his commemoration, while Dieter would focus on getting the Oerlikon business units back in the black.

Hortense was impressed with the young but sharp and fluent curator of European art. "Charlie" Moffett had turned thirty-two shortly before Hortense and the Foundation held their second meeting with him in October. Hortense knew she had to win his

commitment because Moffett became the focal point of her probe to gauge the level of interest for the art exhibit honoring her father. She had researched his background and learned that, at a young age, Moffett had curated shows on Degas, van Gogh, Monet, and Manet at the venerable Metropolitan Museum of Art in New York City, where wealthy and powerful American bankers and industrialists had bought many prized European artworks from the time of van Gogh's death to the start of World War II. Over that half-century stretch, J. P. Morgan, Henry Clay Frick, Andrew Carnegie, and John D. Rockefeller, among others, imported thousands of pieces of art, from paintings, sculptures, medieval arms, and textiles to artifacts from ancient civilizations.

Charles Moffett bridged the chasm between two of the United States' most prestigious museums, the Met in New York and now the National Gallery of Art in Washington, DC. Hortense wouldn't take that feat for granted.

In October 1987, Moffett was sent the following letter on behalf of Hortense:

> Dear Mr. Moffett,
> Mrs. Anda has asked me to forward to you the information concerning the paintings of the Bührle Collection not belonging to the Foundation and therefore, not listed in the catalogue.
> We have sent 2 sets to London. By separate mail, you will receive 3 sets for you, Mr. Tinterov [sic] and Mr. Brettell. Also by separate mail, you will receive the requested 13 x 18 black and white photographs of all of the paintings going to the exhibition.
> For Washington you receive a set of 3 pictures each, New York and Chicago only asked for 2 pictures each.[13]

The tactic of sending three letters concurrently to Charles Moffett at the National Gallery of Art (NGA), Gary Tinterow at the Met, and Richard Brettell at the Chicago Institute of Art worked.

It did more than plant the seed of an idea for a grand exhibition on Impressionist and Post-Impressionist masters; it unlocked the gates to the top art museums in America, if not the world. Ideally, Hortense hoped, the exhibition could make its way to all three museums, whose experts would collaborate to compose and compile the descriptions of the works.

Behind the scenes, Hortense employed Dieter to oversee a team of specialists and historians to catalogue the collection and produce an art book filled with colorful reproductions, inside stories, vignettes, and anecdotes presenting Emil G. Bührle as an art collector with exquisite taste and appreciation for modern art amid the turmoil of two world wars. Hortense recalled her father telling her, when she was a teenager, that it was the treasures of European art that saved Paris from being bombed like London and other British cities by the German Luftwaffe during World War II.

With his business acumen, Dieter understood that to win over the American museums, the Foundation would need to hire curators to catalogue Emil's art book that would be tied to the exhibit. It was to be a key factor in the advertising and marketing of the exhibition as a whole and its individual works.

He was right. When Hortense pitched the idea of a catalogue book to be published by the Foundation, more requests for meetings in Switzerland and the United States came to pass.

<hr />

As is the case with any major project—a Broadway musical, a film production, the construction of a new building or airport terminal—planning and resolving the many disparate elements and logistics that make a project successful took time. A large-scale, world-class exhibition required both sides of the exhibit—the art owner and the host museums—to negotiate, compromise, and resolve issues early on in order to synchronize the planning details.

By June 1988, many open-ended issues remained unresolved. On Friday, June 3, Charles Moffett, through his assistant Cassandra, wrote a lengthy memorandum to "D" (meaning the director of the National Gallery of Art, John Carter Brown III, who helmed the institution from 1969 to 1992).

The memo began:

> This afternoon I spoke with Philippe de Montebello about the Bührle Collection exhibition.
>
> He remains reluctant for the following reasons: First, by the Met's calculations the "figures for shared expense budget are optimistic." Next, he complained that the "old masters section" made no sense, strictly limiting the paintings to a narrowly defined era. Third, Charlie thought the title from an unknown Swiss arms dealer—*Masterpieces from the E. G. Bührle Collection*—"sucked" to put it mildly. Finally, on the cost-benefit ratio, with the expense prohibitively high, the "run was too short" to recoup the investment of the exhibition. [14]

The memo went on to emphasize Frau Anda's temperament, adamant if not obstinate in her insistence that a "smaller, tighter exhibition" was not going to happen.

Moffett also reminded Director Brown that the "first organizational meeting" between both sides had taken place in Zurich in June 1987, and that "little progress has been made" since the second meeting in October 1987. He also pointed out that, in addition to the "serious unresolved problems," his team would miss the "first deadline for the catalogue (December 1988) because the authors are reluctant to write entries for a project that may collapse."[15]

Worst, he pointed out that the Met's Gary Tinterow (15 entries for the book) might not be "involved," and asked "whether Chicago will find someone to replace Rick Brettell (15 entries)."[16]

Moffett concluded that though the "practical problems can be resolved," the exhibit is "expensive and unfocused," and called his participation an "exercise in frustration." Moffett saved his best shot for last, writing: "If I were the triage officer at the NGA, I would not waste further resources on the Bührle exhibition unless most of the outstanding problems can be resolved quickly. It has become a candidate for museological [*sic*] euthanasia."

He strongly suggested a replacement exhibition including the same Impressionist artists, "Still Life and Flower Painting ready for January 1990."

By the following Tuesday, with the skill and patience of a diplomat, NGA Director J. Carter Brown needed to assuage his talented but young and temperamental curator, which he did by alleviating Moffett's concerns, writing a letter to Frau Hortense Anda-Bührle, announcing:

> First, I am pleased to be able to report that we have learned that The Federal Council on the Arts and Humanities will support the exhibition. However, without a final list of insurance values for each art in the show, the Council will not indicate the level of support. We believe that it will ultimately be in the range of $50–75M. We will need the values by August 1st in order to submit the final application.[17]

J. Carter Brown shifted the tone and stated that he was "not optimistic" about securing the Met's participation in the show, since "Mr. de Montebello's reservations are rooted in concerns about the budget as well as the focus of the exhibition."[18]

Two days later, like a coach on a losing football team that had to keep the players focused on the next game, Brown sent a short note to the Met's director, Philippe de Montebello, thanking him for the Metropolitan's "involvement" in the project that was still tenuous.

A week later, de Montebello called Brown and echoed Moffett's sentiment about the bad working title of the exhibit, *Masterpieces*

from the Collection of Emil G. Bührle. To make matters worse, the Met director poked fun at Emil and Dieter's Nazi-linked, arms-dealer past, suggesting an alternate title: *Hidden Treasures of Switzerland.*[19]

In the same memorandum to the file, the NGA director also noted two alternate titles, *Quality: The Collecting Achievement of Emil G. Bührle,* and *Paintings by Manet, Cézanne, Van Gogh, Picasso, and Thirty-Five Other Masters.* They were not great, but better.

When Charles Moffett got wind of the alternate titles for the Bührle exhibition, he grew more incensed, not assuaged. He toned down the words, but not his aversion to the show. The title was key for him to get involved and not mar his stellar fine art reputation. Inwardly, he was tired of the compromises that the US museums, particularly the NGA, had to make to keep the show alive.

By late fall 1988, J. Carter Brown had to find a solution to the title of the exhibition that would please both sides: Hortense Anda-Bührle and Charlie Moffett. So he flew to Zurich with the sole purpose of viewing the paintings. Upon seeing the greatest private art collection in Europe, J. Carter Brown labeled the exhibit *The Passionate Eye* (according to a 2013 email from the Emil G. Bührle Foundation manager Lukas Gloor to this author).

Brown, who might have felt a sense of spiritual connection with the late Emil, appreciated the number and quality of the artworks the collector had accumulated during the first half of the twentieth century. Brown's personal tour of the Emil G. Bührle Foundation, showcasing the many paintings in the landmark villa, reminded him of the great Barnes Collection housed in a mansion in Philadelphia. The tour made a believer out of him that the show indeed would be a grand success. When he met Dieter Bührle for the first time and learned about Oerlikon Aerospace's connection to US defense contractor Martin Marietta, Brown's thought turned to the practical side of things; he knew he had his first corporate sponsor to back the show. He would go through his Rolodex to find a congressman

or senator who was connected to Martin Marietta to make the key introduction.

On December 9, still in Zurich but ready to fly back to Washington, Brown transcribed a "memorandum for the file" via telephone. Referring to his meeting with Hortense, Brown said over telephone about the Bührle exhibition: "The title [Hortense] and I worked out—and I have to bounce it off Charlie Moffett here later today, but you can try it on others—it would be 'The Passionate Eye: Impressionist and Other Paintings from the Collection of E.G. Bührle' and then the dates '1890–1956.'"[20]

Charlie did latch onto the new title for the show, *The Passionate Eye*. And like J. Carter Brown, he knew the subtitle had to be worked out—and that's what Hortense and Moffett did.

By early 1989, with the exhibition still a year away, the final title and companion art book had finally been resolved. It would be called *The Passionate Eye: Impressionist and Other Master Paintings from the Collection of Emil G. Bührle*.

After Gary Tinterow of the Metropolitan Museum of Art and Rick Brettell of the Chicago Institute of Art had both dropped out of the show, as Brown knew might happen, Hortense Anda-Bührle bestowed on Charles S. Moffett the duty of cataloguing twenty-four of the painting entries for the book, *The Passionate Eye*, to be published in 1990 by the Oerlikon-Bührle Group's book company, Artemis, in Zurich.

Of those twenty-four entries that Charles Moffett would write, six were descriptions of van Goghs, including Dieter's *Wheat Field with Cypresses*, one of three of the same landscape paintings Vincent had painted in the summer of 1889, during his confinement to the Saint-Rémy asylum.

In the essay, Moffett wrote:

Van Gogh was fascinated by the cypresses as the natural equivalents of architectural forms, 'as beautiful in lines and proportions as an

Egyptian obelisk.' . . . Like cypresses, wheat fields are among van Gogh's most important metaphors. Wheat, for the artist, was 'the germinating force' in the cycle of life and the creative process.[21]

Few people knew that Moffett cited Ronald Pickvance, the longtime Scottish fine arts professor at the University of Glasgow, Impressionist art expert, and Vincent van Gogh author. Even fewer knew that, strangely, the NGA curator somehow had either left out or deliberately omitted the name Emile Schuffenecker from the painting's history. Art researcher and van Gogh specialist Benoit Landais, who has long been calling attention to Schuffenecker's history as a forger, insists, "Moffett was aware of the poisonous smell of the Schuffenecker name."

5

The Honey Trap

By mid-February 1989, the marching orders on the book from the National Gallery of Art's editor-in-chief, Frances P. Smyth, were to marshal the disparate entries and essay writers into a cohesive production and push the project forward with the catalogue, meeting the schedule for the opening of the exhibition in spring 1990.

Smyth, who had flown with Charles Moffett to Zurich for the February 2 meeting with Hortense Anda-Bührle, Dieter's son Christian Bührle, two others from the Emil G. Bührle Foundation, and three representatives from the Bührle Group's publisher Artemis Verlag, wrote a detailed "memo for the file." She noted what was discussed, what needed to get done, and who was in charge of the various tasks necessary to open the exhibition in fifteen months. The memorandum was copied to six museum executives, as well as J. Carter Brown and Maryann Stevens of the Royal Academy in London.

The two sides agreed on the title for the book and exhibit that included Frau Anda's "enthusiastic" support for Director J. Carter Brown's name of the show. The cover artwork to adorn the catalogue—which would be like a coffee-table book—was chosen:

van Gogh's *Blossoming Chestnut Branches*, painted long after the art-ist's arrival at Auvers-sur-Oise, a farming commune northwest of Paris, after his yearlong stay at the asylum. Like *Wheat Field with Cypresses, Blossoming Chestnut Branches* had a complex history of ownership. Today, *Wheat Field with Cypresses* hangs in a gallery at the Met, and *Blossoming Chestnut Branches* resides in Switzerland as part of the Emil G. Bührle Foundation, never to tour again.

The meeting also addressed a number of more minor logistical is-sues. Frances Smyth stated that the "Foundation will prepare a bro-chure describing their work which they will put in the catalogue before shrink-wrapping it."[22] The National Gallery of Art would ask to see a mockup of the brochure's "text and design" and state how many copies would be needed for the exhibit and gift shop. The group also chose the eight Bührle paintings to be used for reproduc-tions; one of those would be *Wheat Field with Cypresses*.[23]

Smyth also listed "postcards, note folders, and posters" that NGA would choose with input from London and Montreal museums, the second and fourth legs of the tour.

The NGA's editor-in-chief put emphasis on other items, the order of the artworks and the need to keep the Bührle name out of the spotlight:

> Frau Anda wishes all works not in the Foundation collection to be simply credited as "Private Collection," not as "Collection of Mrs. Hortense Anda-Bührle" or "Collection of Dieter Bührle."
>
> Works in the catalogue will be arranged chronologically in a sequence to be suggested by Charlie Moffett and sent to the Foundation.[24]

Director Brown wrote a thank-you note to Hortense: "Your col-lection, which is much broader in scope and so overwhelming in

quality, will, of course, be 'the news,' as it has never been seen before in the US." The director also mentioned that pictures from the Annenberg Collection, less than one-third of Emil G. Bührle's, were "on view all summer in nearby Philadelphia just the year before," something that seemed to suggest success for *The Passionate Eye*. Unbeknownst to Brown was the Bührles' ulterior motive for setting up the exhibition—their plan to sell *Wheat Field with Cypresses* to the right billionaire art collector. Walter Annenberg, they would come to realize, fit that bill to a tee.

In June 1989, J. Carter Brown informed Hortense that the smaller, but "good quality," Annenberg Collection of Impressionist art would be shown simultaneously with *The Passionate Eye* exhibition at the National Gallery of Art. From the point of view of the NGA, the reason was clear—to "double" or "triple" overall attendance. For a museum that had an annual budget of $51.4 million in 1990—79 percent of it funded by the US federal government—the decision was grounded in economic reality and made good business sense.[25]

In her response to Brown's letter, Hortense played it cool, aloof; with a royal air, she stated she was a bit disappointed that the exhibit needed to be bigger to draw larger crowds, when the "artists names" alone should have been able to achieve the same end goal. Then, in a phone call with Hortense a week later before she boarded a train to Florence, Brown found her "fairly cheerful and resigned to the double showing."[26]

While Brown focused on statistics about "overlapping artists" beyond the constellation of Gauguin, Monet, Cézanne, Pissarro, and van Gogh, and how well the two exhibits would play off each other side by side, Hortense, with Dieter behind the scenes, was preparing a honey trap for the big whale, Walter Annenberg.

Mr. Brown's greatest attribute was being a dealmaker with a grand vision who got things done. In helping create the modern museum blockbusters at both the New York Metropolitan Museum and the

National Gallery of Art, from the huge *Treasures of Tutankhamun* to the successful *Treasure of Houses of Britain*, J. Carter Brown could deliver shows better than P. T. Barnum. He saw that bringing in a fine art collector and media magnate with the well-known American name of Ambassador Walter Annenberg would help elevate the profile of the unknown Swiss family name of Bührle and guarantee a well-attended, moneymaking exhibition of the highest standards.

When Martin Marietta leveraged its sponsorship for the tour, it forced one minor change in the catalogue cover. Van Gogh's colorful *Blossoming Chestnut Branches* was out, replaced with Camille Pissarro's *Road from Versailles to Louveciennes* (1870).[27] The substitution was fine with Dieter and Hortense as long as the face of the exhibit, Dieter's painting *Wheat Field with Cypresses*, remained on the cover of the brochure.

6

Seduction at Sunnylands

April 1990.

Sitting in the living room of their spacious, naturally lit modernist estate of Sunnylands in Rancho Mirage, California, Walter Hubert Annenberg and his wife, Lee, were sifting through the mail. He opened an oversized envelope from the director of the National Gallery of Art and pulled out a handwritten note from J. Carter Brown. The director wished *all* of them good luck with the dual art exhibits that would take place next month, showcasing Annenberg's private art collection alongside that of the late German-Swiss arms manufacturer and art dealer Emil G. Bührle.

Ambassador Annenberg took out the book on the exhibition— *The Passionate Eye: Impressionist and Other Master Paintings from the E.G. Bührle Collection*—and sliced open the shrink wrap with a sterling silver letter opener. With a steady hand, the eighty-two-year-old philanthropist tore off the plastic sheath. He pulled out the exhibit's brochure and admired the cover with van Gogh's landscape masterpiece *Wheat Field with Cypresses*.

There on Walter's lap sat the catalogue with Camille Pissarro's *Road from Versailles to Louveciennes* staring at him with its bright yellow summer scene of a couple walking their daughter on a dirt road in nineteenth-century France. Annenberg grinned at the cover. He then gazed fondly out the window wall to the lush green grass with cacti and trees, manicured hedges, and a golf course set across his 200-acre estate on Bob Hope Drive near Palm Springs. It dawned on him that the idyllic scene of Pissarro's art matched the beauty and brilliance of the Southern California sun with the purple San Jacinto Mountains set against the distant horizon. He wondered how the Impressionist master would have painted Sunnylands, had he lived in the modern age.

Artemis, the Swiss publisher, removed the dark left side of Pissarro's painting that showed a pair of women with a little girl talking in the shade of a tree. *Clever,* he thought. He came to the conclusion that Artemis knew what it was doing when it used the lighter, brighter half of Pissarro's artwork on the book jacket and wrapped the darker half of the painting around to the back cover. The graphic designer had manipulated the image to project a softer aura with a golden ambiance. Alluring. Exquisite. Effective.

More than clever, he acknowledged. Later that day, Walter realized, he would have to go to his 3,400-volume library and pull out the art history catalogue on Pissarro's oeuvre to compare the full *Road from Versailles* painting to the reimagined version that appeared on the back and front of the exhibit catalogue.

"Lee, take a look at this beautiful cover. Isn't it marvelous?" he said, turning around to show his wife the catalogue.

"Why, yes," she said. Sitting on a plush white linen sofa, Leonore Annenberg, Walter's second wife of forty-one years, pushed her reading glasses down and gazed at the book cover. "It does look grand, Walter," she said, as she held up a letter from the White House. "It's as superb as this note from the First Lady. She and George had a wonderful time last month at Sunnylands. They enjoyed the dinner

we hosted in honor of George's presidency together with [Japanese] Prime Minister Kaifu and his lovely wife."

"How could they not, Lee? It was a sumptuous affair. Great company, better conversation. The entire evening matched the red-hot economy in Japan . . . The guests loved our art collection. One day I think a Japanese conglomerate will make an offer to buy it. And I am sure I sold George on the idea of Sunnylands being the Camp David of the West."

Walter looked past his wife and saw the empty space above the fireplace mantel where his most beloved acquisition, van Gogh's *Roses*, usually served as the centerpiece, the fulcrum of his art collection, the center of attention and light of the room. But that painting, along with dozens of others that he and Lee had collected and bought over the decades, had been shipped to the National Gallery of Art in Washington, DC, to be exhibited alongside the private collection of Emil G. Bührle.

With most of his fine art elsewhere, Sunnylands felt empty, as if the Annenbergs had just sent their children off to college for the first time. Sure, there were the Chinese porcelain and Meissen vases and lesser artwork, along with many other items of prestige and luxury. Yet nothing, he knew, beat the masters of Impressionism and Post-Impressionism.

Walter Annenberg recalled the first two fine art purchases he made in the 1950s: Vincent van Gogh's *Olive Trees* and Claude Monet's *The Stroller*.

Over the years, he and Lee added Auguste Renoir's *The Daughters of Catulle Mendès* and *Reclining Nude*, Cézanne's *Seated Peasant*, Monet's *Camille Monet on a Garden Bench*, and Pablo Picasso's *At the Lapin Agile (Harlequin With a Glass)*.[28] He still chafed at the memory of being outbid by the J. Paul Getty Museum in November 1987 at an auction for van Gogh's *Irises*.[29]

As he had done before, Annenberg reminded himself of a saying he had coined to soften the blow, and said with exaggerated enthusiasm, "I like my *Irises* better," referring to Monet's *The Path Through*

the Irises that he acquired the same year he lost the van Gogh to the Getty Museum.[30]

He held the tall coffee-table book on his lap and looked at the *Passionate Eye* brochure. Vincent van Gogh's *Wheat Field with Cypresses* stood out on the cover of the brochure, more so than Pissarro's painting on the book jacket. The van Gogh's landscape image was bold and colorful, framed by a thick dark blue border on the top with the title of the exhibit, and a matching border on the bottom providing the show details:

National Gallery of Art
May 6—July 15, 1990
The exhibition is made possible
by Martin Marietta Corporation[31]

Like a young boy about to open a birthday gift, the excited art collector opened the book and flipped through the pages to the back, where Vincent van Gogh was alphabetically listed, and saw entry No. 62, written by Charles Moffett, on *Wheat Field with Cypresses*. Right there: a larger image of the van Gogh masterpiece with the wheat field, bushes, and cypress trees in the foreground; the bluish Alpilles Mountains in the background crowned by a big sky with swirling, windswept clouds blowing east to west above; a breeze on the ground blowing the wheat and bushes across the painting in the opposite direction. He compared what he saw in the painting to his Sunnylands estate. He saw the commonalities of nature's rarefied beauty, a bright southern sun pinned high above an unmatched landscape of serenity. What van Gogh painted in capturing the view at the asylum with the wheat field in the foreground achieved a similar perfection of lasting beauty to the land that Walter and Lee bought back in 1963 that indeed made an impression on all who laid eyes on the estate.

Walter imagined that in lieu of van Gogh's wheat, he saw the green sod on his property; instead of the tall painted cypresses, the

palm trees of the Palm Desert were more than a suitable stand-in; and the low-range Alpilles were, in his reckoning, a close European cousin to the San Jacinto Mountains. Seeing something he loved, he suddenly knew he had to wrestle van Gogh's masterpiece from Dieter Bührle's hold.

Walter read through the provenance of *Wheat Field with Cypresses*. He saw van Gogh had created the painting during his yearlong stay at the asylum, May 1889 to May 1890; after Vincent and Theo's deaths less than a year later, the painting resided with Theo's widow, Jo van Gogh-Bonger, and her son for a dozen years before being sold to a Paris art dealer. A few sales later, the painting made its way to art dealers in Germany, where it was eventually sold to Franz von Mendelssohn, heir of a German-Jewish banking dynasty—the family tree of classical composer Felix Mendelssohn.

Although what Walter saw in the Mendelssohn heritage was not necessarily a mirror of his own German-Jewish ancestry, he felt there were certain similarities between the families' histories; the reflection made him crack a sheepish grin. In the roots of Franz von Mendelssohn's bloodline was a close facsimile of the Annenberg family. Both patriarchs shared the same first name—Moses. In Annenberg's case, his father "Moe" immigrated to the United States in 1900, while the eighteenth-century German-Jewish banking family's patriarch was a famous German philosopher, Moses Mendelssohn, who paved the way for the banking dynasty to be chartered in 1795 and grow beyond Bavaria until the rise of Adolf Hitler's Third Reich in the twentieth century.

Annenberg traced the painting's ownership to Emil Bührle, who bought it in 1951 from the heirs of Franz von Mendelssohn and then willed it to his son, Dieter, upon his death in 1956.

"So this painting does belong to Dieter and is not part of the Foundation," he said to himself, sensing a buying opportunity. Having not spent the $53.9 million on van Gogh's *Irises* three years

earlier when he lost the bid on that painting, Walter had the money to buy another Impressionist masterpiece. He thought about the painting's current owner and his past.

He had a gut feeling that, for the right price, he could convince Dieter to sell the painting to him, especially with the help of the Annenberg's dear friend J. Carter Brown. After all, Brown had attended one of his and Lee's politically popular dinners at their Sunnylands estate in July 1988, when the director made inquiries about what the Annenbergs were planning to do with their billion-dollar fine art collection.[32]

While not committing to the National Gallery of Art or any other of the museums thought to be on the short list of candidates for the eventual repository of the collection—the Los Angeles County Museum, the Metropolitan Museum of Art, and the Philadelphia Museum of Art, in the city where Walter and Lee lived half the year—he did appreciate J. Brown's idea to convert Sunnylands into an extension of the NGA, a museum open to the public on the West Coast under their care.[33]

Walter stood up and waltzed over to Lee. He handed her the brochure and opened the book to the larger image of van Gogh's *Wheat Field with Cypresses*. She looked at the moving, brilliant landscape painting, put the brochure down, took the book from her husband, and read Moffett's essay.

"Lee, after you read that section, go to the back and check the provenance. The older brother to Hortense owns the painting, not the Foundation."

"That means I should talk to Frau Hortense Anda-Bührle and whisper sweet nothings to her about her brother . . . What a grand old name for a dame," she said with a chortle.

"Do you like the painting?"

"I love this van Gogh. But can we buy it, Walter?" She looked at the centerfold of the painting on the following page.

"We should examine it at the exhibit next month in DC, then see if we can't move to make an offer with Carter's help."

As she examined the provenance of the painting, she said, "It sure would be cheaper than bidding on it at the auction houses."

And so Walter and Lee agreed on their first step. What neither one of them knew at the time was that the provenance Charles Moffett had provided was incomplete. (It is unclear whether knowing the Schuffenecker connection would have made a difference, however—they owned another painting with a provenance that went through the Schuffenecker brothers, so, as Landais points out, "the name was not necessarily a scarecrow to them.")

Their fixation on getting another van Gogh for the Annenberg Collection made Walter and Lee less focused on the details of its history. There were only three *Wheat Field with Cypresses* in the world, three van Gogh variations on the same landscape study. They had to have the painting. Walter knew one *Wheat Field* was with a private collector in America. The second—and final, according to most experts—version hung in Gallery 45 at the National Gallery, London; it had a different provenance through the Tate Museum in the 1920s.

When he was the US Ambassador to Britain from 1969 to 1975, Walter recalled, he and Lee had visited London's National Gallery and seen that painting for the first time. Having donated millions of dollars to various London causes, charities, and institutions after the sale of his bully-pulpit newspaper, the *Philadelphia Inquirer,* in 1969, the connected Annenberg would have little trouble getting the history and technical report from the National Gallery about their version of the van Gogh masterpiece.[34]

As Lee scanned other van Gogh artworks in the *Passionate Eye* catalogue, she handed a letter from the Ronald Reagan Presidential Library to her husband, saying, "Looks like Ronnie's project will open on time next year. Good work, Walter."

"Maybe by then we will own one more van Gogh masterpiece," he said.

"That would make it painting number fifty-three for Sunnylands."

7

Making an Impression

Tuesday, May 1, 1990.

The National Gallery of Art held the press breakfast and preview for *The Passionate Eye* in the East Building. At the head table, from left to right, sat Daniel A. Peterson, Senior Vice President of Martin Marietta, NGA Director J. Carter Brown, Frau Hortense Anda-Bührle, and Charles S. Moffett.

Missing from the press conference were two notable worldly, similarly hard-knuckled businessmen: Dieter Bührle, chairman of the Oerlikon-Bührle Group, defense partner with Martin Marietta; and Ambassador Walter H. Annenberg. Both men deserved to be at the opening breakfast for the exhibit. Both men would have stoked controversy.

Conveniently absent, Dieter was back in Zurich due to business concerns, shielded from journalists who missed an opportunity to drill down into the history and stewardship of the arms manufacturer that had blood on his hands from Jewish Holocaust victims, American servicemen in both the Pacific and Atlantic theaters of World War II, blacks in apartheid South Africa, and Israelis from

the sales of gun batteries to Egypt prior to the 1973 Yom Kippur War.

What about Walter Annenberg? Why wasn't he sitting at the table right next to his close friend J. Carter Brown? What was his liability to the exhibition? Was Walter a risk, being the former owner of *TV Guide* and the *Philadelphia Inquirer*, along with other media and broadcast outlets, who attacked political and journalist enemies with hardcore retribution near and far? Had Walter attended the breakfast, it would have been akin to putting an old great white shark into a pool of young barracudas. One could surmise that Leonore Annenberg had advised Walter not to attend for that very reason.

For the well-attended press conference, the Oerlikon-Bührle Group and the National Gallery of Art went heavy with preemptive damage control. The day before, Ruth Kaplan, the NGA's external information officer, sent a memorandum to Brown outlining the problems with Emil Bührle's arms dealer past during World War II. The notes she gave him warned about a particular journalist and prepared him for probing questions about Emil Bührle's Nazi-tainted past, questioning whether the NGA should have commemorated his legacy as an art collector at all.

Kaplan wrote:

> The one issue which is more than likely to come up is the question of Bührle's arms sales during WWI [*sic*]. For your additional background, the Bührle company sold arms to the Allies during the war but did not directly sell to the Axis. The Swiss government made a deal with the Nazis when Germany surrounded Switzerland and no supplies go in or out of the country. The Swiss agreed to provide arms and pharmaceuticals to the Nazis in exchange for an open route of the country. This question is likely to be posed by Elliot Nagin of The City Paper who has been assigned to do a cover story about Bührle's wartime activities . . .[35]

One defensive tactic the NGA adopted for "non-art related" inquires was to prep Hortense on how to answer questions from the press by coming up with a list of nineteen "possible questions and their recommended responses."[36] Without a doubt, Hortense had to protect her father's legacy, reputation, and family name, even if it were unknown outside of Switzerland. Below are some of these questions and suggested answers:

Question 2: Why [has] the Bührle family never considered donating the collection to a museum?

Answer 2: For us it was very important that our collection remain intact and as a whole, the way our father assembled this harmonious, well-thought collection. Donating it could have meant a split up of the collection.[37]

Question 3: Has the Foundation ever sold any paintings?

Answer 3: In 1960 we sold approx. 20 paintings of minor importance in order to establish a capital fund which would assist the Foundation in maintaining both the collection and the house in which the collection is hung.[38]

Question 6: In your opinion, what is the most expensive aspect related to maintaining an art collection of this stature?

Answer 6: I would say that the security installations are very expensive.[39]

Question 8: With Japan's reputation for being the highest bidders on the auction block, would you consider selling any paintings if they were to make you an offer?

Answer 8: We do not have a reputation for selling our paintings.[40]

Three of those four questions focused on whether the Bührle heirs would ever part with selling a painting, especially artwork of outstanding and historical value, such as a Vincent van Gogh masterpiece. The answers to those three questions were a firm *No, No,* and *No,* as in not open to further discussion.

In answering the question on "cost" of maintaining the collection, Kaplan inserted the only response to what was hot news at that time. In the spring of 1990, security at fine art collections around the world were on high alert. Seared in their minds was the St. Patrick's Day robbery of the Gardner Museum in Boston six weeks earlier—a theft of priceless masterpieces valued at a combined $500 million. With the Bührle exhibit coming on the heels of the biggest art heist in history, it was important to supply Hortense with the right response should the question arise.

The scripted answers, devised to insulate Frau Hortense from a barrage of questions and soften the depiction of the business dealings of Emil Bührle and his company during and after World War II, did not fool everyone. One journalist in particular wasn't buying the story.

———

In January 1990, the *New York Times* chose thirty-one-year-old Michael Kimmelman, "a writer of proven scholarship and journalistic flair," to be its chief art critic.[41]

Of Jewish descent, Kimmelman would prove to be a thorn in the side of all participants involved with *The Passionate Eye*. For Kimmelman, there was no fog of war, no gray, just black and white. He knew Emil Bührle supplied the Nazis with weapons that killed Americans and Allied troops during the war. He knew that Oerlikon sent its heavy-duty guns to Japan. The art critic wouldn't be swayed, not in light of the vast troves of priceless European art stolen by Hermann Göring and his Nazi collaborators.

But the poison dart that Michael Kimmelman would fire at the exhibit, the Bührle family, and the National Gallery of Art, in the form of a caustic review, wouldn't be published for another three weeks. Did Kimmelman deliberately hold off on writing about the biggest exhibition of the year in an act of defiance? If he did attend the press breakfast that day, he was quiet. Between the morning of

May 1 and May 20, when he finally wrote about *The Passionate Eye*, the *Times* chief art critic published three articles (on May 4, 11, and 14). All of them were art reviews of lesser shows, in smaller venues, with inferior artists. Holding off on his critique was in itself a calculated statement.

⸻

After Martin Marietta's Daniel Peterson and NGA's J. Carter Brown gave their opening remarks, the director introduced Frau Hortense Anda-Bührle, President of the Emil G. Bührle Foundation, to the audience. She took the podium. Like the center of gravity she was to her father's art collection, Hortense calmly placed her six-page, double-spaced, all-caps speech on the lectern and addressed the audience. Speaking with a thick Bavarian accent, she told the story of her father's life and the rise of his career as an industrialist.

Armed with press kits, the journalists learned the Foundation was chartered in 1960; that it received numerous requests over the years to show the collection outside of Zurich; and that due to the logistical challenges of bringing the breadth of artwork to the world stage, the collection would be "retired from international lending after the current world tour"[42] of the four cities.

Well prepared, knowing the subject matter her entire life, Hortense delivered a thoughtful speech about her father, his life as an art lover, and his art collection:

> [He] began to acquire paintings, in particular Impressionists, for it had been the works of these masters that had kindled the fire in his student days. So it was only natural that Manet, Pissarro, Cézanne, Sisley, Monet, Renoir, Degas, Toulouse, Gauguin and van Gogh were to form the nucleus of his collection. He recognized the relationship of these artists to their forebears in Dutch and Venetians such as Cannaletto, Guardi and Tiepolo. And he expanded the collection accordingly.[43]

She dodged any direct probes into her father's past (it helped that the event took place five years before web browsers and search engines existed), and the breakfast went smoothly. The only slip up occurred when J. Carter Brown stood to introduce his senior curator of paintings and, peering into the audience, couldn't find his Impressionist expert. Laughter ensued as it was pointed out that Charles Moffett was right there, sitting at the head table with Brown, on the other side of Hortense.

With the gala dinner—where Walter and Leonore Annenberg conversed with First Lady Barbara Bush, Swiss and US dignitaries, heads of state, and Republican politicians—a success, the buzz about the Annenbergs' and Emil Bührle's art collections likewise was positive. Not a landmine in sight. From the champagne and three-course meal onward, it appeared smooth sailing ahead for the exhibits when the throngs of visitors poured into the museum on opening day, Sunday, May 6, 1990.

Walter had taken a private tour of Bührle's artwork before the first review of the exhibit came out on Friday, May 4. Up close, free of the crowds, he and Lee moved around the East Building, walking quietly from room to room, admiring the collection of masterworks from the Bührle Foundation. When the Annenbergs came to the large gallery room, with its luminous high ceilings, spacious dark green walls, and knee-high baseboard and trim, Vincent van Gogh's *Wheat Field with Cypresses* stood out from the other paintings in the room. In Walter's eyes there was no comparison. It was a classic he had to own.

The ambassador would soon begin to work behind the scenes, make calls, and pull any and all strings necessary to do whatever it took to bring the van Gogh masterpiece into his fold.

He took Dieter's bait.

8

Poison Dart Art Critic

Michael Kimmelman, who was well versed in the myths and facts surrounding Emil G. Bührle's life and his suspect—even tainted—art collection, must have been aware of a scathing magazine article in late 1989, a publicized outing of Dieter Bührle's dark past.

The annual Canadian arms conference, held on October 25–26, 1989, in Ottawa, Canada, was a not-so-veiled sign of protest against the United Nations' "Disarmament Day," observed the day before.

For Richard Sanders, a freelance reporter for the Coalition to Oppose Arms Trade (COAT) in Ottawa, it was an opportunity to shine a light on the conference and its delegates. Since those were pre-Internet days, Sanders did what any good reporter would have done—dumpster dive for intelligence. He lifted business cards and arms brochures out of wastepaper baskets and trash bins, picked up fliers and marketing materials from exhibit booths, and stayed under the radar, not drawing suspicious eyes to his real purpose for attending the bizarre trade show. He knew that no arms manufacturer

would go on or off the record to speak to him; what's more, had a vendor found out that Sanders was from COAT, he likely would have been shown the door.

One month later, Sanders published "Merchants of Death Conference" in *Peace Magazine*. In discussing statistics on which arms manufacturers were in attendance, which countries they represented, and which companies sponsored the two-day conference, he zeroed in on one central speaker: Dietrich S. Bührle, also known as Dieter.

On Dieter, Richard Sanders wrote:

> He was following in his father's footsteps. Emil George Bührle, founder of the Oerlikon-Bührle Machine Tool Company, was blacklisted for selling armaments to Nazi Germany during the Second World War. In 1971 Dietrich Bührle was in the Swiss Supreme Court, admitting responsibility for Oerlikon's illegal sales of arms to South Africa, Egypt, Israel, Lebanon, Malaysia and Nigeria.

The article went on to explain that "21 million worth of arms" had been illegally exported by Oerlikon-Bührle Group, with more than half to South Africa, and the forged "end of use certificates" and a shell corporation in France were all that was needed to get it done.

Next, Sanders wrote about how Dieter "got off easy" with a suspended prison sentence, a fine, and three years of probation, and that a couple of other company executives took the fall on Bührle's behalf.[44]

Sanders noted that in the speaker's bio, there was no mention of Dieter's criminal past.

———

In addition to covering the arms dealer's business past, with its moral compass that always pointed to the Bührles' wealth and well-being in Switzerland, Michael Kimmelman also dug deep into Emil

Bührle's art acquisitions. On Sunday, May 20, with *The Passionate Eye* entering its third week with full attendance, he wrote a blistering 1,300-word account that skipped over the artwork and the master artists and gutted the show.

The art review began with the curious title "Was this Exhibition Necessary?"[45] He took a swipe at Walter Annenberg and the Annenberg Collection by openly castigating wealthy private collectors who tried to "enhance" their dented and soiled reputations through the purchase of "vanity art." Most of Kimmelman's concerns, in fact, were of a moral kind:

> But it is also an exhibition that the National Gallery should never have undertaken. The astonishing thing is that this public institution evinces no embarrassment.[46]

Kimmelman threw a left hook at Bührle and his past:

> What is nowhere mentioned in the catalogue is that Bührle-made arms were distributed to the Nazis as well as to the Allies. Nor is anything said about Dieter Bührle—the collector's son and the present chairman of Oerlikon-Bührle, who owns many of the works in this exhibition— except that he continued to buy art for the family firm after his father's death. A reader will search in vain for news about Dieter Bührle's conviction in 1970 in Switzerland for illegal arms sales.[47]

He then took his gloves off and pointed out a very specific and damning association. "And only the most scrupulous reader of the small print on the back of the catalogue will notice curious bits of information like the provenance of Renoir's *Portrait of Mademoiselle Irene Cahen d'Anvers*, which traces the painting to the collection of Hermann Göring,"[48] the *New York Times* chief art critic wrote.

When J. Carter Brown and Charles Moffett read the scathing review on Friday, May 18, in the *New York Times* weekend edition,

their jaws must have hit the floor. Sure, Moffett expected some-
thing to come out, a hit job on Emil Bührle and his collection. He
got wind that such a piece was going to come out when he met
Michael Kimmelman at the exhibit on Monday, May 7. What he
didn't expect was the Molotov cocktail the art critic hurled in the
direction of all participants.

Moffett wrote a memo to the file:

After seeing the Annenberg and Buhrle [*sic*] exhibitions this after-
noon, Michael Kimmelman came to see me.

He had only one thing on his mind: the question of morality
and the Buhrle family. He asked me several questions about E. G.
Buhrle's arms business, most of which I couldn't answer.[49]

Kimmelman went on to pound Charlie about Dieter's conviction
and the fine paid by the company in 1970 for selling illegal arms.
Whenever Moffett tried to move the conversation to art, Kimmel-
man turned it back to questions on morality.[50]

Up to May 18, a dozen positive reviews, local and regional, had
been written about the twin exhibits, several with a title playing off
the word "Impression." Up to that point, the National Gallery of
Art, Hortense Anda-Bührle, the Annenberg Collection, and Martin
Marietta had avoided most forms of controversy. Now they were the
targets of censure and ridicule.

Meanwhile, J. Carter Brown wrote a letter to the Art and Edu-
cation Committee of the Trustees to preempt anger and heated
reaction to the Kimmelman review, reminding them, "You may
remember that at the time the Bührle exhibition came up for
approval by the A&E Committee in 1986, I mentioned that
we would be incurring the risk of some journalistic reaction to
business activities of the Bührle firm, and that it was felt at the
meeting that we should not let this deter us from a major art
opportunity."[51]

But Kimmelman had done his homework. He knew some of the unpublished history of Emil and Dieter Bührle. He nailed the industry of war—superficially "purified" by the commerce of art—to the cross. He accomplished the investigative feat seven years before the CIA declassified "Operation SafeHaven," which showed the movements of Emil Bührle during the war across France, his network of art dealers, his connections to Hermann Göring, the laundering of the Nazi Reichsmark into gold and Swiss francs, and the sales of arms for artwork and other forms of payments with Nazi Germany, despite the claims made by Emil's children to the contrary.

Kimmelman wrote his hit piece eighteen years before the Simon Wiesenthal Center's detailed, 165-page 2008 brief, *The Hunt Controversy: A Shadow Report*, which reported on the looted art of Jewish and European collectors and dealers. That report dedicated a full chapter to the schemes, dealings, and connections of Emil G. Bührle during World War II. Nothing in the *Shadow Report* enhanced Bührle's reputation as an art collector. In fact, it had the opposite effect of discrediting the industrialist, suffocating any chance his family had to rehabilitate his reputation.

———

In August 2015, a new book appeared, titled *The Bührle Black Book: Art Stolen for the Zurich Kunsthaus*. Researched, investigated, and written by Dr. Thomas Buomberger, a Swiss historian and journalist, and Guido Magnaguagno, an art historian, it skewered the Bührle Foundation art collection. Its authors pointed out in an email to this author: "Not enough research has been done into the provenance of all the paintings."[52]

Dr. Buomberger has called on the Swiss government to open an investigation into the nineteen cases of artwork with suspect provenance that the authors profiled in their book, which does not include Dieter Bührle's *Wheat Field with Cypresses*, since neither Dieter's estate nor the Foundation had owned the painting for

nearly a quarter of a century. The authors complained that the Büh-rle Foundation continues to receive public subsidies (the Kunsthaus in Zurich was being renovated to host the art collection in 2020).

———

Kimmelman was way ahead of the curve when it came to the dark undercurrents of the Bührle father-son dynasty. His piece, however, met with some resistance, and not only from Brown and the NGA. On May 21, New York businessman and art enthusiast Doug Russell wrote a strongly worded rebuttal to Kimmelman's piece, in which he called out the art critic for "forwarding his bias" instead of focusing on art. Russell wrote his diatribe not to the editor of the letters section, but to the publisher of the *New York Times*, and he was savvy enough to copy J. Carter Brown.

On May 24, Piers Rodgers, secretary of the Royal Academy of Arts, wrote a letter of complaint to the editor at the *New York Times*, expressing a similar sentiment about focusing on the art itself:

> Your readers may be interested to know that the artists who form the Membership of the Royal Academy debated the ethical issues involved two years ago. There was an overwhelming majority in favor of the proposition that no moral taint could possibly attach to a work of art unless it were at the moment of its creation. It is in the public interest, and in the interest of their creators, for great works of art to be shown regardless of their provenance.[53]

The Royal Academy of Arts in London would be the fourth and final destination of *The Passionate Eye* tour. Several other people and professionals responded to Kimmelman's piece in the *New York Times*.

When the show was over in mid-July, J. Carter Brown and Charles Moffett knew they had a winner on their hands. Over 200,000 visitors showed up to see the exhibitions; dozens of glowing reviews

were published in local, regional, national, and international magazines, newspapers, and journals. The show was a smash hit. If one left out the acerbic review from Michael Kimmelman, there was a lot to be proud of. Annenberg's exhibit wound up traveling through Chicago, ending in the Los Angeles County Museum of Art before the fifty-two paintings returned home to their rightful place in the 20,000-square-foot estate of Sunnylands.

The Passionate Eye exhibition headed north to Montreal, where large crowds would see it, before heading overseas to Japan. By spring 1991, the exhibit ended its international tour at the Royal Academy of Arts in London.

9

Letting Gogh

Walter Annenberg ignored Michael Kimmelman's piece in the *New York Times*. The octogenarian philanthropist didn't let the noise get to him, even though Kimmelman claimed that the Annenberg Collection was less significant than that of the Bührle Foundation in both the quantity and quality of artwork.

When the twin shows ended at the National Gallery of Art in mid-July 1990, J. Carter Brown faxed the numbers for both exhibits to Walter. Statistics don't lie. In "ninety-two days the show was up, some 341,473 people had seen it."[54]

Annenberg saw that art exhibits made a lot of money. But he also saw that in drawing the masses, a major exhibit would be heavily trafficked—people pounding the grounds day and night, using the facilities, grabbing a meal. Those numbers gave Walter pause. He realized a draw of tens or hundreds of thousands of visitors a year would place a lot of stress on the Sunnylands property, on its beauty, as well as become a burden to the wealthy enclave of the nine-city district of Palm Springs.

That kind of environmental impact made the ambassador reflect, deep down, on whether it was worth turning his and Lee's

home, even at its robust 20,000 square feet, into a satellite wing of a museum. He loved his paintings. He also loved the land, the fresh air and beauty of Rancho Mirage. But the artwork, he further reflected, deserved to be seen by hundreds of thousands of people. He knew that could only take place at a major museum in a major city, not at Sunnylands.

So Walter focused on New York City and the renowned Metropolitan Museum of Art on Fifth Avenue. Ever the negotiator, he gave Met Director Philippe de Montebello a strict list of conditions that the museum would have to meet or exceed in order to receive the donation of his art collection—if, in the end, he decided to give it to them. That list included the requirement that the more than fifty works of art be housed in one wing, his wing, with none of the paintings ever to be lent on tour, sold, or put in cellar storage.[55]

Seeing there was stiff competition for the Annenberg Collection in 1990, the Metropolitan Museum of Art formulated a plan to win Walter and Lee over and separate the Met from the other institutions in the running. "The Met commissioned an eight-foot-square model of its nineteenth-century European painting galleries with scale." The model was based on the "paintings the museum already owned. According to Christopher Ogden's account, Lee Annenberg declared it *brilliant.* 'I took one look and said, "Walter, this is it."' As a further inducement, the Met promised to create a thirty-minute film starring the Annenbergs at Sunnylands talking about their art."[56]

The film would be made a full two decades before reality TV shows (such as *Keeping Up with the Kardashians*) that made talentless but attractive people celebrities. The film, together with the scale model, exceeded Walter and Lee's expectations and strict conditions. They were sold. They were thrilled. The deal with the Met had been sealed in sculptor marble.

On March 12, 1991, *New York Times* art critic John Russell wrote a lengthy article, giving the major art donation—the largest private art collection gift in half a century—and the philanthropist behind

it the coverage they deserved. In an era before YouTube, Twitter, Facebook, and viral videos, the gift to the Met gave Walter and Lee Annenberg center stage and blanketed coverage coast to coast on TV and in newspapers and magazines.

Of the billion-dollar collection of more than fifty works of art, which would be turned over the Met after Walter Annenberg died, Russell wrote: "The installation of the Annenberg collection will be done in the context of a planned overhaul of the galleries devoted to Impressionist and Post-Impressionist paintings."[57]

The article also included an interview with Walter Annenberg: "'It is my intention,' Mr. Annenberg said yesterday in a phone interview, 'that all of my paintings should go to the Metropolitan Museum. I love them with a passion, and I want them to stay together after I'm gone.'"[58] Walter explained his reasoning for choosing the Met:

> Much as I respect the other institutions that have lately shown our collection—the Philadelphia Museum of Art, the Los Angeles County Museum of Art and the National Gallery of Art in Washington—I happen to believe in strength going to strength, and I think that the Met is the proper repository for them. In making this announcement, I want to get the news out that the collection will be kept together and is not for sale.

Russell concluded the article by profiling Walter's business dealings as a publisher and mentioning his recent purchases of works by Picasso, Monet, and others. The art critic left out certain details from the ambassador's past, like those of Moe Annenberg's racketeering and providing mafia muscle, or Walter's own tax evasion issues and an ongoing $3.36 million property tax battle with Montgomery County, Pennsylvania, that he wouldn't settle for years.[59]

Michael Kimmelman, chief art critic for the *New York Times*, didn't remark on the huge donation when it was announced. That would come three months later, at the start of summer, on the eve

of the opening of the exhibition—*Masterpieces of Impressionism and Post-Impressionism: The Annenberg Collection*—at the Metropolitan Museum. Instead of drilling down into Annenberg's suspect moral past, the way he had attacked Emil and Dieter Bührle and the National Gallery of Art for hosting *The Passionate Eye* exhibit the year before, he left Walter unscathed. There was not a word of negative press to be found on such a massive donation.

Kimmelman's focus turned away from Annenberg's past indiscretions, his questionable business practices, and personal morality run amok, and unearthed the gems in the art collection instead:

> Mr. Annenberg's taste tends toward big statements by big artists. Rarely does he venture down art-historical byways. Conventionalism in this case translates into some major paintings. And if there are smaller works that may not represent every artist at top form, there are important Monets like "The Bench" and van Goghs like "La Berceuse," for which this collection is understandably famous.[60]

The Annenberg Collection show at the Met appealed to masses of art lovers and enthusiasts who had flooded the same exhibitions the year before at the National Gallery and other locations. When the show at the Met concluded later that summer, the Annenberg Collection returned home to Sunnylands to be enjoyed by Walter, Lee, their family, friends, and guests from Hollywood to the White House for the rest of the decade. One of the conditions the Met had to accommodate was to allow Walter to enjoy his paintings until his death in 2002. After that, the entire Annenberg collection was sent back to the Metropolitan Museum for permanent residence in New York City.

———

In 1992, Walter Annenberg still searched for new Impressionist paintings to purchase for the Met. In part, the search must have been

spurred by the fact that his art collection paled in size, scope, and top-tier paintings when compared to that of the Bührle Foundation, which was more than three times as large. Competition between billion-dollar art collections had to have stoked Annenberg's passion and oversized ego. Walter was driven by the superior artwork in the Emil G. Bührle Collection. Among other works, he set his sights on van Gogh's *Shoes*, painted in 1888 in Arles, and bought it at auction for $40 million from Siegfried Kramarsky family.[61] Eventually, he turned his attention to Dieter Bührle's van Gogh, *Wheat Field with Cypresses*. He knew that would make a huge splash in the media. So he hired New York art dealer Stephen Mazoh to broker the transaction (Mazoh would work together with the Met curator of Impressionist paintings, Gary Tinterow).

Mazoh, who was born, raised, and educated in Baltimore, Maryland, fell in love with the art world coming out of college when he worked for Ferdinand Roten, a print dealer in the 1960s. By the end of the decade, Mazoh had exhausted both the print and art markets in Baltimore, and realized in order to take the next step in his career he would have to move to New York City. Prior to being hired by Annenberg to close the deal with Dieter's painting, Mazoh had made deals on behalf of the Whitney Museum of American Art, the National Gallery of Art, and the Baltimore Museum of Art.[62]

The deal on *Wheat Field with Cypresses* would go against the claims that Frau Hortense Anda-Bührle had made to reporters in 1990 at the Emil G. Bührle Foundation art exhibition, when she insisted that the Bührles would never sell any of their paintings. She had emphasized that the Bührles were not in the business of selling artwork, and that they had no interest in ever breaking up their father's art collection, as it was seen as an extension of their "family." Moreover, Hortense stated that the only time they had ever sold artwork in the past was in 1960, and that was solely to secure seed money to fund and charter the Emil G. Bührle Foundation. This time they would sell a van Gogh, and, contrary to what one would expect, without

going through an auction house, despite the possibility of a bidding war that could escalate the painting's value. It is a decision that is difficult to understand on the surface.

But then, one particular name, one odious but familiar name, had vanished from the pages of history, at least temporarily. It was a name that many van Gogh experts had long suspected of being linked to some likely van Gogh forgeries.

The missing name was that of Emile Schuffenecker, a brief owner of *Wheat Field with Cypresses* after Jo van Gogh-Bonger sold it with seven others of her brother-in-law's paintings in 1901.

"Schuff," as Vincent van Gogh referred to him, was a friend of Theo van Gogh and Paul Gauguin (according to Landais, Vincent himself had never met him). He was small in frame and stature, a lesser artist than either one of those masters. He also became a collector of van Gogh paintings by the late 1890s. Was it an accident that Schuffenecker's name was left out of the *Wheat Field with Cypresses* description that would accompany the painting in four major museums on three continents for *The Passionate Eye* tour? It was left out of Charles Moffett's essay on the painting in the Artemis book of the same name. Did the senior curator at the NGA and Impressionist art expert, who had broken into the industry at the Metropolitan Museum of Art, fail to double-check the painting's provenance before sending his portion of the manuscript to the Swiss publisher?

The omission remains an unanswered question, and the premature death of Charles Moffett—on December 12, 2015, from pancreatic cancer—makes the resolution of the mystery unlikely. But how does one account for the omission of Schuffenecker's name from the provenance of a *second* van Gogh painting in the same catalogue entry that Moffett wrote? It makes no sense. It had to be a deliberate act, but why? What was his motivation in removing the suspected forger from history? Was he paid by the Bührles to do so? Or, more plausibly, could it be that Moffett didn't want Emile Schuffenecker's suspect name tainting his or van Gogh's legacy?

Stranger still, he left Nazi leader Hermann Göring's name in, but removed Emile Schuffenecker's name twice in the same book, meaning, as Landais wrote, that "for the art trade, a . . . Schufenecker is more dangerous than a . . . Göring." Moffet must have known that Schuffenecker was a forger.

———

When news emerged that Stephen Mazoh had brokered the final sale between Ambassador Annenberg and Dieter Bührle, three years to the month after Walter and Lee had first laid eyes on the masterpiece at the National Gallery of Art's *The Passionate Eye* exhibit, the art world was abuzz. As had been the case with the van Gogh *Shoes* acquisition the year before, Walter Annenberg bought *Wheat Field with Cypresses* for $57 million in spring 1993. Instead of having the painting shipped to Sunnylands to be admired by Walter, Lee, and their friends for the rest of Walter's life, the painting was immediately flipped to the Metropolitan Museum of Art as a "gift" that would join *Shoes* and, one day, the rest of the Annenberg art collection.

For Walter and Lee to enjoy the painting, they would have to travel to New York City and view it on the wall of the Met's Impressionist gallery dedicated to them.

When news of the sale was confirmed, Michael Kimmelman was agog about yet another lofty gift donated to the Met by Annenberg. He wrote,

In one of the most glittering additions in recent years to its outstanding collection of 19th-century European paintings, the Metropolitan Museum of Art has been given Vincent van Gogh's "Wheat Field With Cypresses." The 1889 scene of a windswept landscape beneath a roiling sky has been donated by Walter H. Annenberg, a former United States Ambassador to Britain and a longtime trustee of the museum, who has promised to bequeath his entire collection of paintings to the Metropolitan.[63]

Kimmelman continued:

Most important, "Wheat Field With Cypresses" will now be joined with "Cypresses," another signal work from the same period in the artist's career. Just as the van Gogh "Vase of Roses" in the Annenberg Collection complements the Metropolitan's "Irises," the horizontal composition of "Wheat Field" complements the upright "Cypresses."[64]

The art critic also loosely discussed the painting's provenance. His limited view from 1993—a year before the World Wide Web went live with search engines and more than ten years before the Van Gogh Letters online database was launched—told him that "Prince of Wagram in Paris" owned *Wheat Fields* in and around 1906, and that "Franz von Mendelssohn, a Berlin collector, owned it from 1910 through at least 1921."[65]

In fact, Franz von Mendelssohn owned the Met's version of *Wheat Field with Cypresses* until his death in 1935. By then the German-Jewish banking director had become an outcast in his homeland, scapegoated by Adolf Hitler and kicked out of the bank that his great-great-grandfather founded in 1795. With his money, prestige, and reputation stolen from him, he and his brother Paul died soon after the "Jude" measures were implemented and enforced. Like other Jews under the new regulations installed by the Third Reich, Franz and Paul had been driven out from their positions as executive managers and board members of their family bank in Germany.

It would take the Met's Gary Tinterow an additional five years, until 1998, to learn that the gap in the masterpiece's official history from 1921 to 1951, when it was sold to Emil G. Bührle—a full thirty years—had been filled by the von Mendelssohn family, who hid their family art collection on a farm near the Swiss border during the war and then smuggled the paintings across the southern German border. They achieved that feat despite the voracious

appetites of Emil Bührle and the Nazi Hermann Göring to steal, loot, and barter art while war swept through Europe, taking advantage of intimidated art dealers and scared, impoverished owners.

Accounting for the gap in the provenance between 1921 and 1951 failed to confirm the darker years of *Wheat Field's* ownership from the summer of 1889, when Vincent van Gogh created the landscape painting at the asylum, until the Prince of Wagram, a Paris art collector, had purchased it in 1906. Those seventeen years form the grounds of not just a suspicious audit trail of ownership, but a broken provenance that goes to the core of the question of the painting's authenticity.

I reached out to Lukas Gloor, the manager and historian of the Foundation of Emil G. Bührle Collection since 2002 (with limited reference to the *Wheat Fields with Cypresses'* provenance, since it was sold a decade prior to his joining the Foundation). In a November 20, 2013, email, he wrote:

The [1990] tour was planned to commemorate the collector Emil Bührle's 100th birthday. The coincidence with the sharp rise in prices for Impressionist and Modern paintings in the 1980s was certainly accidental. However, that coincidence later should prove to be not without consequence, since one of the Van Gogh's belonging not to the foundation, but then still to a family member, ended up in the collection of Walter H. Annenberg in 1993. Annenberg is said to have seen the painting for the first time when it was on show at the NGA in Washington, where his own collection was exhibited at the same time. The painting *Wheat Field with Cypresses* hangs now in the Metropolitan Museum of Art.[66]

Certainly, "not without consequence" was a line not without irony. So was it a "coincidence" that a convicted felon of forged sales certificates, seller of illegal arms in the black market to rogue regimes, had scouted the mark Walter Annenberg, the way a poker

player tracks the tell of an eager player? Through his sister Hortense's intelligence-gathering forays while heavily involved in *The Passionate Eye* exhibit in Washington, DC, Dieter came to understand the Annenberg Collection and the owner's persona and psyche.

Like Walter Annenberg, who further polished his philanthropist image and secured his status as generous gift giver and patron to the arts, the Met's curator, Gary Tinterow, was equally proud to have played a major role in bringing the Impressionist masterpiece to the museum. He stated as much in his biography for the Houston Museum of Fine Art, where he is now the director.

Wheat Field with Cypresses became the centerpiece of the Annenberg Collection at the Met long before the rest of the artwork would arrive after Walter's death in 2002. Before arriving there, the painting had traveled a winding path: Hitler's Nazis. Apartheid South Africa. The Iranian mullahs. Chicago mafia. These are the threads of its provenance—a good provenance, indeed.

But there was one pair of hands that came before them, a copyist's hands, a suspected forger's hands, those of a friend to Theo and Vincent van Gogh, a lesser artist who left little impression with his own artwork—Emile Schuffenecker.

II

DESCENT INTO SAINT-RÉMY

church behind, failed in a brief stint as a missionary, and spent time in London working in the art galleries before moving back to The Hague. He was a total failure in relationships with women, from his first cousin to a prostitute. His odd, intense behavior, gravitating toward peasant life and downtrodden women, made him a virtual outcast in his family. It was the ultimate fear of being "cut off from money" that forced his return home to his native Holland.

Vincent van Gogh the artist didn't really come alive or flourish until he arrived in Paris, at the behest of his younger brother Theo, an art dealer. In Paris, van Gogh found himself liberated and influenced by the French School of Impressionism. In Arles, in the south, he became more intoxicated by its bright colors, the space and sunlight, less bustle, and a more laid-back atmosphere than the big city to the north. His dream had been to paint and live among his peers as an artist, but no one followed him to the south except Paul Gauguin, who was paid by Theo to live and paint with Vincent. The arrangement didn't last even a year.

Now, with Gauguin chased off into the night, the feeling of impotence spread from Vincent's groin and infected every cell of his body. His blood ran cold; the artist colony dream was dead.

Van Gogh had been hurt before. He recalled his failures. That December night was different, however. Being cast aside by a man and painter he truly admired, a man with as much lust and passion as himself, but with a greater libido and success with women, hurt Vincent more than his previous litany of failures.

Rushing back, he barreled through the green door of the yellow house. Standing in the dark living room, he looked around at Gauguin's possessions, his studies and drawings, and thought about slicing them. He then saw, in the shadows, an unfinished painting of flowers on an easel. He stepped toward it, raising the razor, ready to strike, when suddenly he caught his murky reflection in a glass vase. Whipped into a frenzy by his dark inner twin, he stepped into the bathroom and stared at his maniacal, menacing, hyena-wild

reflection, rubbed his stubbled neck, lifted the razor and, grabbing his left ear, sliced it off in a silent scream, locking eyes with his reflection in the mirror.

Ever the artist, he looked at the fleshy lower piece of ear, studying the blood as it oozed down his fingers, pooling in the palm of his left hand. The blood wasn't red or brownish or dark maroon; it was black like the night. Vincent put his lopped-off bloody ear in an envelope, wiped his hands clean, and put down the razor, still wet with blood, like a used painter's knife.

He then ventured out into the night one more time, heading to the brothel that Paul Gauguin frequented. He knocked on the door. Footsteps approached—a creak of a floorboard. A young prostitute opened the door and looked warily at her sporadic client. He didn't seem right. His appearance was off, disheveled. There was an odor of absinthe on his breath, and his eyes were dark spades with bags underneath them, vacant, with no spark of life.

He handed Rachel the envelope and said, "Guard this object carefully."

Rachel squeezed it, felt the squishy contents, then peeked inside. She saw the bloody piece of Vincent's ear; she looked back into his eyes, tried to figure out which side had lost it under the scarf he draped over his head, and almost fainted. She leaned against the doorjamb for support and watched the crazed Vincent dash away.

What Vincent didn't know was that one of the married men being serviced by Rachel that night was his dear friend, Postmaster Joseph Roulin. Learning what had happened, Roulin got dressed and went to the yellow house to aid the injured artist.

=====

One week later on Sunday, December 30, 1888, the column "Chronique locale" in *Le Forum Républicain,* a local newspaper in Arles, reported on the event:

Last Sunday, at half past eleven in the evening, one Vincent van Gogh, a painter, a native of Holland, presented himself at brothel no 1, asked for one Rachel, and handed her . . . his ear, telling her: "Keep this object carefully." Then he disappeared. Informed of this act, which could only be that of a poor lunatic, the police went on the following day to the home of this individual, whom they found lying in his bed, by then showing hardly any sign of life. The unfortunate was admitted to the hospital as a matter of urgency.[69]

Vincent's psychotic break put him in the hospital. There he befriended a young medical intern, Dr. Felix Rey, who cared for the self-mutilated artist for two weeks. Vincent's wound healed remarkably well, quicker than the doctor had expected to see in a thirty-five-year-old patient with a variety of physical ailments. The fortnight in Old Hospital gave Vincent peace, a sense of well-being, as well as separation from absinthe and from obsessing over his insecurities.

The new year brought a renewed passion for painting—it was a way to keep his mind busy, keep it off the darker impulses. Vincent would busy himself writing letters to his brother, inquiring about whether he had "terrified" Paul Gauguin,[70] who had gathered his belongings from the yellow house while Vincent was in the hospital and moved away from the "poor lunatic."

It was painting, the therapy of painting, that aided Vincent's rapid recovery. On Monday, January 7, 1889, Vincent returned home and wrote an upbeat letter to his brother Theo, who lived in Paris during Vincent's stay in southern France:

Mr. Rey came to see the painting with two of his doctor friends, and they at least understand darned quickly what complementaries are. Now I'm planning to do Mr. Rey's portrait and possibly other portraits as soon as I've accustomed myself a little to painting once again.[71]

In January, Vincent painted two self-portraits with a bandage wrapped over his head covering his mutilated ear. For the portrait, he tilted his head to show the right side of his face with his unharmed right ear wrapped in cloth, intact underneath it. The second portrait showed the same—but a more relaxed van Gogh. So relaxed was his facial expression that he appeared to be indifferent to the whole episode, as if nothing of note had happened. (Benoit Landais argues that one of the self-portraits was actually painted by Schuffenecker.)

Then he painted Dr. Felix Rey. It was a portrait that showed the handsome, raven-haired, twenty-three-year-old physician, with a goatee, in a dark blue suit. But in an approach different from the two self-portraits, Vincent painted Dr. Rey from the left side, prominently capturing his intact left ear, flushed with the blood of life matching his rouge lips. It was as if Vincent the patient, and not the artist, had made a symbolic gesture, a connection with the doctor.

Vincent connected with Felix Rey in other ways, too, as the two tried to find the reason for van Gogh's ailment. Beyond his childhood intensity and inability to read people's social cues and tells, Vincent suffered from a broad array of health issues.

The artist openly discussed his poor diet and held that being "impressionable," as Dr. Rey saw it, "was enough to have had what I had as regards the crisis, and that currently I was only anemic, but that really I ought to feed myself up," as Vincent wrote to Theo in a lengthy letter. He ended up telling the doctor that if the "crisis" reoccurred, he would "keep to a rigorous one-week fast, if in similar circumstances [the doctor] had seen many madmen quite calm and capable of working—and if not then would he deign to remember occasionally that for the moment I myself am not yet mad."[72]

What Vincent really needed, however, was not to adjust the diet, but rather to stop using white lead paint to "prime the canvas, or as impasting, in order to give firmness to the foreground."[73] He would also have had to stop being careless with the oil paints that came in fat toothpaste tubes and that were loaded with toxins; stop his

unconscious habit of "nibbling" on those paints from time to time; stop eating them when the coldness of depression swept in; and stop drinking turpentine, which also had its toxic ingredient thujone, a pine tree resin from sap bored out of a living tree. All of that, combined with predispositions to mental health issues and to epileptiform seizures that manifested themselves in Vincent (as well as his sister Wilhelmina, whose failed suicide attempt got her committed to an insane asylum at thirty-five, and his brother Cor, who committed suicide in South Africa),[74] contributed to van Gogh's declining health.

Many physicians, then and now, have looked for a single explanation for van Gogh's mental state, his psychotic break, and his numerous ailments. But no single disease, hereditary or acquired during his vagabond lifestyle as a starving artist, can sufficiently explain his mania and poor health. The episodes became more frequent and longer in duration after he cut off his ear. After observing the attacks, both Dr. Felix Rey and Dr. Peyron, van Gogh's physician at the Saint-Rémy asylum later that year, diagnosed van Gogh with epilepsy and considered it to be the chief cause of Vincent's psychosis.

———

Given that this diagnosis was based simply on observation, and that van Gogh did not display any symptoms before he began painting at the age of twenty-seven, it may make more sense to look more closely at environmental causes, especially given that van Gogh's voluminous letters discuss his pale and gray skin, symptoms associated with lead poisoning; abdominal pains that could have been caused by the combination of lead and thujone from turpentine and absinthe; and severe, premature tooth decay and gingivitis of the gums. The last symptom, too, has been associated with lead poisoning.[75]

Adding fuel to the bonfire of Vincent's charged personality was foxglove, a medicine used in the nineteenth century to deal with

mental health patients. It was derived from the *digitalis* plant, a natural steroid with a toxicity that affects the heart. High consumption of foxglove in concert with lead poisoning from the oil paints, along with his consumption of absinthe—which also contained thujone, which, when combined with absinthe, has mind-bending effects—put van Gogh on an accelerated destructive path that would lead to death.[76]

Yet the chemicals that hurt the artist may have also contributed to the immortality of his art. Absinthe, when drunk in large enough quantities, made some people see yellow swatches and yellow halos around certain objects, effects that we see in many of his paintings.

＝＝＝＝

Whatever the combination of ailments and triggers he was suffering, by late April 1889, Vincent realized it was time to commit himself to the Saint-Paul-de-Mausole, Saint-Rémy. He had help from the town of Arles. The ear incident was the latest of a long list of complaints about van Gogh being a boorish drunk, constantly poor and unkempt, more a gypsy nomad than a bohemian artist. Chasing off Gauguin, frightening the prostitute Rachel, and making the local news had made Vincent a marked man in a town that no longer wanted to tolerate him. If he was a danger to himself, the people of Arles felt he could be a danger to others with his erratic behavior. So the folks of Arles sent a petition to the mayor on February 27, 1889, demanding that he remove Vincent van Gogh from the city.

They wrote:

> Dear Mr. Mayor
> We the undersigned, residents of place Lamartine in the city of Arles, have the honor to inform you that for some time and on several occasions the man named Vood (Vincent), a landscape painter and a Dutch subject, living in the above square, has demonstrated that he is not in full possession of his mental faculties,

and that he over-indulges in drink, after which he is in a state of
over-excitement such that he no longer knows what he is doing
or what he is saying, and very unpredictable towards the public,
a cause for fear to all the residents of the neighborhood, and
especially to women and children . . .[77]

By mid-spring van Gogh had been in and out of the Old Hospital
in Arles a couple of times. Through Reverend Salles, an elderly care-
taker of Vincent in Arles, Vincent was introduced to the head phy-
sician at the asylum in Saint-Rémy. He began to converse with Dr.
Théophile Peyron, a French naval doctor. After making the decision
to voluntarily check himself into the asylum at Saint-Rémy, Vincent
communicated his decision to Theo. A week later he received a letter
from his brother:

It pains me to know that you're still in a state of incomplete health.
Although nothing in your letter betrays weakness of mind, on the
contrary, the fact that you judge it necessary to enter an asylum is
quite serious in itself. Let's hope that this will be merely a preventive
measure.[78]

Theo was also concerned that convalescing at the asylum for an
extended period would likely limit his brother's ability to paint for
at least three months. If that happened, it meant no money coming
in to pay for the boarding.

On May 8, 1889, a reverend from the local Protestant Church
accompanied Vincent van Gogh on the 8:51 a.m. train from Arles
to Saint-Rémy-de-Provence.[79]

Likely keeping the expenses in mind, the artist took third-class
accommodation at the asylum—a small room with a single barred
window on the second floor of the old monastery. It had a view of
a tranquil wheat field, the stone wall marking the boundary of the
hospital property, a cluster of pine trees, rolling green hills, and the

tops of the limestone ridges of the Alpilles range in the background, where the summer sun rose each morning over those rounded peaks facing southeast.

Theo's practical concerns mostly proved unfounded. Although the doctor wouldn't clear the artist to walk outside the asylum building until a thorough exam of his mental and physical state had been completed, painting was not forbidden; on the contrary, it was encouraged, since it could very well be a boon to Vincent's spirits.

The week before Vincent checked himself into the Saint-Rémy asylum, he wrote to his dear brother Theo:

> I recently sent off two crates of canvases. D58 and 59—by goods train, and it will take a good week more before you receive them. There's a heap of daubs in there which will have to be destroyed, but I've sent them as they are so that you can keep what appears passable to you. I've added Gauguin's fencing masks and studies, and the Lemonnier book.[80]

After clearing out his possession from the yellow house in Arles, sending dozens of paintings to his brother in Paris, and storing personal belongings and some furniture with the Postmaster Joseph Roulin—who, in the end, was one of Vincent's very few friends in Arles—the artist was ready for the next phase of his life.

Vincent found his accommodations at the asylum quite good, since there were "30 empty rooms" and two additional rooms, besides the one he slept in, that he was allowed to use. He would use one room to paint in, the other to store the paintings so they could dry (his thick impasto paints and zinc whites took longer to dry than their alternatives). Vincent drew inspiration from the asylum courtyard, the cloister area, and the natural landscape that surrounded the property. He continued writing a detailed letter to his brother, describing his accommodations and surroundings:

I assure you that I'm very well here, and that for the time being I see no reason at all to come and board in Paris or its surroundings.

I have a little room with grey-green paper with two water-green curtains with designs of very pale roses enlivened with thin lines of blood-red. These curtains, probably the leftovers of a ruined, deceased rich man, are very pretty in design. Probably from the same source comes a very worn armchair covered with a tapestry flecked in the manner of a Diaz or a Monticelli, red-brown, pink, creamy white, black, forget-me-not blue and bottle green.

Through the iron-barred window I can make out a square of wheat in an enclosure, a perspective in the manner of Van Goyen, above which in the morning I see the sun rise in its glory.[81]

Vincent also wrote to his brother that he took a hot bath twice a week, which settled his digestive issues: "my stomach is infinitely better than a year ago."[82] Perhaps more profound, he no longer mentioned prostitutes and brothels in his letter, the last mention being two months before his arrival to Saint-Rémy. He had also used more zinc white, which was less toxic than white lead paints. Confinement to the asylum grounds, its courtyard, and on rainy days a kind of waiting room with other patients contributed to Vincent being sober for the first time in years. No absinthe, no alcohol, no abuses of either tormenting his mind or body. The malnourished artist, who had lived in Arles for a year on bread, coffee, alcohol, and smoking a pipe, began to put weight onto his skinny frame. It appeared that his stay at the asylum at least curbed the mental breakdowns he had experienced before—until the summer heat.

In the same letter, Vincent also asked for a detailed list of paint colors he needed, as he gushed about the different bright hues he saw in Saint-Rémy, with its big sky, golden hues, and olive green plants, bushes, and trees. He received the paint he needed from Père Tanguy's shop in Paris, but tragically his newfound enthusiasm would reverse many of the improvements: lead-based oil paints would

accumulate that spring and into summer in his digestive tract, in his blood, and in his lungs when he inhaled the dust, flakes, and microfibers of dried paints that he lightly sanded. And they would soon contribute to a new mental breakdown and a deep period of inertia and lethargy. His prodigious painting at the asylum upon his arrival would contribute to the decline of his health by midsummer. Vincent was caught in a vicious cycle of majestic artistry and mental breakdowns that would follow him to the end.

The first four paintings Vincent produced at the asylum were *Irises, Lilacs, Trees with Ivy in the Garden of the Asylum*, and the *Garden of the Asylum*.[83] He captured them in their wild, florid beauty, with an Impressionist approach, and not as traditional "still life" studies he had done in the past—these new paintings were more wild, true to nature, more colorful with certain reds and purples and yellows that popped off the canvas. They were not dark and morose, like his first masterpiece, *The Potato Eaters*, painted in Nuenen, Netherlands, in 1885.

During these early months, Vincent's communications to his brother continued to discuss practical arrangements and art. He did not devote much space to his own mental health issues, though he knew that another breakdown was always near and could pounce on him at any moment, like a squall on a clear day. He did write about other patients, however; new patients who were far worse off than him—tearing the place up, shredding straitjackets, and screaming incessantly. Van Gogh himself concentrated on painting, which was a form of therapy. It would become his salvation for the next year.

In less than thirteen months, van Gogh would create 142 paintings. During that yearlong stay, he suffered a couple of relapses that shut him down from both painting and letter writing. Vincent was only well enough to paint for eight to nine months in the self-imposed exile from the outside world.

It is the quality of the paintings, which include several of his iconic masterpieces, from *Starry Night* to *Cypresses*, that shows that

the year in Saint-Rémy was the most productive of the art master's short life. In the letters Vincent wrote during that period, he often relayed to his brother the color, images, and beauty of what he saw in nature, which underscored his love and enthusiasm to paint:

> For the flowers will be short-lived and will be replaced by the yellow wheatfields. The latter, above all, I would like to capture better than in Arles. The mistral (since there are a few mountains here) appears far less annoying than in Arles, where you always get it at first hand.[84]

The masterpieces he would create, however, came at a high cost.

11

Finding van Gogh

After the first month in Saint-Rémy, Vincent van Gogh was satisfied with where he ended up. As he explained to his brother Theo, "Not one single time have I had the slightest desire to be elsewhere; just the will to work again is becoming a tiny bit firmer."[85] In addition to feeling alive and enthusiastic about painting again, he was now also free to move beyond the property wall he looked at every day through the iron-barred window, unlike the other patients at the hospital.

The property wall tantalized van Gogh. It reminded him of his limits in mental and physical health. It was a wall he captured so vividly in his early June painting *Wheat Field After the Storm*. That landscape showed the wall containing the monastery wheat field on one side, while keeping wild nature out on the other side. The wall became less of a barrier while he got fitter in mind, body, and spirit, as he knew soon he would walk beyond it and explore natural beauty up close.

When Vincent first arrived at the old monastery converted into a hospital, his friend, railway postman Joseph Roulin, wrote a letter stating, "You seemed to me disposed to begin your work in earnest

again, the countryside is beautiful, you cannot lack for models."[86] The postal clerk, who came to Vincent's aid after the artist mutilated his ear and who rolled, packaged, and shipped his paintings north by train to Paris where Theo lived, was now gently nudging his Impressionist friend to look beyond any wall and embrace all that nature had to offer him.

In another letter, Roulin further encouraged the artist: "Continue your paintings, you are in a beautiful part of the world, the countryside is very beautiful, the soil is very well worked, you will find a great change in the farming down there, you will not find gardens that look like cemeteries, as in Arles."[87]

When June came about with the days growing longer and with nature transitioning toward summer, Vincent knew "there were lots of flowers and color effects" and asked his brother if he could send "another five meters of canvas in addition."[88]

He was ready to paint again at a prodigious level.

Before he ventured further afield from the property line, Vincent wanted to return to a theme that had moved him in Arles. He had painted the *Starry Night Over the Rhone,* in which he captured a ring of stars floating over Arles, with gaslight reflections shimmering on the water, outside, with candles wedged in his straw hat to illuminate the work in the darkness. For the new *Starry Night,* van Gogh wouldn't be standing outside like he did with so many of his nature paintings. Perhaps for the first time, he painted the image from memory—the stars and the planet Venus and the moon were out that night, but he added something that wasn't there outside his asylum window: a village with a church steeple in its center. He would paint it from inside his room using his imagination.

———

The painting, which one day would become the most recognized and replicated piece of art in history, had been created by a hybrid of Vincent's skills. He synthesized a part of the nocturnal landscape

with his eyes peering out the bedroom window; other parts, such as the small town and cypresses, he imagined with his inner eye, supplementing his imagination with details from his memory. He also added several overt and subtle touches to the painting.

In a way, *Starry Night* represents van Gogh's attempt to put his past failures behind him. After that painting, van Gogh would take his easel and paint box and venture off the grounds for the first time. *Starry Night* was a nod to the past with eyes looking ahead, an attempt at a departure from all that had pained and disappointed him in the past.

The overt symbol of the church at the center of the painting, upstaged by the robust cypresses and luminous stars, represented a symbolic break, a departure from the artist's religious past. (He had twice failed the church's exam because of his refusal to learn the "dead language"—Latin. One had to wonder about that, since Vincent was fluent in his native Dutch, as well as French, German, and English.)[89]

The church was no longer the center of Vincent's world. Nature was. In Christianity, the natural world is one of temptation, where one is apt to lose his faith and commit a sin; nature is closer to Satan than God as a result (we might remember that the first sin was committed in the Garden of Eden with the temptation to bite into the forbidden fruit). And yet, subtly, Vincent painted eleven stars in *Starry Night*, as if he were tipping his hat in honor of Christian faith. In the view of most art historians who have analyzed the masterpiece, the eleven stars are a clear reference to Genesis 37:9, where Joseph has a dream that includes eleven stars and provokes a rebuke from his family.

Perhaps there was a sense of personal identification at play that was mirrored by the symbolic choices in the painting: "In the Bible, Joseph was thrown into a pit, sold into slavery, and underwent years of imprisonment, much like Van Gogh did the last years of his life in the Arles [*sic*] asylum."[90]

Blogger K. Shabi advanced the Old Testament interpretation of *Starry Night* for the literary journal *Legomenon* in its "What is the meaning?" series. But it just as easily could have symbolically referenced the eleven disciples, with Venus being Jesus and a falling moon Judas, from the New Testament. Either way, Vincent steeped that painting with symbolism aplenty, with the cypress in the foreground reflecting his embracing of nature over religion. That was the symbolism that mattered to him.

Like the Broadway musical *Joseph and the Amazing Technicolor Dreamcoat* that followed van Gogh a century later, putting the story of "Joseph the Dreamer" to life with dance, music, and colorful lights in the theater, Vincent's canvas became a "technicolor dreamcoat" that expressed his feelings, how he related to nature, and why he pivoted and transitioned away from religion without fully severing his roots. Van Gogh's roots, like those of the trees, shrubs, and plants he painted were essential to his being, to being grounded, to standing upright.

Admired for the virtuosity of the impasto brushstrokes, the stars emboldened by the maelstrom swirls that would become van Gogh's hallmark, his signature style of Impressionism meets Expressionism, *Starry Night* also became a science project one hundred years after the artist's death. Many experts and researches have claimed van Gogh saw and was influenced by the black swirls that French author and astronomer Camille Flammarion had drawn of the spiral galaxy, using a powerful telescope, in 1881.[91] (Vincent was an avid reader and Flammarion was a very popular science fiction writer in his day. Thus, van Gogh must have read him.)

Another question about the *Starry Night* has been the extent to which it might be taken as an accurate depiction of the night sky over the asylum. If US art professor Albert Boime was the first to look at *Starry Night* in a new light in 1984, then the scientists who followed in his wake in 2002 took the research to the next level, deploying local astronomers, celestial software, and data analysis

that tracked the movements of the moon, planet Venus, and the stars hovering over Saint-Rémy in June 1889. They managed to figure out the date the stars were aligned in the way depicted in the painting, with Venus as big and bright as the morning star, and they even accurately pinpointed the exact time that Vincent saw Venus through his bedroom window.

Starry Night represented an artistic turning point in Vincent's stay at Saint-Rémy. In the next few weeks he would spend the days outdoors, painting *en plein air*, up close to his subjects. He finally crossed the walled boundary of the former monastery to go see nature's temple firsthand in the divine majesty of summer.

His signature brushstrokes wouldn't end with the stars, moon, and Venus in *Starry Night*. They would be adapted time and again to bold daylight landscape paintings, such as the towering *Cypresses*—in the Annenberg Collection at the Metropolitan Museum of Art—and *Wheat Field with Cypresses*, where he applied those swirls to cotton balls of rolling clouds that drifted over the Alpilles mountains.

———

Van Gogh packed his French box that contained tubes of paint, brushes, a jar of turpentine, a folding-stock stand, rags, a painter's knife, and the moist color box that contained watercolors. He put on his worn straw hat and stepped outside of the old monastery walls, as if being freed from religious persecution, his sentence commuted:

> There was a range of hills, the Alpilles, with countless olive trees at their feet and an occasional solitary cypress crowning them to counteract the gentle ups and downs of the hills with a bold vertical. Little by little, van Gogh ventured closer to his new find: there was less of the field in his pictures and the landscape beyond came within reach. *At the Foot of the Mountains* identifies the crowns of individual trees merging into the foothills—a presentation possible only once the artist came closer.[92]

By late June, Vincent had amassed an impressive and diverse family of landscape paintings: *Green Wheat Field with Cypresses*; *Wheat Field After the Storm*; the vibrant *Field with Poppies* with its first signs of pointillism; *Cypresses*; *Cypresses with Two Female Figures*; *Green Wheat Field*; and a couple of *Olive Groves*, one of them a drawing. After finishing more than a half dozen landscapes, the artist was feeling his oats again.

But none of those "wheat fields" or "cypress" paintings were the study that would become *Wheat Field with Cypresses*, for which he would have to venture at least a mile from the monastery in order to be in front of the subject.

Spiritually armed with the still-drying *Starry Night* in the storage room next to his bedroom, van Gogh desired to tackle a big sky landscape that would incorporate the passion and beauty of *Starry Night* he saw and imagined but repurpose it, give it a wilder edge with conflicting colors, with chaotic movement in opposite directions set against the rugged shoulders of the Alpilles range.

By July, Vincent van Gogh had run the equivalent of an artistic triathlon: he had painted dozens of canvases, many of them masterpieces; drawn dozens of matching drawings; and stayed sober, appearing to be the only sane—though never entirely stable—person in the insane asylum for the first two months.

12

Descent into Madness

The summer heat came to the south of France, enveloping people in a cocoon of apathy and idleness and choking them. It would prove especially destructive for Vincent. His work didn't stop completely, however. In a June 25 letter, he wrote to Theo: "We've had some fine hot days and I've got some more canvases on the go, so that there are 12 no. 30 canvases on the stocks. Two studies of cypresses of that difficult shade of bottle green. I've worked their foregrounds with thick impastos of white lead, which gives firmness to the ground."[93] These lead whites, used to prime the canvases, were kryptonite to Vincent.

As the summer heat of southern France bore down on Saint-Rémy-de-Provence, weakening van Gogh's desire to venture far afield, the change in the types of paintings he would produce over July and August became clear. He completed only two more field paintings: *Enclosed Field with Ploughman* and *Wheat Field with Reaper at Sunrise*. Then there were three up-close studies—*Tree Trunks with Ivy*, *Undergrowth with Ivy*, and another *Tree Trunks with Ivy*. Since those paintings were produced on site, it is little surprise that he painted them under the thick canopy of trees in shade, out

of the scorching hot sun that tormented him, breaking down his psyche, zapping his spirits, draining his body of energy.

After suffering a prolonged attack—from sunstroke or tinnitus or a seizure or nibbling on paints or inhaling the lead whites or a combination of many of those ailments—in late July and through most of August, van Gogh went off the 1889 version of the grid. Depression set in, along with inertia, night sweats, personal demons, and dark illusions. He stopped painting. He also stopped writing his literate thousand-word letters to his brother, sister, and sister-in-law. His previous correspondents, Theo, Jo van Gogh-Bonger, and railway postmaster Joseph Roulin, wrote to Vincent in August trying to get him to respond. But for more than a month their inquiries after his health and state of being were met with silence. Each letter went unanswered, making the wait more anxious as time passed by. At the end of August, Vincent came around and explained his self-imposed quarantine.

At that time, he picked up the paintbrush again. He would create three self-portraits, ranging from dark hues to brighter and then to an intense flare. Each portrait captured his left ear intact—yes, the same ear he mutilated in his argument with Paul Gauguin and that he gave to Rachel the prostitute as a memento. Two of the self-portraits depicted van Gogh with a crimson beard. The middle portrait showed a clean-shaven artist with pursed lips, not quite smiling, not somber.

The summer tally produced a meager eight paintings over a period of nine weeks, about one work of art every nine days. Many of those were not *new*; more like copies, derivative, lacking in both originality and passion. Prior to that, Vincent had been painting and drawing at a rate of one study per day. The precipitous drop in productivity was noticeable; gone were the optimism and desire that he had rediscovered in late May and through all of June.

The artist was human after all—flawed, sad, drowning in an ink-dark pool of doubt. Vincent broke his summer silence and wrote to

Theo for the first time on August 22, 1889, writing: "You can imagine that I'm very deeply distressed that the attacks have recurred when I was already beginning to hope that it wouldn't recur. . . . These days, without anything to do and without being able to go into the room [Dr. Peyron] had allocated me for doing my painting, are almost intolerable to me."[94]

Vincent must have sensed that the summer would be a difficult one much earlier. On July 2, 1889, Vincent's 1,416-word letter to his brother Theo highlighted many of the great paintings and drawings he created, pairs of them. He also hinted at the depths of his sadness, writing about it from his asylum room in the stifling heat. It suffocated van Gogh, producing the sluggish idleness he had detested in other people he saw in the South of France. The end of that long letter, of his quiet cry for help, read:

> It is precisely in learning to suffer without complaining, learning to consider pain without repugnance, that one risks vertigo a little; and yet it might be possible, yet one glimpses even a vague probability that on the other side of life we'll glimpse justifications for pain, which seen from here sometimes takes up the whole horizon so much that it takes on the despairing proportions of a deluge. Of that we know very little, of proportions, and it's better to look at a wheatfield, even in the state of a painting.[95]

There was trouble on another front. Theo was having difficulty selling Vincent's latest artworks. The Impressionist movement wasn't really selling in the art market at all. That meant money left Theo's hands each month to support his brother, but the world had not awakened to van Gogh yet as an artist. Money was going out, but it was not coming in as a return on Theo's investment in his older brother's work.

Theo must have wondered if Vincent's artwork would ever sell. Since Vincent was an unknown artist outside his circle of Parisian

friends, Theo had trouble not only selling his brother's paintings, but also getting his artwork to be shown in the right venue.

Not only was Vincent living in a mental hospital 500 miles south of where the Impressionist artists lived, he was part of an art movement that, in his own words, had "no unity."[96]

Regardless of the reception of his work, the artist kept painting. He also managed to provide detailed descriptions that went with the stunning works that he sent to Postmaster Roulin, who then rolled the still-damp canvases with the paint facing out, stacked four or five on top of each other, inserted the rolls into shipping tubes, like architectural drawings, and sent them with Vincent's letters by postal train north to Paris to art dealer Theo van Gogh. These letters are a great source of information about these works that would prove invaluable in the inquiry into *Wheat Field with Cypresses*.

The description of the drawing *Reaper*, for instance, said: "The latest one begun is the wheatfield where there's a little reaper and a big sun. The canvas is all yellow with the exception of the wall and the bottom of purplish hills."[97]

That of the painting *Wheatfield After a Storm* read: "The canvas with almost the same subject differs in coloration, being a greyish green and a white and blue sky."[98]

The description of the ultra-up-close, vertical painting *Cypresses* read: "I have a canvas of cypresses with a few ears of wheat, poppies, a blue sky, which is like a multicolored Scottish plaid."[99]

And the description of the painting *Reaper* read: "This one, which is impasted like the Monticellis, and the wheatfield with the sun that represents extreme heat, also thickly impasted, I think that this would explain to him more or less, however, that he couldn't lose much by being our friend."[100]

Yet none of these four similar studies were *Wheat Field with Cypresses*, though they certainly shared similar elements of nature.

Even in his lucid, beautifully written descriptions of four of the ten works he shipped along with the July 2 letter, Vincent hammered

away about the intense heat with words like "big sun" and "all yellow" and "extreme heat." Whatever the combination of triggers he suffered from that summer, one thing was clear: mentally and physically, van Gogh didn't do well in extreme states.

On that same Tuesday, July 2, Vincent penned another thousand-word letter, this one to his sister. He confided in her about the state of his life, of the solitary profession of being an artist, writing: "What else can one do, thinking of all the things whose reason one doesn't understand, but gaze upon the wheatfields. Their story is ours, for we who live on bread, are we not ourselves wheat to a considerable extent, at least ought we not to submit to growing, powerless to move, like a plant, relative to what our imagination sometimes desires, and to be reaped when we are ripe, as it is?"[101]

Two paragraphs later, he bluntly stated: "I, who have neither wife nor child, I need to see the wheatfields, and it would be difficult for me to exist in a town for long."[102]

Vincent wrote to Theo on July 5, again to Theo and sister-in-law Jo the next day, and to his mother on July 8. He informed them that he would take a day trip back to Arles, leaving the asylum for the first time since he had arrived.

In Arles, he learned that the reverend who escorted him to the asylum had left for summer holiday in Marseille by the Mediterranean coast, while Dr. Felix Rey had taken a trip north to Paris. The journey to Arles wasn't a total loss, however. Van Gogh was able to retrieve paintings he had stored with Joseph Roulin and ship the leftover items from Arles to Theo. But not seeing his two key contacts, who had previously helped him climb out of the black hole of his depression, likely taxed his fragile mental state and primed him to succumb to the midsummer attacks.

On July 14, van Gogh mailed the artwork he created during his stay in Arles. It included five paintings: *View of Arles, Orchards in Blossom, The Ivy, The Lilacs,* and *Pink Chestnut Trees in the Botanical Gardens in Arles.* He also "enclosed another seven studies."[103] Those

studies covered subjects he had drawn and created in both Arles and Saint-Rémy—works he would temporarily abandon until September; one of these was *Wheat Field with Cypresses.*

He also wrote a second, longer letter to Theo to pass on to "his pal" Paul Gauguin, saying, "Above all, dear fellow, I beg of you, don't fret or worry or be melancholy on my account, the idea that you would do so, certainly in this necessary and salutary quarantine, would have little justification when we need a slow and patient recovery."[104]

Vincent understood what it would take for him to recover—time and patience. But when the attacks finally arrived with the apex of summer heat, those words, "slow and patient," and other sayings were rendered meaningless. The two July 14 letters were the last that Vincent wrote until the third week of August. They sounded pragmatic and stable enough. We can see from Theo's practical reply that there seemed to be no cause for concern just yet:

> As from the 15th of this month I no longer have the rue Lepic apartment, and as it was absolutely impossible to store all the canvases at our place, I've rented a small room in Père Tanguy's house where I've put quite a few of them. I've made a choice of those which are to be taken off the stretching frames and then we'll put others on them. Père Tanguy has already given me a lot of help, and it's going to be very easy to let him continually have new things to show. You can imagine how enthusiastic he is about colored things like the "Vineyards," the "Night effect," etc.[105]

If there was any information in Theo's reply letter that Vincent took in, it was that the growing volume of artwork needed additional storage, stretching, and display space, which were offered by Père Tanguy, who was the go-to art supplier for Vincent's special paint colors, pigments, fine canvases, and variety of paintbrushes. That must have given the artist some hope. Tanguy would likely display his artwork, so Theo could sell a couple of them.

13

Lasting Impressions

With Vincent ready to move beyond the healing process of the summer attacks with the three self-portraits he painted in August, it would soon be time for more meaningful artwork. He strolled next door to the storage room, picked up the *Wheat Field with Cypresses* study he had drawn, and recalled his wandering in the woods outside the asylum walls in late June.

For Vincent to paint such a magnificent scene, he had to walk halfway between where his room stood in the corner east wing of the asylum and a large overhang at the top of the Alpilles crag. It was a distance of about 8,800 feet, or over a mile and a half.[106]

Of the weather that month and that year, D. W. Olson's Texas State research group found the following:

Meteorological observations from 1889, preserved at the Météo-France archives, show that favorable conditions prevailed on both of these evenings. Very heavy rain fell on May 14th and 15th, but skies cleared on May 16th. No rainfall at all occurred during the entire first 2 weeks of July, and the fraction of the sky covered by clouds decreased on July 13th from 50% to 30%. The weather

records provided a good consistency check but did not help us to establish a unique date.[107]

The wet May contributed to two of van Gogh's other wheat field studies, *Green Wheat Field* (green because of the rain) and *After the Storm*. (The unique date was for van Gogh's *Evening Landscape with Rising Moon*, which Olson, with his team and astronomers from Arles, confirmed in 2002.)

With days getting hotter in late June, turning the wheat incandescent yellow, Vincent walked from the asylum wall to a place called Haute Galline—"high" or "raised hen"—near Eygalieres. The pitch overlooked a wheat field with cypresses standing tall in the corner, with foothills rolling to the mounds and shoulders and peaks of the Alpilles and a big windswept sky of roiling clouds rising high above.

In order to paint the *Wheat Field with Cypresses* as a study, Vincent first drew a copy of the landscape using black chalk, a reed pen, and ink on graphite on woven paper.[108]

Before Van Gogh treated cypress as the principal subject of his canvases (ca. June 25), he included them in two landscape paintings with wheat fields, of which one served as the model for this sheet (drawing) . . . The artist executed two other paintings of the same composition, which has led to differences of opinion about which was the first version, that is, the one after which this drawing was made.[109]

The drawing technique allowed him to experiment with the colors, using "long thin lines, small dots and areas left blank." Like *Sunflowers* before it, *Wheat Field with Cypresses* became a passion for Vincent to perfect, to tinker with and refine. Along with the study, one of the three painted versions was allegedly completed in June, the First version (the one that would eventually end up at the Met). After sunstroke and another "attack" forcing van Gogh to take

the summer off, the artist returned to the study and, in September, painted the Small and Final versions that he instructed Theo to send to his sister and mother in Holland, respectively.

One of the drawings of *Wheat Field with Cypresses* resides today in the Van Gogh Museum in Amsterdam. Of the three *Wheat Field with Cypresses* paintings, not one is hanging anywhere in Holland. Two of the landscapes are in America (the First and the Small versions); the Final version is in London. So instead of a painting valued at around $100 million today, the Van Gogh Museum owns the drawing of the study, which is worth a great deal less.

———

That September, van Gogh emerged from his summer stupor with his mind clouded, as though waking from a weeklong absinthe bender. Although he eventually regained some of his equilibrium, he had to be feeling at a loss. A loss of confidence. A loss of hope. His dream of a studio in the South of France and his optimism died that summer. Like his mental health, they would never fully return.

The cornucopia of emotions that Vincent experienced can be found in the paintings he created when he first came to Saint-Rémy that May. They can be found in the bright colors, the passionate iconic swirls of objects, like the sun, stars, and clouds, and in the thick impasto brushstrokes that separated his skill as a master with the brush from his Impressionist peers. No one in France painted like the Dutchman.

Van Gogh's deepest feelings and emotions, twisted in the throes of his ailments, have become a joy to us as museum visitors, art lovers, art collectors, art curators, and art historians more than a century after his premature death.

Deep inside, Vincent wanted to get back to the May–June zenith of creativity, but he knew it would take time to get there. He couldn't just come out of his misery, pull away from the insufferable heat, the sunstroke, the fear of the next attack—the toxic mix was still there

for him in late summer—and wish that the reoccurrence of the next psychotic break would somehow be forestalled all on its own. Like a wounded animal, he needed time to heal.

The artwork that he created during this period wouldn't be on par with the starburst paintings he made a season before, with the intense colors and epic strokes and swirls. It would be more refined, with tighter strokes, and on subjects that wouldn't require being *en plein air*. Van Gogh had enough studies to work from to keep busy, to see if he could recapture that initial zest and artistry without leaving the asylum.

For Vincent, these paintings were baby steps. But underneath he had to cleanse, expel the layers of pain and doubt from a lost summer. The first three paintings he created coming out of sunstroke depression were self-portraits. Straightforward. Easy. Light on the fingers, second nature, but emotionally necessary. Use the mirror, look at his face, see his own reflection, study his expression at that moment in time, even capture an intense, predatory wolf-like stare, and yet paint with quicker brushstrokes influenced by the staccato taps and touches of Pointillism.

British art teacher Ashlee Farraina captured van Gogh's state by examining all of the artist's dozen and a half self-portraits on her art and photography blog; writing about self-portrait No. 12, the third of such paintings from summer 1889, she holds that it:

> brings together all the elements of Van Gogh's later work: a choice of color that reflects his emotional state and a style of drawing that pulsates with energy. It was painted shortly after he left the St. Rémy asylum in July 1889 and shows that he was still fighting his demons. It is arguably the most intense self portrait in the history of art.[110]

That intensity can be gleaned from his August 22, 1889, letter to his brother Theo, in which he was conflicted. In the second paragraph of his letter to his brother, Vincent wrote, "You can imagine

that I'm very deeply distressed that the attacks have recurred when I was already beginning to hope that it wouldn't recur."[111] As before, he also continued to write about how painting was quite necessary for his recovery.[112]

He went on to share his summer of pain with his brother:

> For many days I've been absolutely distraught, as in Arles, just as much if not worse, and it's to be presumed that these crises will recur in the future, it is ABOMINABLE. I haven't been able to eat for 4 days, as my throat is swollen. It's not in order to complain too much, I hope, if I tell you these details, but to prove to you that I'm not yet in a fit state to go to Paris or to Pont-Aven unless it were to Charenton.
>
> It appears that I pick up filthy things and eat them, although my memories of these bad moments are vague, and it appears to me that there's something shady about it, still for the same reason that they have I don't know what prejudice against painters here. I no longer see any possibility for courage or good hope, but anyway it wasn't yesterday that we found out that this profession isn't a happy one.[113]

Self-confined to his bedroom and studio rooms at the start of September, van Gogh used the iron-bar window as a portal to his studies from early June. As he wrote to Theo:

> I have two landscapes on the go (no. 30 canvases) of views taken in the hills. One is the countryside that I glimpse from the window of my bedroom. In the foreground a field of wheat, ravaged and knocked to the ground after a storm. A boundary wall and beyond, grey foliage of a few olive trees, huts and hills.[114]

One day, after having gazed long enough at the wheat fields at the foothills of the Alpilles range from his room, van Gogh went

back to his studio next door. There, he picked up the preliminary sketch of *Wheat Field with Cypresses*, drawn in charcoal, and studied the majestic landscape, then turning to the drawing in reed pen, examining the swirls.

As with all his studies—compositions that often had several permutations, like the fourteen still-life *Sunflowers* paintings—Vincent started with a sketch and then later a drawing to flesh out the details of the work. Using the drawing (he usually also made an initial painting version, which in this case either did not exist or does not survive) as a model, he took out a carpenter's pencil and, beginning at the center of a blank canvas, marked the location of three boulders, the bushes to the left, and then the tall and shorter cypress trees on the right side of the painting. He outlined the foothills in the middle background and then traced the shape of the Alpilles mountains in the background.

Before painting the study, he would prime the canvas and then pencil in the outline of the figures or the elements of nature, from trees to villas, and work from the center of the canvas out to the edges, mapping locations of tree lines, rooftops, walls, boundaries of fields, the horizon, and sky above to capture the backgrounds. After doing the sketches and drawings first, by the time he painted on canvas he could do it with the eye of his brain—from memory—as it would be intimately familiar territory for him.

That *Wheat Fields with Cypresses* drawing, which hangs today in the Van Gogh Museum in Amsterdam, was drawn with pen and ink. He executed it first using a thick carpenter's pencil. He then inked over the pencil's marks once he was happy with what he had drawn. (When he first arrived in Arles in 1888, van Gogh "discovered the pen (made from local hollow-barreled grass, sharpened with a penknife). It changed his drawing style. He created some extraordinary drawings of the Provençal landscape, including a series of drawings of and from Montmajour (east of Arles), in reed pen and aniline ink on laid paper. The ink has now faded to a dull brown.")[115]

Wheat Field with Cypresses was one of those "extraordinary drawings"—several of them in fact—that turned into an extraordinary masterpiece. It is believed there are three of these masterpieces in existence. The First, thought to have been painted in June 1889, hangs today in the Metropolitan Museum of Art in New York City; the Small one was sent to Vincent's sister "Wil" and is now in a private collection of the late Greek shipping magnate Stavros S. Niarchos; the Final version made its way from the South of France to the Tate in London and eventually to the National Gallery in the early 1960s, where it remains to this day.

In 1987, the National Gallery's Impressionism and technical experts, John Leighton, Anthony Reeve, and Raymond White, conducted a deep analysis of the Final version, *A Wheatfield, with Cypresses*. Why did this technical examination occur in that year? Technology had a new way of performing a CSI-like deep-dive investigation to home in on all of the subtle techniques that Vincent van Gogh used. X-ray machines, high-powered microscopes, chemical analysis of paints, and infrared radiation allowed scientists, researchers, and art experts a new glimpse into how the artist worked and with what materials. That included, but was not limited to, paint types that were unique to van Gogh, pigment colors, the pencil lines underneath, the lead white primer, weave counts of the canvas, hidden signatures, "do overs" or scratch outs, thin and thick impasto brushstrokes. All of that and more was condensed into a twenty-page technical report, which was above and beyond a painting's condition report, as it offered a much more detailed and multifaceted analysis.

Incidentally, 1987 was not only the year that technology arrived at the National Gallery in London. It was also the year that two van Gogh paintings—*Sunflowers* and *Irises*—broke records at the preeminent auction houses. Finally, it was also the year that Dieter and Hortense Bührle got serious about honoring their father's private

collection with a global tour, while identifying and priming suitors for the future sale of Dieter's *Wheat Field with Cypresses* landscape, the First version of the painting.

Leighton, Reeve, and White published the findings of the dense report in the *National Gallery Technical Bulletin*, Volume 11, 1987. Today the report is published online alongside the painting. It reads:

> Several of the samples show a thin, discontinuous layer of black pigment recognizable microscopically as wood charcoal on top of the white ground, indicating some preliminary sketching of the design before painting. . . . It is likely that Van Gogh would have defined the principal parts of the composition in a charcoal drawing on the canvas when working from one of his earlier pictures of the group. In each case the underdrawing is present beneath lines of paint which divide the main elements of the landscape horizontally— at the point for example where the dark blue line separates the cornfield from the more distant blue hills and mountains, and in the immediate foreground where the yellow stalks of corn give way to pale green and cream.[116]

The X-ray revealed the pencil etchings under the paint that "defined the principal parts of the composition in a charcoal drawing on the canvas."

The report also captured the painting technique of the landscape:

> It is evident that Van Gogh would have painted the "[A Wheatfield], with Cypresses" quite rapidly, and the intermingling of colors revealed by some of the cross-sectional samples confirms this. For example, in the streaks of mauvish grey in the foreground at the very edge of the cornfield, the color can be seen to have been worked into the underlying white and yellow layers whilst the paint must still have been wet. . . . Elsewhere, though, a more organized, discrete layer structure is found suggesting subsequent adjustments

to the composition after the initial layers had dried. . . . There is also evidence from the constitution of the paint that modifications to the design, if only minor, were made at a later stage (see the pigment section below under 'white'), which supports the view that No. 3861 was not the first in the series of paintings, but evolved by Van Gogh in the studio as a version of the theme.[117]

In essence, for the first time, art experts could see behind the paint and brushstrokes and examine those in a very scientific way. It was as if they were Superman with X-ray vision that could see underneath the surface layer. It also gave the researchers at the National Gallery the DNA of van Gogh's pigments, with three colors being unique to him—custom-made by Père Tanguy's paint shop in Paris.

Professor of art history H. W. Janson wrote about *A Wheatfield, with Cypresses*: "The field is like a stormy sea; the trees spring flame-like from the ground; and the hills and clouds heave with the same surge of motion. Every stroke stands out boldly in a long ribbon of strong, unmixed color."[118]

What Professor Janson had seen in the National Gallery's Final version of the painting, Vincent saw with his eyes, an explosion of life from the tall cypresses and bushes, to the wheat all blowing in one direction, while the windswept sky is full of big and swirling clouds flying across the canvas in the opposite direction.

Like the various components of his *Wheat Field with Cypresses* subject, the artist's moods and emotions could often fly in opposite directions.

14

Trains, Rolls, Impasto

By the third week of September 1889, Vincent decided it was time to ship a *roll* of paintings, including some of his repetition studies, to Theo. Rolled-up canvases, four to six of them stacked on top of one another with the thick impasto paint often not fully dry, were packaged compactly; tubes of paintings were stuffed in crates and put on the goods train.

For an artist who lived month to month on his brother's stipends, it was the most economical way to ship his paintings from Arles up to Paris. Unfortunately, it was also the way that was more damaging to the paintings' condition. This method of packaging would accelerate the aging of a painting, as some of the stacked canvases in the roll would stick to one another, particularly on hot and humid days like those of the September in question. Upon receiving them, Theo knew that the paintings would have to be touched up and restored before they could be exhibited or sold.

In a September 20 letter, Vincent wrote, "I'm also adding a study of flowers to the roll of canvases—not much, but anyway I don't want to tear it up." (Art scholars believe the "study of flowers" was one of the *Irises* paintings.)[119]

Eight days later, he "dropped Theo another line" that he had removed three studies from the "consignment of canvases (which you will have already), since by removing them the *roll* cost 3.50 francs less for carriage. So I'll send them next opportunity—or rather they're leaving today with other canvases—the following."[120]

Those studies he held back, to save his brother some money, included the various versions of *Wheat Field with Cypresses*.

———

Painting continued to carry a practical and an emotional significance for van Gogh—giving them as gifts was a way for him to ease the anxiety of his loved ones, as well as show that he was painting again, and painting well, with color and virtuosity. He wrote to Theo, "Soon I'm sending you a few smaller canvases with the 4 or 5 studies I wanted to give to Mother and our sister. These studies are drying at the moment. It's no. 10 and no. 12 canvases, reductions of the *Wheatfield and Cypresses*, *Olive Trees*, *Reaper* and *Bedroom* and a little portrait of me."[121]

———

The National Gallery of Art's 1987 *Technical Bulletin* also included the description of van Gogh's signature impasto with reference to the *Cypresses* painting:

> "I have a canvas of cypresses with some ears of wheat, some poppies, a blue sky like a piece of Scotch plaid; the former painted with a thick impasto like the Monticellis, and the wheatfield in the sun, which represents the extreme heat, very thick too (note 10)."
>
> This description matches the painting now in Switzerland which has the same dense impasto as the recently completed "Cypresses", a surface which is an accumulation of several layers of paint.[122]

The "thick" and "dense impasto" also applies to the *A Wheatfield, with Cypresses*, the Final version of that repetition study catalogued

by the National Gallery in London. "A blue sky like a piece of Scottish plaid," on the other hand, is a very specific, very detailed description that Vincent included in his letter to Theo on July 2, 1889.

Of the 864 paintings in van Gogh's oeuvre,[123] only one is referred to as having a "multicolored Scottish plaid" sky, *Cypresses*. This seemingly minor point will play a central role in determining the authenticity of the different versions of the *Wheat Field with Cypresses* paintings.

Cypresses, which is a vertical canvas hanging today at the Metropolitan Museum—donated as part of the fifty-two paintings in the Annenberg Collection in 2002—should not be confused with the First *Wheat Field with Cypresses* landscape, which is a different painting altogether. The vertical *Cypresses* already belonged to the Annenberg Collection, while the First version of the landscape painting was purchased by Walter Annenberg in spring 1993 and immediately donated to the Metropolitan Museum of Art, for the then sky-high price of $57 million.

Upon arrival, the Saint-Rémy paintings would be handled by Theo, or maybe a messenger, someone like Jo's brother, Andries Bonger, and then by Père Tanguy, or some employee at his art house. Someone would stretch them out and fully dry them (without the benefit of today's climate-control heating, careful ventilation, and air conditioning). The 142 paintings that arrived from Saint-Rémy would be cared for in the primitive *au naturel* state, aging at an accelerated rate due to being stacked and rolled, compressed into tubes, and stretched; many were then stacked under Vincent's bed or stuffed back in the tubes for storage.

The rate of aging would be especially high for the landscape and nature paintings that van Gogh created outdoors. Having been painted outside, exposed to the elements, those paints would have collected dust particles: microscopic bits of earth, dirt, and pollen.

The National Gallery of Art's *A Wheatfield with Cypresses* condition report didn't find any pollen in the paints they examined under microscope, by X-ray, with chemical analysis in the laboratory, or using UV-fluorescence photographs. No earth, no pollen. Nothing.

On impasto brushstrokes, they quoted van Gogh:

> It was painted so quickly and has dried in such a way that the essence evaporated at once, and so the paint is not firmly stuck to the canvas at all. That will be the case with other studies of mine too, which were painted very quickly and very thickly.[124]

The fact that Vincent "painted so quickly" when working on the Final version of the landscape confirms the way he painted his study—the outline layout, then working from his sharp memory with the agile brushstrokes of a master artist. Other observations from the Bulletin included:

- "Besides, after some time this thin canvas decays and cannot bear a lot of impasto."[125]
- "[. . .] you will, by varnishing, get the black, the very black tones, necessary to bring out the various somber greens."—A neat trick he learned from Paul Gauguin.[126]
- It is not clear why both the size 30 versions of "A [Wheatfield], with Cypresses" escaped this treatment but the difficulties in finding a suitable protective layer.[127]
- The impasto is extensive and very raised with many delicate brittle points. This rough surface could not be cleaned using normal methods.[128]
- He was also aware of its relatively poor drying qualities, and in the impasto of the pure white of the sky in No.3861 relatively deep, sharped-edged cracks have formed.[129]

What the National Gallery scientific team also discovered was that Vincent likely finished the Final version of the picture quickly, but then came back and touched up a few areas; that the thick impasto fields in the foreground were painted in layers; that the "cracking" of the painting was due to its being rolled up for shipping in the crates and then north to Paris by train; and that being painted in the studio inside the asylum kept the artwork in otherwise good condition. Unlike the model version of the painting or the drawing that was rendered outside at the end of June, the London version was not contaminated by dirt.

Based on additional scientific, technology-based tests, the *Technical Bulletin* stated emphatically, "The vigorous swirling brushstrokes are very clearly displayed in the photograph of the reverse by transmitted light. The condition of the painting sets it apart from the three others in the Collection [*ed.:* a reference to the drawing, the Met's First version, and van Gogh's sister's Small version] as it is both unlined and not impregnated with anything which would change the refractive index of the paint and ground. It has never been varnished or treated with polishing wax."[130]

For some reason, perhaps because of his mental state, emerging from the lost summer, Vincent didn't varnish and seal the canvas as he had done with many other of his paintings in Arles and Saint-Rémy.

Talk about the "devil in the details." Three decades ago, the National Gallery in London nailed down virtually every aspect of its masterpiece, arriving at the conclusion that it was the Final version, painted indoors and not subjected to pollen, and that its impacted impasto was the result of rolling a still-damp painted canvas and the years the painting spent languishing after Theo van Gogh died prematurely in January 1891.

———

In late October 1889, Vincent received a letter from Roulin, who talked about being happy to hear that he was painting again (there

was a period of productivity after the summer delirium subsided), that he should "finish [the works] in good health," and that his "return to Paris is almost decided." Above all, Roulin used the power of words and the eternal bond of friendship when he wrote: "Let us hope that one day again we shall have the happiness to shake hands and to tell each other in person such good things and to cement our friendship once more."[131]

When van Gogh read that letter in his room at the asylum, he must have thought about the first time he met Roulin over a drink at the café, or the night when he cut off his ear, when Joseph Roulin followed him home to make sure he was all right, or the six portraits he did of the old man and the one of his wife Augustine and youngest daughter. But whatever glimmer of hope Vincent gained from reading, and perhaps rereading, that letter would come to a grinding halt in the darkest months of December and January, when his affliction, his "attacks," returned with a vengeance.

There was also some positive news, however. At the end of January 1890 Vincent received a letter from his sister-in-law Jo. It was a breakthrough, a shift from his status of an unknown to public recognition. She wrote:

This morning Theo brought in the article in the Mercure, and after we'd read it Wil and I talked about you for a long time—I'm so longing for your next letter, which Theo is also looking forward to. Shall I read it? But everything has gone so well up to now—I'll just keep my spirits up.[132]

What his sister-in-law was referring to was the fact that a renowned French art critic, Albert Aurier, wrote a five-page article on the up-and-coming Impressionist painter titled "Les isolés: Vincent van Gogh," in *Mercure de France* (January 1890). "In his article Aurier praises Van Gogh's 'strange, intense and feverish work' (*oeuvres étranges, intensives et fiévreuses*) and calls him a worthy successor to

the seventeenth-century Dutch masters. In his eyes, Van Gogh is not only a realist with a great love for nature and for truth, but also a symbolist who uses his idiom to express 'an Idea' (*une Idée*). . . . [133]

"With regard to Van Gogh's technique, he writes that it matches his artistic temperament: 'vigorous, exalted, brutal, intense' (*vigoureuse, exaltée, brutale, intensive*). His palette is 'incredibly dazzling' (*invraisemblablement éblouissante*) and his brushstrokes 'fiery, very powerful and full of tension' (*fougueux, très puissants et très nerveux*). Aurier closes his article by lamenting that Van Gogh will never be completely understood, for he is 'too simple and at the same time too subtle for the contemporary bourgeois mind' (*à la fois trop simple et trop subtil pour l'esprit-bourgeois contemporain*)."[134]

Aurier had seen, for the first time, van Gogh's artwork—six paintings in total—at an expo, "au salon de XX à Brussels," that took place from January 18 to February 23, 1890.[135]

The works provoked controversy, much like van Gogh's life. He displayed six paintings that included two versions of *Sunflowers*, *The Ivy*, *Orchard in Blossom*, *Wheatfield*, *Rising Sun*, and *The Red Vineyard*.[136] He was promptly accused of being "too modern" by Henry de Groux, who was part of the XX movement, an "avant-garde group of 20 artists" also exhibiting at the expo. De Groux even wanted to pull his own work from the show "if he found it in the same room as the 'the laughable pot of sunflowers by Mr. Vincent.'"[137] That slight didn't sit well with van Gogh's Impressionist pals, Toulouse-Lautrec and Paul Signac, who took umbrage and nearly caused a fight on opening night. "The next morning, de Groux resigned. To the critic of *Le Journal de Charleroi*, it was understandable: this artist had been 'very justly exasperated' by Van Gogh's sunflowers."[138]

Other reactions were far more positive. Claude Monet, for instance, understood better than most the raw beauty and vitality of van Gogh's artwork and stated it was the "best of the expo." An additional show of support came from Anna Boch, who purchased

The Red Vineyard for just over 400 francs, or what today would be the equivalent of $2,000.[139]

Why did Anna Boch buy the painting? Was it the colors? Did it remind her of a place and time in her life? Or was it more likely that she knew Vincent through her younger brother Eugene, and knew van Gogh was poor and needed help? She was also Dutch and a painter, like van Gogh, so perhaps there was a sense of kinship.

Albert Aurier's article, "Vincent van Gogh: The Isolated One," hit a nerve with the artist, silenced Henry de Groux, and showed the path forward for the new trend in art at that time—Post-Impressionism. Van Gogh was not quite a star, however, since the "bourgeois"—or what has been referred to as "upwardly mobile" middle class in our time—really didn't understand the unique quality, deep symbolism, and intrinsic ties with nature and its inner meaning that Vincent van Gogh displayed in his artwork. In fact, his paintings would languish with little movement, in terms of sales or perceived value, for another decade.

Upon reading the Aurier article about the new Dutch master, Vincent wrote a long and endearing note to the prominent art critic:

> Dear Mr. Aurier,
> Thank you very much for your article in the Mercure de France, which greatly surprised me. I like it very much as a work of art in itself, I feel that you create colors with your words; anyway I rediscover my canvases in your article, but better than they really are—richer, more significant.[140]

And then, after he finished the letter and signed his name, Vincent added the following:

> When the study I send you is dry right through, also in the impasto, which will not be the case for a year—I should think you would do well to give it a good coat of varnish.

And between times it should be washed several times with plenty of water to get out the oil completely. This study is painted in full Prussian blue, that color about which people say so many bad things and which nevertheless Delacroix used so much. I think that once the Prussian blue tones are really dry, by varnishing you will obtain the dark, the very dark tones needed to bring out the different dark greens.[141]

Neither his first sale nor the glowing art review did Vincent's mental health any good in the long run. He would suffer another attack—whether from epilepsy or from nibbling or inhaling the paints or from depression—that spring. And perhaps, deep down inside, he felt it was time to swim upriver like a salmon—to go north to his brother Theo, whom he loved dearly, and meet Theo's wife, Jo van Gogh-Bonger, for the first time, and see the new life in his nephew named after him, and take advantage of the pause from the attacks he expected to reappear.

Even as he was planning the journey, concerns mounted about the state of his mental health and whether it was advisable for him to leave, especially unaccompanied by anyone who could keep an eye on his fragile health. He seemed to think that he was stable enough to do so. On May 4, 1890, just before he left, Vincent wrote to his brother:

First, I categorically reject what you say that I should be accompanied throughout the journey. Once on the train I no longer run any risk, I'm not one of those who are dangerous—even supposing I have a crisis, aren't there other passengers in the carriage, and besides, don't they know what to do in all the stations in such a case?

You're giving yourself worries here that weigh on me so heavily that it might directly discourage me.

I've just said the same thing to Mr. Peyron, and I pointed out to him that crises like the one I've just had have always been followed

by three or four months of complete calm. I wish to take advantage of this period to move—I want to move in any event, my desire to leave here is now absolute.[142]

Once in Paris, he would examine the paintings from his two-year stay in Arles and Saint-Rémy, consider how to improve upon those works of art with some "touchings" or new copies, and then head outside France's capital for the final chapter of his life.

15

Deaths of Two Brothers

Before departing for Paris, Vincent spent two weeks getting his life in order, finishing paintings, and making sure that the canvases could spend the next month in the room to dry[143] before being sent after him to Paris. Van Gogh was focused again. He took with him thirty kilos of luggage,[144] the French box, painting supplies, and articles of clothing.

On April 17, 1890, Vincent traveled north. He boarded the train that would travel for fifteen hours from Arles to Paris. He had ample time to decompress, and he did not worry about the reoccurrence of an attack, since he wouldn't be alone on the train that would make several stops along the way. He reflected on what had taken place during his years in the South of France, including his one-year self-imposed exile at the asylum, and looked forward to a fresh start, a reset—as well as to meeting Jo van Gogh-Bonger, his sister-in-law, and his nephew, named after him, for the first time. The destination was important in other ways. It would be a return to a city where he was introduced to the Impressionist movement of Gauguin, Monet, Pissarro, Bernard, and other great masters.

From the rolling train, Vincent gazed out at the spring fields of green wheat and the thousands of stalks of sunflowers not yet ready to bloom, and thought about all of the art, the hundreds of paintings and sketches and drawings that he had sent by the very same railway.

When he finally arrived in Paris in the morning, he was greeted by his brother. They walked over to Theo and Jo's new apartment at 8 Cité Pigalle and climbed up four flights of stairs.

Vincent knew he wouldn't be staying long, as did his brother. For one, the hectic pace of city life no longer suited Vincent's needs or mental state, as a person or as an artist. He wasn't sociable. And whatever desire he had ever had to converse with strangers had been diminished by his year in the asylum. It was no longer people and streets that provided him with the stirring "models" from which to paint; instead, he looked outward to the countryside with its riot of bright colors. He anticipated—or feared—that his attacks in Paris might be fiercer during the extremes of heat and darkness. So Theo and his close friend, Impressionist artist Camille Pissarro, felt it would be best to send Vincent out into the country nearby to be looked after.

After arriving at the apartment, Vincent reviewed the few paintings that Theo kept in Vincent's room, *The Potato Eaters* hanging in the dining room and *The Orchard in Bloom* in the bedroom; a number of others from The Hague, Arles, and Saint-Rémy were stashed under the bed and in the closets.[145]

Next, Theo took his brother to Tanguy's shop in the Rue Clauzel. The visit was a shock for Vincent: "My paintings and those of other painters piled haphazardly. A real mess! In vain did I grumble, Tanguy opposed me his usual affable smile: 'Where do you want me to put your paintings, Vincent! You know I lack space.'"[146]

The conditions he saw stressed Vincent to the point that he wanted to find a new home to store his paintings. He worried about holes and bedbugs. He must have wondered about the arrangement

Theo made with Tanguy. In those stacks of paintings, Vincent's canvases from Arles and the asylum were showing signs of accelerated aging, as well as the impacted impasto, the cracking and chafing from being rolled up and stacked on top of one another.

On the third day back in Paris, Vincent packed for the next, and last, leg of his journey: he was heading to Auvers-sur-Oise, a rural country town northwest of Paris.

Upon arrival, he met Dr. Paul Gachet. He would be the last doctor to care for Vincent, a physician who had been referred to Theo by Camille Pissarro. Old man Gachet had narrow eyes and a high, square forehead cut by a receding hairline. The odd look was emphasized by a thick, amber-highlighted mustache with a speckle of hair beneath his lower lip. The look caught Vincent's artistic eye. But the rent to live at Dr. Gachet's home was twice what he would end up paying across town at Auberge Ravoux, a bed-and-breakfast inn in its day. Dr. Gachet steered his patient to the quaint inn across town, saying: "daily bed and board priced at 1 franc and 2.50 francs respectively."[147]

By declining Gachet's steeper price of six francs a day, Vincent had money left over to drink, enabling a return to the mind-bending blur of absinthe that stoked his demons and bedazzled his imagination with a radiance of bright yellow colors. He was once more surrounded by the beauty of wheat fields, and he felt the desire to paint again, as he did when he first arrived at Saint-Rémy a year before.

Painting at a rapid pace—eighty paintings over his last seventy days—Vincent wrote to his mother and sister on July 14, 1890:

For my part, I'm wholly absorbed in the vast expanse of wheatfields against the hills, large as a sea, delicate yellow, delicate pale green, delicate purple of a ploughed and weeded piece of land, regularly speckled with the green of flowering potato plants, all under a sky with delicate blue, white, pink, violet tones.[148]

The last letter Vincent wrote to his brother Theo—less than two weeks later—had a change in tenor at the outset: "I'd perhaps like to write to you about many things, but first the desire [to paint] has passed to such a degree, then I sense the pointlessness of it."[149]

Without missing a beat, Vincent wrote on discussing family issues and tidings before he moved on to Paul Gauguin's Brittany paintings that he found "beautiful" and moving; he also added remarks on other artists. Although he admired his peers' artwork, he spoke little about his paintings other than applying himself "to my canvases with all my attention."[150] The pointlessness he referred to might have been a sense of hopelessness that he felt begin to well up deep inside him. He must have sensed the end was near. If he did, he put on a good mask.

———

On a hot Sunday afternoon, July 27, 1890, right after lunch, Vincent left the inn for the field with his easel and folding stool. As the day progressed, with the suffocating heat bearing down on him, Vincent suffered attacks once more, whether from sunstroke or seizures or a bioaccumulation of toxins. Either way, the nomad artist was staring into the abyss, the great void in his life. He saw darkness. He took out a pistol he had acquired the day before and stared at the bright yellow madness of the sun as it snarled at him. His usually steady hand began to waver with the gun sitting heavy in his palm, his fingers wrapped around the metal stock instead of the customary wooden paintbrush. Desperate, he aimed the barrel at his chest. But when he squeezed the trigger, his trembling hand dropped, and he shot himself in the stomach instead. Struck with immense pain, but not yet dead, Vincent watched the sunset come and go. Out of the corner of his eye he saw a murder of crows disperse to the sky, scared off by the thunderbolt strike. The crows flew away just as he had imagined them scattering in a raucous flight in his last painting, *Wheat Field with Crows.*

By nine o'clock that evening, he staggered back to the inn. The innkeeper and his wife, Madame Ravoux, were sitting on the front porch, worried about why Vincent was late for dinner. Seeing him clutch his stomach, Mme. Ravoux asked Vincent if he was okay, and he wheezed, "No. . . ."

The pair took van Gogh upstairs to his room, then went to fetch Dr. Gachet, who dressed the wound that night. By the next day, the innkeeper had sent a telegram to Vincent's brother in Paris. Theo was on a train to Auvers-sur-Oise later that morning to see his dying brother one last time.

By his bedside, Theo urged his brother to live, strive on, not to give up. But for Vincent, there was no turning back, no more heading down to the wheat fields to paint, no more sunsets or sunrises, no more handshakes or letters to write, no more absinthe to mute his pain, no more nightmares or attacks. No more hopelessness.

Vincent rebuffed his brother's pleas, stating, "The sadness will last forever."

He then fell into a coma. At 1:30 a.m. on Tuesday night, July 29, 1890, Vincent van Gogh was pronounced dead by the innkeeper. By the next day, word had spread. Many of his fellow artists came to Auvers to join the funeral procession.

The death of Vincent was a cold blade plunged into Theo's heart.

The younger brother, whose own health had been failing for years, must have felt his own mortality and been shaken by it. Theo had contracted syphilis a few years before his marriage to Jo Bonger; the disease must have gnawed at his mind. The death of Vincent more than wounded Theo's heart—it had to be a psychological and physical blow as well. Suffering and aware of his coming demise, he knew time was short.

16

Widow's Intuition

With news of Vincent's death reaching the studios and the Salon in Paris, prominent members of the French art world, including the young Post-Impressionist Emile Bernard, art critic Albert Aurier, artist Tom Hirschig, and Andries Bonger, among others, met with Theo van Gogh in Auvers-sur-Oise on July 30, 1890, to attend the funeral. (The Salon was the greatest annual art event in Europe, dating back more than 150 years. It was Paris's official art exhibition, the exhibition of the Académie des Beaux-Arts.)

The innkeeper Adeline Ravoux, in her memoir of Vincent van Gogh, recalled: "The house was in mourning as if for the death of one of our own. The door of the café remained opened but the shutters were closed in front. In the afternoon, after the bier was set out, the body was brought down to 'the painter's room.'"[151]

Vincent was lying in the coffin. Albert Aurier wrote of the scene:

On the walls of the café where the body lay all his last canvases were nailed, forming a sort of halo around him, and rendering his death all the more painful to the artists who were present by the splendor of the genius which radiated from them.[152]

Emile Bernard painted the funeral scene of men dressed in black suits. Dr. Paul Gachet was heartbroken, as was the sobbing Theo. They interred Vincent with his painter's easel, folding stool, and paintbrushes, which were placed into the grave before the coffin.

Though much was lost that day, there was also something gained as Andries Bonger met one of Vincent's old and influential friends, Emile Bernard, at the funeral. Andries was not just a relative of van Gogh. He was also an art collector. Soon he would be tasked with creating the *catalogue des oeuvres* of van Gogh, which would include the paintings that Theo cared for in France.

When the funeral was over, Theo removed all of Vincent's paintings from his lodgings and sent them back to Paris. Before he could inventory the hundreds of paintings that he possessed in France—which didn't include the ones Vincent had given away to Dr. Rey, railway postman Joseph Roulin, Dr. Paul Gachet, artists such as Paul Gauguin and Emile Bernard, or the ones he had sent back to their family in Holland—he was struck down by the latent, slow-acting disease of syphilis. After Theo was committed to a hospital for paralytic dementia, he quickly faded away.

Jo van Gogh-Bonger was a young widow with little money in the form of liquid assets. But she sensed she was sitting on a goldmine; she just had to wait for the day the market for French Impressionism paintings took off. Since her brother Andries was an art collector and knew the Paris art scene well, and had also worked in the insurance field, he would be a good accountant for putting together a ledger, an inventory of all van Gogh paintings stored in her apartment and in Tanguy's shop and house. All those were owned by the van Gogh-Bonger families in France.

Together they would create the *Catalogue des Oeuvres de Vincent Van Gogh*. In the ledger marked by Andries's handwriting, they ended up listing 364 paintings.[153] Many were portraits of Vincent, some were copies of several studies, and others, like the Millets, "translations" ("copies"); for these, Andries used the same number

over and over, so the original number was 308 and would evolve to 364. That catalogue, published in 1891, would become known as the Andries Bonger List—or A. B. List.[154]

There is a striking absence in the A. B. List. Nowhere is there any mention of the *Champs de blé avec Cyprès—Wheat Field with Cypresses.* Nowhere in the ledger book could one find Vincent's stirring landscape study that he had begun in June 1889 at Saint-Rémy, with a drawing, and finished in September, after taking most of the summer off because he was overwhelmed by his maladies and the heat. One of Vincent van Gogh's top ten masterpieces is entirely absent from the A. B. List; there is no mention of *any* of the versions. Not the First version. Not the Small version. Not the Final version. In the case of the latter two versions, the absence can be explained by the paintings' history, which will be discussed below; not so when it comes to the First version.

With the A. B. List in hand, Jo van Gogh-Bonger sensed an opportunity was awaiting her and her brother-in-law's paintings back in the Netherlands, where art collectors would appreciate the new Dutch master. Jo, together with her brother Andries and the hordes of paintings and letters, would travel north over the border, through Belgium, and into Holland, where she would keep tight control of the exhibits, the publicity about Vincent, the consignments, and ultimately the sales of the paintings.

———

Before Theodorus van Gogh—named after his father—had been committed to the insane asylum in a complete collapse in October 1890, he made sure he gave his wife Jo and her brother Andries—"Dries"—strict instructions on what to do with Vincent's massive collection of artwork, as well as his troves of letters stored in a cupboard. He insisted on the need to make and keep an inventory of the paintings, and tried to explain to her how to sell the art in the years to come.

Art dealer Theo was a great instructor; he knew exactly what to do and communicated that to his wife. Jo, for her part, was an even better listener and would become the gatekeeper to her brother-in-law's masterworks, introducing Vincent van Gogh to the world. Ever the wise woman, she would wait for the right time to sell some of the paintings after the Impressionist new school painters' art market took off.

She would bring a woman's touch to selling Vincent's "peasant genre," a woman's intuition to knowing whom to trust, and a woman's patience to selling the paintings at the right time for the right price while keeping many pieces of art in the family and not flooding the market with too many van Goghs. That tactic, strategy, and execution were repeated and perfected by the auction houses of the day, driving an air of exclusivity both for the artists and their particular artwork. Jo also took meticulous care in transcribing and organizing the 850 or so letters written in French, as well as translating them first into Dutch, then eventually German, and, during the last decade of her life, from the 1910s to 1925, into English.

Along with Theo's letters and others that Vincent had kept, she would publish the archival record of communications of all of the letters between Vincent, Theo, and their mother and sister, and the letters from doctors Ray and Peyron, Postmaster Joseph Roulin, and Jo herself.

Jo van Gogh-Bonger was twenty-eight years old when Theo died on January 25, 1891, in the asylum in Utrecht, Netherlands. He was clinically insane. When he died his death certificate read: "dementia paralytica." It was thought to be caused by "heredity, chronic disease, overwork, sadness."[155]

In 1914, Johanna van Gogh-Bonger would have Theo's body exhumed from his native Dutch soil and his body sent back to Paris to be buried alongside his brother Vincent, where today their headstones sit side by side—the master artist and the art dealer brother.[156]

By 1914, Vincent van Gogh was one of the most famous, celebrated, and renowned artists in the world. Jo put her brother-in-law on that trajectory, an ascendancy that would continue long after she passed away in 1925.

17

Wheel Ruts in the Road

The 1890s became known as the "Gay Nineties" in America and the "Naughty Nineties" in Great Britain, the result of decadent art created by Aubrey Beardsley and playwright Oscar Wilde.[157] Meanwhile, in Paris, for the Post-Impressionist new artists, it would be another hard, decade-long slog to gain exposure and sell paintings.

Initially, Vincent's death didn't set the world on fire in terms of art sales or name recognition. He first became a known entity in his native Holland, due to the spot-on business instincts of Johanna van Gogh-Bonger who, with the help of her brother Dries, took her infant son Vincent and "almost the entirety of Vincent's painted and graphic oeuvre" with her north of the border.[158]

To make such a big move, Andries needed assistance. He got a helping hand from an old friend of Vincent's, the young man he befriended at the artist's funeral—Emile Bernard. It is well documented that Emile Bernard, together with Andries Bonger, "classed, put in order, [and] prepared the packaging and shipping of Van Gogh's works" for Jo van Gogh-Bonger's journey back to Holland.[159] He also took photographs of some of the artwork and would later

become a collector of van Gogh. Finally, he also wrote about the artist and his stirring paintings in several publications over the years.

Bernard's devotion to Vincent went further. By 1893, he began "publishing passages in *Mercure de France* from the letters he had received, accompanied by an extensive introduction."[160] After four such publications, he got permission from Jo to publish some passages from the letters between Vincent and Theo.[161] Those letters, combined with Jo and Andries working the galleries and exhibits in and around Bussum, Netherlands, located southeast of Amsterdam, humanized van Gogh and provided exposure for his artwork.

Jo van Gogh-Bonger did not limit her promotional work to Netherlands only; she never forgot about the Paris art scene. By 1895, she was doing business with Ambroise Vollard, a prominent Parisian art dealer and one of van Gogh's early champions. He bought several of Vincent's paintings to "flip" them for a higher price.

In early 1896, Johanna organized two dedicated exhibitions in Holland: one in Groningen in February, where 101 works were shown, and a second in Rotterdam in March, where 52 pictures were shown. In September of that year, Vollard was finally permitted 56 paintings by Van Gogh at his new premises on Rue Lafitte in Paris.[162]

Jo also allowed Vollard to purchase a few paintings but "deliberately marked some of the best pictures as 'not for sale.'"[163] Not trusting the men she dealt with, she came up with ways to ensure that he wouldn't get his hands on all of them. By doing so, Vollard as an art dealer and businessman would have to prove his salt in making sales at market prices to build a long-term relationship with her.

In the end, "Johanna and Vollard disagreed on the high prices she put on the works, and by February Vollard had sold only two drawings." As more exhibitions followed, Jo made sure she didn't work herself into a corner with the influential art dealer, working with

other dealers and galleries so as not to become too dependent on any one dealer or exhibition.[164]

In 1896, Vollard put on two one-man shows: one during the summer, the second in the fall. "It was from the first of these that it is believed the Sutros bought their painting. The van Goghs acquired by the Unwins and the Sutros were among the first of the artist's works to be sold by dealers in Paris."[165] Thomas Fisher Unwin acquired a van Gogh "flower still life sometime in the early 1890s from Père Tanguy in Paris." It was a painting that was not on the A. B. List, since Tanguy himself was the owner. British dramatist Alfred Sutro and his wife Esther were also art collectors from time to time.

To put into perspective the enormous grassroots effort and long-term success of Jo van Gogh-Bonger in marketing and selling Vincent's art, one can look at some other painters of the time: Gauguin sold his first painting in 1892, Cézanne in 1911, and Seurat in 1919. Britain and Berlin, and America for that matter, didn't catch the wave of Impressionist work until the start of the twentieth century. By then, van Gogh was outselling his contemporaries.[166]

━━━━

Claude-Emile Schuffenecker (also known as Schuff) was a third-class artist when compared with the talent, vision, and dexterity of either his friend Gauguin or van Gogh. But he knew great art when he saw it, and he wanted to get his hands on van Gogh's work early. Schuff purchased two paintings from Jo: the still life *Les Fleurs* for 300 francs, and *Undergrowth with Two Figures* for 200 francs. In a March 1894 letter, he recommended that she should embrace those prices; by his next letter to her, she did indeed accept his offer, though "by this time Tanguy's widow had asked for a larger commission, so Schuffenecker ended up paying a slightly higher total, namely 525 francs."[167]

What few people knew about Claude-Emile Schuffenecker, who had met Paul Gauguin at a stock brokerage firm a decade before, was that he had inherited money from his parents and invested that

bounty in a gold company, which took off. From that point forward, Schuff lived the life that Gauguin had always lusted for and dreamed about living . . . painting with no worries about money or concern about where the next paycheck or sale of a piece of art would come from.[168]

Lacking sufficient talent, Schuffenecker did not become a great artist. Instead, he became a shrewd investor, often complaining that he was broke when in fact he wasn't, remaining cheap and miserly, never telling his community that he was well off so that he could underpay for paintings he desired to poach from his peers, who were far superior.

This deception led to a difference of perception of the two art buyers vying for van Goghs. While Schuffenecker was wise, acquiring van Goghs directly from Jo van Gogh-Bonger and through other art dealers, Vollard earned a reputation as an art "stealer"—so nicknamed—driven by his overt greed. Vollard would try to fool and manipulate Jo and, when that didn't work, cajole her, trying to blind her to get her to agree to his awful terms. She learned to walk away, to not answer his letters. By the end of 1896, Jo had other ideas. As a businesswoman, with a son growing up fast, she had acquired thick skin.

Still, the Parisian art dealer Vollard pushed forward, convincing Jo to loan him the artwork that would mirror a retrospective she had done in the early 1890s in the Netherlands. For that one show, she agreed to provide "works on paper [including] forty-three drawings, thirteen watercolors, and a lithograph."[169]

But the exhibit tanked; few showed up for the van Gogh retrospective. The press ignored it. "Vollard lamented to Johanna, people and art enthusiasts 'won't concern themselves with this exhibition.'"[170]

Shaming the art dealer for his failure to execute, Jo began to phase Vollard out from doing business. Still, "Vollard did not give up promoting Van Gogh's works. However, he was forced to find other sources to stock his gallery because Johanna effectively refused

to do business with the hard-bargaining dealer after relinquishing to him a half dozen canvases and ten drawings for a paltry sum in March 1897."[171]

By the end of the decade, Jo van Gogh-Bonger was running out of art dealers whom she could trust in lending, negotiating, and selling van Gogh's paintings. Vollard was proving unsuitable. She also broke off a relationship with another Paris art dealer, Lucien Moline, in 1895.

Learning that Emile Schuffenecker had bought several van Goghs and had helped put the paintings in shows in Oslo, Norway, and seeing the art market rise at the turn of the century, Jo decided it was time to make a big move with Vincent's paintings, some of his iconic classic artwork.

That break would arrive at an exhibit in 1901.

18

1901 Making a Name

In 1898, Emile Schuffenecker painted the *Portrait of Julien Leclercq and his Wife*, a pastel on paper. It was a tribute to the friendship between Schuff, the investor—middling artist and art collector—and Leclercq, the French poet and art critic.

The portrait, which hangs today at Cornell's Herbert F. Johnson Museum of Art in Ithaca, New York,[172] was also a token of appreciation to Leclercq for persuading Jo van Gogh-Bonger to provide a few van Gogh paintings to the contemporary art exhibition in Oslo that the art critic had arranged. Jo had grown accustomed to brushing off art dealers that irritated her through the years, but Schuffenecker knew when to approach her and when to recede into the shadows and not bother her. Although he owned several van Goghs by the end of the century, in addition to "owning one of the finest art collections in Paris,"[173] he needed an intermediary to deal with Jo when he felt their business relationship was a bit tense and frayed, from the poor introductions he made and from sales of van Gogh paintings not going through. That intermediary was Julien Leclercq.

Leclercq was married to Fanny Flodin, a Finnish pianist. Sculptor Hilda Flodin was her sister.[174] With a Scandinavian wife and a

sculptor sister-in-law, who was connected to Finnish royalty and the art world, it was only natural for the art critic Leclercq to organize the Oslo exhibition. As more art dealers and collectors acquired or sought to acquire the artwork of van Gogh, who was finally becoming a household name at the end of the decade, Leclercq and Schuffenecker foresaw the increased momentum in the market at the turn of the century. Together, they plotted to get their hands on more of the Dutch painter's masterpieces, while also seeking to broaden van Gogh's name recognition and drive up the value of his art.

By then, Julien Leclercq was already the owner of *Starry Night*, the masterpiece that hangs today at the Museum of Modern Art in New York City. Van Gogh himself thought it was a subpar effort, telling Theo that his better works included the themes of olives, wheat fields, and sunflowers. Perhaps this was because of *Starry Night*'s connection to Christianity, the halos around the stars and Venus, and the embellished peaceful town beneath the night sky that gave a kind of Christmas feel to the painting. The other subjects were all connected to nature, tied to Vincent's heart, his passion, and his life as a painter.

In spring 1900, Jo loaned eight van Gogh paintings to the persistent Julien Leclercq, who had written several letters to her, each time emphasizing the fact that Vincent van Gogh's artwork was on the brink of fame. In the end, he got through to her by suggesting that the loan coincide with the *Exposition Universelle*—the World Expo—in Paris that would begin on April 15, 1900.[175]

Jo van Gogh-Bonger sifted through a box of the 1890s articles, reviews, and critiques of van Gogh's artwork from critics, such as Aurier and Leclercq. She pulled out the 1890 review in the *Mercure de France* and reread what it had said about the artist:

> Like Salvator Rosa, he is a tormented spirit. His power of expression is extraordinary, and everything in his oeuvre derives its life from his own technique. His was an impassioned temperament,

through which nature appears as it does in dreams, or rather, in nightmares. . . . At the Salon of the Indépendants there are ten paintings by Van Gogh that bear witness to a rare genius.[176]

Jo knew Leclercq was an art critic and not an art dealer. He didn't have his own gallery. But he did possess an understanding of Vincent's artwork with a strong appreciation of his talent. By staying in Paris during *Exposition Universelle*, Leclercq would take advantage of the opportunity: his plan was to display the eight paintings in his apartment during the seven-month expo, which made a lot of business sense to her, as his place would be well trafficked by art enthusiasts; it made sense to Leclercq because he wouldn't have to lease additional space for the exhibit.[177]

When Leclercq received the eight paintings, he saw that the decade-old works, which had been stored haphazardly in Theo's apartment and at the Tanguy shop in Paris, were in bad shape. They had to be restored: "A neighbor and friend of Leclercq, the painter Judith Gerard, notes in her memoirs that he 'called in Schuffenecker, who taught drawing in one of the city's schools and came each day, in return for a small payment, armed with a large box of colors to cover up the holes and glue back flakes of paint.' Gerard observes that Schuffenecker became so enthusiastic about his work that he decided to 'improve' on several other van Goghs that he felt were unfinished."[178]

The paintings from the South of France needed to be restored in order to be presented at an exhibition, and, more importantly, sold to an art collector or dealer. As the restoration took place, there would be at least a six-month period for Emile Schuffenecker to *copy* them, one by one, out of everyone's sight. It was especially convenient that the only person who was likely to detect a forged van Gogh, Jo van Gogh-Bonger, was living in Bussum, Holland, more than three hundred miles north.

Copying other artists' works during the time of the Impressionists was often a way for artists to improve their technique, experimenting

with paints, colors, and brushstroke styles. Van Gogh himself had done it plenty. But for him, it wasn't about copying or reproducing the exact painting, the way a camera would. It was more about *translating* what he saw into his own unique style. Still, for him as for other artists, it was common practice. For example, during his stay at the asylum, van Gogh completed twenty-one copies of Millet's works, both in an attempt to define his own style and as homage to the painter.[179]

At the start of the twentieth century, the art world was quite different than when van Gogh was at the asylum, however. The market for Impressionists and Post-Impressionists had taken off. Claude-Emile Schuffenecker was a man more concerned with making money than developing technique, more interested in squeezing people, even friends, in deals to pay the lowest amount possible while reaping the biggest profit.

Leclercq, too, was not immune from the impulse to profit from the sale of van Gogh's work. To maximize this profit, he needed to have his own art exhibition, with van Gogh as the main artist, in Paris. But Jo van Gogh-Bonger wasn't keen on the idea, knowing that the art critic, who was also a poet, couldn't bankroll or sponsor it. So she ignored his October 12, 1900, letter. Then, on November 25, Leclercq followed up with another letter, this time using "now or never" psychology, writing: "I am asking you to set the date for the exhibition of Vincent's work, and I would like you to choose February 15th. Everything has changed in the meantime and I am no longer master of my own time."[180]

That last line had to give Jo a sense of lost opportunity if she didn't relent, act, and exhibit van Gogh's works in Paris in 1901. She agreed. Outside of transcribing and translating all of Vincent's letters to his family, it would be the single best decision she had ever made. So Leclercq was going to organize the van Gogh exhibition, collecting a total of seventy-one artworks from Johanna van Gogh-Bonger, his own collection, Schuffenecker's collection, and other

Parisian art dealers. The show would be held on March 17, 1901, at the renowned Galerie Bernheim-Jeune, a retrospective called *Exposition d 'Oeuvres de Vincent van Gogh.*[181]

———

Going hand in hand with the Paris exhibition would have been the A. B. List. But, as mentioned earlier, all three of the *Wheat Field with Cypresses* paintings were missing from Andries Bonger's list.

Why is this important? When the former Met curator Charles S. Moffett, at the time the senior curator of paintings at the National Gallery of Art in Washington, DC, wrote the essays for the Emil G. Bührle Collection catalogue *The Passionate Eye,* he said the following about *Wheat Field with Cypresses,* painting No. 62 in the collection:

> The artist clearly regarded 'Wheat Field with Cypresses' as a work of special significance, for on 2 July (1889) he sent a drawing after the completed painting to his brother, and in September he made painted variants for his sister and mother.[182]

That is one drawing and two paintings. The van Gogh letters of July and September back up the art expert's assertion of how many versions of the drawing and painting of that particular study existed: one and two, respectively.

So how does that stack up with the Metropolitan Museum of Art's claim that there were three paintings? Based on the brothers' correspondence, we know that in September, Vincent painted, shipped, and directed Theo to send the Small and Final versions of *Wheat Field with Cypresses* to their sister and mother in Netherlands. But what if, during Vincent's June 1889 study of the landscape, he only completed the drawing, never painting the so-called "First" version that the Met claims to own?

If the late Charles Moffett were alive today, how would he weigh in, given his breadth of knowledge about the artist, his thorough

understanding of van Gogh's brushstrokes and impasto, and his insights on the painter's symbolism?

Why couldn't his twenty-first-century counterpart at the Met, Susan Alyson Stein, curator of European art and Impressionism, come to the same conclusion that Moffett did when it came to the number of paintings in this study and the fact that the Small and Final versions of the painting were sent on to the van Gogh family in Holland from Vincent in Saint-Rémy through Theo in Paris?

In the book she edited with Asher Ethan Miller in 2006 for the Metropolitan Museum, *The Annenberg Collection: Masterpieces of Impressionism and Post-Impressionism*, which included texts by her, Colin B. Bailey, Joseph J. Rishel, and Mark Rosenthal, Stein wrote:

> One week later, on July 2, he (van Gogh) reported that he had done another "canvas of cypresses with some ears of wheat, some poppies, a blue sky like a piece of Scotch plaid," also painted in . . . "Thick impasto" but now set in a "wheat field in the sun, which represents the extreme heat." The canvas in question is the present "Wheat Field with Cypresses." Van Gogh came to regard it as one of his "best" summer landscapes and repeated the composition three times.

But, as I briefly discussed earlier, Vincent van Gogh Letter No. 784, dated July 2, 1889, which is the letter that Susan Stein cites above, didn't mention the "Scotch plaid" multicolored sky in reference to *Wheat Field with Cypresses*. No, the letter referred to another painting, not a horizontal landscape, but that tall vertical one. It is a painting that the Met also owns, called *Cypresses*, that Stein also wrote about in her book. That tall painting was also donated by the Annenberg Foundation to the museum and hangs today on the wall not far from the *Wheat Field with Cypresses*.

When the two paintings are seen side by side, it is clear that only *Cypresses* has "a blue sky, which is like a multicolored Scotch

plaid." The sky of *Wheat Field with Cypresses* doesn't have anything remotely like tartan-patterned hues or design at all. The two main colors, with varying shades of both, are light blue and cotton white clouds depicted in van Gogh's famous swirling brushstrokes that he invented for the *Starry Night* painting.

When this author noticed the discrepancy in January 2016, he sent Stein an email pointing out the error, but Stein never replied to clarify or rebut the discovery.

There is another important misidentification in Stein's description. The second line of "thick impasto" and "extreme heat" in Stein's description are actually references to yet another painting, *Reaper*. This work depicts a reaper in the wheat field emblazoned in an explosion of yellow, from the color of the stalks to the heat of the sun burning on top of the field, like a furnace.

So how did Stein and company, the so-called experts on European art and Post-Impressionism, get the reference so wrong? In their book, they arrived at just one painting, *Wheat Field with Cypresses*, while the van Gogh Letter No. 784 clearly refers to two paintings—not one—that resemble the Met's painting only in name, and not by what was depicted in the picture.

The question becomes: are there any references to a third *Wheat Field with Cypresses*, the so-called First version of the painting?

In doing a deep dive into the Van Gogh Letters database, which can be accessed online by anyone in the world, this author could not find a single mention or citation for a *Wheatfield and Cypresses*—as the study and its painting and the drawing versions are called in the English translation of the letters—painting, just the drawing that resides today in the Van Gogh Museum in Amsterdam.

Further research showed that the study's specific name only shows up in eight of the hundreds of letters, two at the start of summer 1889 and six that autumn, as Vincent informed his mother and sister that they would each receive one of the landscape paintings. The

last letter that mentioned *Wheatfield and Cypresses,* Letter No. 824, was written on December 7, 1889.

Either those two versions of the *Wheat Field with Cypresses* study, which can be found today in London (the Final version) and in the private Greek collection (the Small version), were delivered to Holland per Vincent's repeated instructions to the meticulous Theo to send them on to their beloved mother and sister in time for Christmas, or those two paintings remained in France. But if the latter had happened, those two paintings would have shown up in Theo's possession when he took "control" of all of Vincent's paintings and artwork in the wake of the artist's death; and they would have shown up and been written into the *Catalogue des Oeuvres de Vincent van Gogh* by the equally meticulous Andries Bonger in 1890–91.

But, as previously discussed, the title *Wheat Field with Cypresses* doesn't show up in the original November 1890 A.B. List of 308 paintings. Those paintings didn't vanish and then one day magically reappear. They must have been sent to Vincent's mother and sister in Holland. At some point over the next decade one of these two *Wheat Field with Cypresses* made its way into Jo's possession, probably from her mother-in-law, Anna Carbentus van Gogh.

By 1900, mother van Gogh would have been eighty-one years old. She likely knew that her days were numbered, that all three of her sons had died before she passed on, and of the effort that Johanna and Andries Bonger had invested in marketing, selling, and protecting the name and paintings of Vincent. So it makes complete sense that she would give up one or perhaps even more paintings gifted to her long ago by Vincent.

So the journey of the two paintings to Holland explains their absence from the A. B. List. It is more problematic that the alleged third version of the *Wheat Field with Cypresses,* currently in the Met's possession, does not show up in this inventory. Since it was not sent to an alternative location or recipient, it would have been kept by

Theo, and would thus have been recorded in the list with the other works.

That never happened.

———

The decision by Jo van Gogh-Bonger to sell the eight paintings to Emile Schuffenecker and lend seventy more to Julien Leclercq precipitated an unfortunate course of events. Not everything would be rosy about that business deal on the side of Leclercq and Schuffenecker.

When the show opened on St. Patrick's Day in 1901, a few of the van Goghs on display were *L'Allée des Alyscamps*,[183] *The Seine with the Pont de Clichy, 184 Prisoners Exercise*,[185] and the Final version of *Wheat Field with Cypresses*,[186] which was lent by Emile Schuffenecker, as was *Fourteen Sunflowers*, a work of unclear provenance.

The authenticity of this last painting has been recently questioned, for reasons that are quite similar to the circumstances of the *Wheat Field*, namely that it is missing from all records prior to appearing at Schuffenecker's. Geraldine Norman, an art critic who in the late 1990s discussed the possibility that one of the *Sunflowers* was a forgery, suggested that neither auction house nor most art experts in 1987 had a good handle on who Emile Schuffenecker was at the time. She wrote about the famous auction:

> Vincent's original painting of fourteen sunflowers now hangs in London's National Gallery, and his own copy is in the Van Gogh Museum in Amsterdam. But nowhere in his correspondence to his brother, Theo, is there mention of a third version—the one now known as the Yasuda Sunflowers. The canvas first surfaced in a 1901 Van Gogh exhibition in Paris, listed as the property of one Monsieur Emile Schuffenecker. It's known that Schuffenecker had access to the painting for six months for restoration; the question is whether he also seized the chance to copy it.

"If I am right," Norman wrote in London's *Sunday Times*, "the painting was Schuffenecker's undisputed masterpiece."[187]

Had we only had the art critic's accusation on record, then all might have passed quietly in the night. Vincent did copy a number of still life paintings of sunflowers, some with twelve petals, others with fourteen petals, with some of those paintings landing at the Tokyo shipping company, the London National Gallery of Art, and the Philadelphia Museum of Art.

Controversy first arose on the very first day of the van Gogh exhibition, which was shared with a half dozen other artists from his era. Julien Leclercq made quite a scene:

> The first documented forgeries or erroneous attribution are two Arles landscapes which Julien Leclercq removed from the van Gogh exhibition at Bernheim-Jeune in 1901. They belonged to Theodore Duret and were described in Meier-Graefe's "Entwicklungsgeschicte der modern Kunst" as "two curious landscapes." In the exhibition catalogue, which he dedicated to Johanna van Gogh, Julien Leclercq crossed out numbers 56 and 57 and added the explanation—"Withdrawn from the exhibition as not being by Vincent. Initially included by me sight unseen."[188]

Was it Emile Schuffenecker who forged those two Arles landscapes? Was it Emile Schuffenecker who copied the *Fourteen Sunflowers*? Did Leclercq, who might have been in on the plan, make a scene to show Jo van Gogh-Bonger that he was going to weed out any suspect paintings, while allowing other Schuff copies to be embedded in the grand exhibition with real van Goghs? It's hard to say. But in reality, it was the most direct way to pull bad Schuffenecker forgeries, "initially included by me sight unseen," while keeping the better and potentially more profitable forgeries in place.

The connection between the exhibition and forgeries has already been noted: "A number of Schuffenecker's false Van Goghs seem to

have come on the market." Geraldine Norman, a British cultural reporter, speculated that those extra paintings were used to "bulk out" the more than seventy paintings in the 1901 Van Gogh exhibition in Paris.

Julien Leclercq had cleaned out the two obvious forgeries from the show, so instead of seventy-one paintings by van Gogh, the retrospective exhibition had been whittled down to sixty-nine. It worked to perfection.

A very clever con. A great ruse.

A forgery can only take place after the artist dies. It has an even better chance when the main art dealer who knows or represents that artist passes away. But in the case of the two deceased van Gogh brothers, one the master artist, the other the art dealer, their untimely deaths eleven years prior handed over all of the paintings to Johanna, giving her ample time to become familiar with them, to learn their histories from the van Gogh letters, leading her to become a living expert on Vincent's paintings—at least those in her possession. So the forger had to take special care not to provoke suspicion on her part.

Of course, we should also consider the question of whether Claude-Emile Schuffenecker had enough smarts, daring, talent, skill—and was unscrupulous enough—to make money off his dead acquaintance. Schuff was not only pals with Vincent and Theo, but also ran in the same circles as the likes of Gauguin, Pissarro, Bernard, Monet, and many other artists of their day, so he would be well familiar with their particular methods and characteristics.

Schuffenecker and Paul Gauguin had first met in 1872 at the Pont-Aven art school, and then went on to work together at a stockbroker's office. The minor artist Schuff encouraged Gauguin to take up a career as an artist; Gauguin did just that, becoming a starving artist, while Emile Schuffenecker made it a point to always stash away money, like a squirrel, yet present himself as poor. Man was meant to exploit diamonds and gold mines, and Schuffenecker was

the latest gold digger determined to leverage the timing and talent of van Gogh and exploit his art for all it was worth at the turn of the century.

The second wave of van Gogh forgery claims was made in the late twentieth century, sixty years after the Otto Wacker wholesale forgeries of van Gogh, which will be described later in this book. "One is an accident, two is a trend," as the saying goes. But so far these claims have been largely ignored by established museums. For instance, in the 2001 edition of its annual journal, the Van Gogh Museum tried to simply wash away the claims of Geraldine Norman and many other investigative journalists and art experts with phrases like "to err is human"[189] (referring to the absence of the Yasuda *Sunflowers*, which was the fourth version of the still life painting, in van Gogh's letter to Theo), or "perceived errors of interpretation and the anomalous brushwork,"[190] (blaming the messenger), or "there is a lack of documentary evidence, nor did the artist's [Schuffenecker] contemporaries characterize him as fraudulent."[191] These attempts to ignore investigative concerns are troubling for several reasons.

First, if the Van Gogh Museum wants to use "a lack of documentary evidence" to support its contention that Schuffenecker didn't forge *Fourteen Sunflowers*, then they must address the problem that there is also no documentary evidence that van Gogh ever painted that fourth version of the still life. Everyone with money to invest and art specialists to vet that painting knew, after its purchase in 1987, that it could never be sold in the open market because it is a fake.

Second, lack of documentary evidence is actually quite in line with Emile Schuffenecker's shady practices. We know that he hid his wealth from his friends, for instance. There were also very few friends available to report this potential fraud. When the van Gogh brothers died in the early 1890s, and Paul Gauguin—who at one time briefly lived with Schuffenecker's family—tried to slake his insatiable wanderlust, traveling aboard a slow ship to Martinique,

Panama, and to the far South Pacific, there was no one left to shine the spotlight on Schuff, the minor artist, and his dealings, legitimate or illegal.

What about Schuff's close friend Julien Leclercq? Well, as fate would have it, he was the rocket fuel that launched van Gogh's fame in 1901 into orbit. He was also the one who organized a follow-up exhibition in Berlin in early October. But he would end up suddenly dying on Halloween night of that year at the young age of thirty-six.

Given that the few friends who knew the introverted investor had either died prematurely or left France, it doesn't take a mathematician to figure out why Schuffenecker's close friends didn't step forward and out him as a con man at that time—by then, he had no "close" friends.

The Van Gogh Museum should also drop all lines of argument on Emile Schuffenecker that read like this: "By the 20th century he had almost ceased to paint, making it highly implausible that in 1901 he would have been tempted to copy a work by Van Gogh, whose style was so alien to him."[192] Because, for one, there was nothing "alien" to Emile in van Gogh's person, artwork, or paintings. Au contraire. The two were part of the same milieu, the same group of artists. And the fact that Schuffenecker officially painted only one painting in the last thirty-four years of his life says it all. Claude-Emile Schuffenecker quit *creating his own work*. He chose the path of least resistance—copying masterpieces rather than creating original works—to maximize profit.

If Schuff had been an artist of great stature, he would have pushed on, just like van Gogh had pushed against his mental and physical ailments and lack of money, and produced a massive oeuvre. But Schuff never had the talent, inner beauty, or connection to the subjects of his paintings that can be seen in the works of van Gogh, Gauguin, and other great masters.

This disparity in skill does show in his forgeries, even the best of them. One of the problems with the Met's *Wheat Field with Cypresses*

is that it clearly has been painted by a different artistic hand. A side-by-side comparison of the Final National Gallery version and the Met's version would reveal this, among other issues, even to a non-art expert.

Perhaps Swiss investigative journalist Hanspeter Born, along with his coauthor and Impressionist art expert Benoit Landais, who was involved in the 1990s second wave of van Gogh forgery concerns, the "Fakes Controversy," stated it best in their thoroughly documented self-published book, *Schuffenecker's Sunflowers*:

> Schuffenecker, not content with doing "Arles" landscapes, also tried his hand at even more demanding "Saint-Rémy" paintings. Mont Gaussier with the Mas St. Paul, F 725—originally owned by Blot and later sold to the Mathiesen Gallery—is a fairly grotesque pastiche in which a peasant woman watches a man who seems to look for a four-leaf clover. This landscape, now rejected as false, is derived from A Meadow in the Mountains; Le Mas St. Paul F 721 that Emile bought from Johanna in 1901 and is in the Kröller-Müller Museum.[193]

Once he got close to copying—not translating—van Gogh's artwork, with money on the nearby horizon, and a good deal of it, why would Schuffenecker ever stop?

Yet his weaker talent was no match for the master's hand or the test of time, with "fairly grotesque pastiche" results.

The ease with which the Van Gogh Museum dismisses inquiries into the paintings' authenticity is unjustified, especially since it is an institution that is supposed to be the last word on authenticity questions, ensuring that the works that bear the artist's name have actually been created by that author. They are expected to do more to put a stamp of authenticity on the paintings that are proven to belong to van Gogh, rather than rubber-stamp new claims as baseless without doing a thorough investigation.

Quality assurance requires it. New generations of art lovers, enthusiasts, students, experts, critics, artists, teachers, and visitors demand that real, fully—not quasi—unquestionable, un-doctored, un-forged van Gogh paintings can be viewed, absorbed, and appreciated.

Now will the Van Gogh Museum look into the provenance and authenticity of the Met's First version of *Wheat Field with Cypresses*?

III
BROKEN
PROVENANCE

19

The Art Restorer's Dream

Art critic Julien Leclercq's brilliant catalogue for the retrospective exhibition of seventy-one van Gogh works of art introduced the artist to the world, and perhaps more importantly, to Paul Cassirer, who attended the Bernheim-Jeune show in 1901.

At the exhibition, Cassirer, a German Jewish art promoter and gallery owner, was introduced to Johanna von Gogh-Bonger. He saw what many other gallery owners and art dealers from Paris and London failed to see in van Gogh's paintings, especially from the late period in Arles and Saint-Rémy. These works were full of intense, dazzling colors and represented the next wave in the art of the avant-garde movement; Cassirer foresaw that they would sell in Berlin, and sell well, feeding the liberal tastes in that German city that was overtaking Munich in its attention to the arts.[194]

For art publisher Cassirer, who had introduced and exhibited Paul Cézanne in Germany with his cousin Bruno Cassirer, Vincent van Gogh was a natural fit.[195] Cassirer and Jo had an easy time understanding one another because they shared a certain culture—they were both northern. She was Dutch; he, Germanic.

The year 1901 was transitional. It was a year that Paul and Bruno Cassirer dissolved their partnership.[196] Paul took over the art gallery business; Bruno focused on publishing. In deference to one another and their families, they signed a non-compete exit contract that stipulated they couldn't compete against one another for seven years in their respective businesses.[197]

Johanna van Gogh-Bonger married for the second time on August 21, 1901, to Johan Henri Gustaaf Cohen, a painter and writer, who would later add Gosschalk to his last name, becoming simply Johan Cohen Gosschalk. He was a "good deal younger than she. We then moved to a house built by Willem Bauer, a brother of Marius Bauer. . . . He [Johan] had a fine, sensitive mind, but his health was poor."[198] Together they raised her son, Vincent Willem, and would live in Paris only two more years before moving back to Holland in 1903.

In May 1902, Paul Cassirer inserted five van Gogh paintings in a show with the Berlin Secession[199]—a rejected group of artists, much like the maligned van Gogh and Gauguin, that formed to repudiate the academic view on art at the turn of the century—presenting the artist and French Post-Impressionism artwork to Berlin.[200] Through the success of that exhibition, Paul Cassirer would pit French "civilization" against "German *Kultur* in the art galleries of Berlin." He did so to bridge the historical differences resulting from the Napoleonic and Franco-Prussian Wars of the nineteenth century, though he also did it to "irritate" the rebel artists of the Berlin Secession movement. As he knew, "For the Germans, *Zivilization* was artificial and false, while *Kultur* [was] not ideological but natural and pure, practical and materialistic, a means of doing things efficiently rather than elegantly."[201]

Cassirer's exhibit of van Gogh established a name for the French-influenced Dutch master, with a pointed difference between van Gogh's Post-Impressionism and the Berlin Secession group: "Cassirer hung his Vincents *avant-garde* style, namely, against the stylish

walls of his gallery designed by Henry van de Velde, where the audience both screamed in horror and gasped in admiration."[202]

In buying van Goghs and selling them in Berlin, Paul Cassirer solidified a long-term relationship with Johanna van Gogh-Bonger based on trust and appreciation for avant-garde art, which was reinforced by the business ethics and temperament of Cassirer, which inspired confidence. Jo trusted Paul to such a degree that she allowed his cousin Bruno to publish van Gogh's letters in his journal *Aus der korrespondenz Vincent van Gogh* (*The Correspondence of Vincent van Gogh*) in 1904 and again in 1906.[203]

The success of Cassirer's early exhibition of Vincent van Gogh's works partly allowed Johanna and Johan Cohen Gosschalk to move into their big house in Bussum, Netherlands, in 1903, where she hung several of Vincent's paintings. Over the mantel hung *The Potato Eaters*. Across the room, over a cupboard, was *The Old Harvest*; over the doorway, *Boulevard de Clichy*. "In the corridor downstairs were Vincent's drawings of the courtyard of the hospital at Arles and the fountain at St. Rémy; in the bedroom the three *Orchards in Bloom*, the *Old Almond Blossoms*, the *Pieta* after Delacroix, and *La Veillée* after Millet."[204]

The house of Johanna and Johan was a veritable mini-museum of Post-French Impressionism. As the Paul Cassirer-led success of promoting van Gogh to the German market continued to grow through the decade, Jo van Gogh-Bonger struck gold of her own. She had continued her tireless quest to make van Gogh and his work known to the wider public, working galleries and art museums:

In this regard the three exhibitions of works by Van Gogh organized by the Rotterdam Oldenzeel gallery in January, May and December of 1903 were important. There, as early as in February of that year, the Utrecht cigar manufacturer, Gerlach Ribbius Peletier, bought the present painting ["Head of a Peasant Woman"] for 500 guilder.[205]

In 1905, Johanna exhibited 474 works from the van Gogh estate—paintings, drawings, and sketches—at the Stedelijk Museum in Amsterdam.[206]

━━━━

1901 was also a threshold year for Schuffenecker, perhaps more so than for Johanna Cohen-van Gogh-Bonger. Yes, she remarried and set her sights on the art markets in the north. But Emile Schuffenecker was the owner of eight van Gogh originals, one of those being the Final version of *Wheat Field with Cypresses.* And he did it with no money down.

At this time, you may remember, Schuffenecker was no longer working on his own paintings. In fact, he would create just one more of his own paintings in the rest of his life. Why? Was it because he was a third-rate artist? Was it because not a single art dealer would give him a "one-man" exhibition on his unspectacular paintings? Or was it that Emile knew his limitations as an artist and was considering other opportunities as he saw the market for French Impressionism and Post-Impressionism take off that year, letting Paul Cassirer and Johanna van Gogh-Bonger do the legwork to drive up the value of van Gogh paintings and spread the artist's fame through northern Europe and, a decade later, to America?

The answer to these questions is a blending of all three. Schuffenecker was an opportunist bent on making money. When the opportunity arrived in 1901 to exploit a hot rising artist, nothing would hold him back. The last painting Claude-Emile Schuffenecker created was in 1905; it was the pastel *The Tower.*[207]

That artwork was an island unto itself. It was painted a decade apart from his ninety earlier, nineteenth-century paintings, with nothing to follow until his death in 1934, or nearly three more decades. Given their less-than-impressive quality, Schuffenecker would have been truly forgotten had he not been called out as a forger after

his death in 1934, and again at the end of the twentieth century during the Van Gogh "Fakes Controversy."

Born and Landais, in their 2014 book *Schuffenecker's Sunflowers,* contributed to the controversy by showing evidence that the Yasuda *Sunflowers* was one such forgery. Born and Landais also convincingly argued that Schuffenecker had forged at least a half dozen other van Gogh paintings, one of which is hanging in the Metropolitan Museum of Art. The coauthors' evidence boils down to some paper-trail breadcrumbs, detailed research on the history of the players involved, connection of dots, and ultimately side-by-side comparisons of real versus fake van Goghs across at least a half dozen paintings.

It seems, however, that they did not address all the evidence—none of their claims, or those from the 1990s Van Gogh Fakes Controversy, or any other source, have ever debunked the authenticity of any of the three *Wheat Field with Cypresses* paintings.

And there is plenty of evidence to be found, which for *Wheat Field with Cypresses* goes beyond normal areas of circumstantial evidence and relies on the accumulation of facts and inconsistencies. There are certain special conditions in the history of this particular work, as discussed in Part II. The Saint-Rémy paintings suffered a different kind of physical deprivation and deterioration over the years, languishing in poor storage. Being rolled up, not stretched and dried properly, and then stored haphazardly in Theo van Gogh's apartment and then Père Tanguy's house, before FedEx, US and climate control existed, accelerated the aging of the National Gallery's version of the painting. The 1987 Leighton-Reeve Technical Report described the degrading process in a technical, scientific, unflinching manner.

And what about the Met's First version? Unlike the National Gallery, the Metropolitan Museum of Art has never made its condition report—aka technical report—public, not even under a Freedom of

Information Act request from Stephen Gregory, the publisher for the English edition of the *Epoch Times*, on behalf of this author.

In this age of transparency, the Met's version appears to have more secrets in the closet than a dirty politician.

But let us return to the condition of the painting. In the case of the National Gallery's *Wheatfield* canvas, the impacted impasto and structural cracking issues of the paint itself can, even today, more than 125 years after it was created, forensically demonstrate that the painting did indeed suffer those stresses, while the Met's version shows no such markings, cracking, or distress. It's as if the National Gallery painting had run the full twenty-six-mile New York City Marathon, crossing the finish line winded, tired, sweaty, thirsty, beaten, and exposed to the elements, while the Met version had trotted out of the Metropolitan Museum at Fifth Avenue on Central Park and jogged the last mile, crossing the finish line as fit and clean as if it had not run the race at all.

In 1901, the year when Emile Schuffenecker would have forged Vincent's work, the forger no longer could have had access to Tanguy's paints and the special, custom-made ground pigments he had created for van Gogh, since Tanguy died in 1894. Those would have been the lead whites, emerald greens, and hot yellows, special orders made only for Vincent and no other artists—not Monet, not Manet, not Cézanne, not Gauguin, not Pissarro. All three of those specific paint types and pigments were used in the authentic *Wheat Field with Cypresses* paintings.

20

Dark Provenances

In the summer of 2013, after contacting the curators at the Metropolitan Museum of Art and the National Gallery in London inquiring about their versions of *Wheat Field with Cypresses*, I was emailed a section of a book, *Masterpieces of Impressionism and Post-Impressionism: The Annenberg Collection*, co-edited by Susan Alyson Stein.

Stein had spearheaded the publication as lead editor in 2009. She is an expert on nineteenth-century European and Post-Impressionist art. I wanted to point out that the attribution for the description of the Met's First version of the painting was wrong, as noted in an earlier chapter; this took place two and a half years after I requested access to the condition report, which she refused to share or make public. (On the opposite end of the spectrum, the National Gallery couldn't have been more open. Its website link to the 1987 Technical Report is a way for all people—not just experts or journalists—who are interested in the painting to review, share, dissect, discuss, learn, and disseminate the details of a thorough scientific examination of the masterpiece.)

Let us turn to the paintings' provenance, however. When the descriptions of both paintings—the First and Final—were compared

side by side, serious questions arose about the identity of their own-
ers, the chain of custody of sales and purchases, and other historical
details.

The Met's *Wheat Field with Cypresses*'s provenance, as described in
Stein's book and other Met materials, went from the creator Vincent
van Gogh to his brother Theo; after Theo's death, the painting was
inherited by Johanna van Gogh-Bonger and her son Vincent Willem.
The Met claims its painting then sat idle for the rest of the 1890s. It
wouldn't be until a decade later that Jo van Gogh-Bonger sold it to
Emile Schuffenecker, along with seven other paintings. Schuffenecker
would hold onto the Met's painting until 1906 (not exhibiting it at
all after the 1901 Bernheim-Jeune exhibition), when he finally sold it
to Louis-Alexandre Berthier, Prince de Wagram.[208] The new owner's
name and title, Marshal Louis-Alexandre Berthier, matched that of
the chief of staff for Napoleon at the outset of the Italian campaign.[209]
Decidedly, the name comes from good family stock.

As stated throughout this book, the Met's version of the paint-
ing's provenance has several issues. In the van Gogh letters from the
summer of 1889, there is mention of a *drawing* of the *Wheat Field
with Cypresses*, but there is no evidence that van Gogh ever painted
the subject in those early summer months of 1889. Compounding
the issue, the Met claims that Theo became the de facto owner of
the painting when Vincent died in July 1890. That couldn't have
been the case either, since nowhere in the thirty handwritten pages
and 300-plus entries of the A. B. List can one find either one of
the interchangeable French names—*Cyprès aux Blés d'or* or *Blés et
Cyprès*. These were the two names used to refer to the Met's *Wheat
Field with Cypresses* in the 1901 Bernheim-Jeune show and later in
the 1909 Galerie E. Duret exhibition in Paris. Not a single entry
attributed to either name, or any other similar third name Andries
might have used to describe the painting.

Is this an omission? A landscape painting of such size and majesty
simply would not have been tossed aside, given away, or forgotten.

No. It would have been recorded, if the painting had been delivered to Theo and kept there as the Met claims. So was there ever a third *Wheat Field with Cypresses*? Probably not. The van Gogh letters interpreted by the online registry and Charles Moffett back in 1990 clearly only reference a drawing and two paintings, the Small and Final, sent to Vincent's sister and mother in Holland.

Even more peculiar was the lack of exhibitions of this painting after the radiant success of the 1901 Bernheim-Jeune Gallery show. Why would such a masterpiece not be put into art galleries or exhibits afterward to garner more interest, spread van Gogh's name, and drive up its value? Why would money-hungry Emile Schuffenecker not do anything with it until he sold it five years later? It's inconceivable.

The history of the National Gallery's *A Wheatfield, with Cypresses* is stranger still as it is described. Yet its physical characteristics—the impacted impasto, cracking, the stress of the paints and canvas being rolled and stored in less than ideal conditions—show that it is a real and original van Gogh artwork from his days in the South of France. The National Gallery's painting went from Vincent to Theo by way of the goods train to Paris in September 1890. Vincent's letter directed Theo to send both the big and little versions of *Wheat Field with Cypresses* to their mother and sister in Holland. That was what was supposed to happen. But did it? One couldn't make that connection from the National Gallery provenance.

That provenance goes from Vincent to Theo to Père Julien Tanguy Gallery, Paris, in 1890.[210] How did that happen? Why did it happen, if it happened at all? Yes, Theo stored and paid for storage on Vincent's growing oeuvre of paintings. And yes, Vincent directed Theo to give certain paintings to Tanguy, including one of the three portraits of him. But there is no record of *Wheat Field with Cypresses* being given to Tanguy in any of the letters. Moreover, if Tanguy had stored that painting, then it would have shown up in the list compiled by Jo and Dries after Theo's death in 1891. And since Tanguy

didn't store it, he had to have bought the painting from Theo. That's not what happened.

The big trouble with that possibility is that everyone has known, everyone has examined, and everyone has agreed that only one van Gogh painting was sold to a buyer during the life of Vincent. So a sale to Tanguy in the first seven months of 1890 could not have happened. Period. And it did not. After Vincent died, Theo took hold of his possessions in Auvers-sur-Oise and sent the belongings and the paintings, in particular, back to Paris under his watchful eye.

Therefore, that sale could not have taken place in August or September of 1890. When Theo's health rapidly declined and he had his psychotic break, for which he was sent to an asylum in his native Holland, no sale could possibly be transacted and left unaccounted for, since Jo and Andries had started the process of inventorying and accounting for all of the van Gogh paintings they owned and stored in France.

So it seems implausible that Père Tanguy or his gallery were ever the owners of any version of a *Wheat Field with Cypresses.*

According to the National Gallery provenance, Tanguy would eventually sell their version in 1901 to art critic, ghostwriter, pamphleteer, novelist, and anarchist Octave Mirbeau,[211] who seemingly sold it promptly after acquiring it. Mirbeau did, in fact, own a couple of van Goghs, including *Irises*, which was one of Vincent's first subjects painted in the garden at the asylum in May 1889. Mirbeau bought it in 1892, as he was one of the early supporters of the artist.[212]

In 1922, Mirbeau's critiques of the artist were compiled under the title *Des Artistes*, with a long remembrance of Vincent after his death. He concluded the piece on van Gogh with:

Oh, how he understood the exquisite soul of flowers: How delicate becomes the hand that had carried such fierce torches into the

dark firmament when it comes to bind these fragrant and fragile bouquets! And what caresses has he not found to express their inexpressible freshness and infinite grace?[213]

If Mirbeau had bought *Irises* in 1892 and kept it for the next thirteen years before selling it to Auguste Pellerin in Paris, then why would this early and enthusiastic supporter of van Gogh buy the National Gallery's *Wheat Field with Cypresses* in 1901 from Tanguy and immediately sell it to Alexandre Rosenberg, who in turn flipped the masterpiece to Bernheim-Jeune Gallery, Paris, all in the same year?[214]

It is quite strange that two *Wheat Field with Cypresses*, the Metropolitan's and the National Gallery's canvases—purportedly painted three months apart and sent their separate ways after reaching Theo van Gogh in Paris—are both lacking any trace of any paperwork, either in the van Gogh letters or the A. B. List catalogue book, that would reliably place them in Paris or even France during this time period. More interestingly, both of those paintings—if this detail is to be believed—randomly ended up at the same Bernheim-Jeune Gallery in 1901 via their two completely different historical routes. It was no coincidence, nor was it blind luck. What really happened was something different. Here's the most likely scenario.

Johanna van Gogh-Bonger retrieved the *Wheat Field with Cypresses* that had been gifted to Vincent's mother and sold that Final version to Emile Schuffenecker. The real painting was exhibited in the spring 1901 retrospective show and catalogued by Julien Leclercq at the Bernheim-Jeune Gallery, which ultimately bought and kept the London version—the real painting—until 1920, when it sold the masterpiece to Dr. Gustav Jebsen in Oslo, Norway. That painting, in fact, would not be shown in an exhibition until 1990 in Amsterdam at the Van Gogh Museum. Dr. Jebsen sold it to the famous Paul Rosenberg Gallery in London in 1923; it then went

to the Tate Museum and ultimately was purchased in 1961 by the National Gallery.[215]

During the time he was in possession of the painting, Schuffenecker had the opportunity to produce his own forged version, which would eventually end up at the Met. He then "sat" on this version until he felt enough time had passed since the 1901 exhibition and he felt comfortable selling it, in 1906. No exhibits of his own. No broadcasting or advertising that he was going to move his canvas. Just lying low, letting the van Gogh hype driven by Paul Cassirer in Berlin and Johanna Cohen-van Gogh-Bonger in Holland gain momentum.

Emile Schuffenecker had pulled off the perfect crime.

But then, Schuffenecker was only an investor, a minimal artist, and an opportunist. He wasn't a seer who could look into the future and predict that technology would allow the two paintings to be scrutinized in granular detail, that they would be examined in high-definition imagery an ocean of time apart, 24/7, from any online access point in the world. Nor could he have envisioned the van Gogh letters being put into a large vat of digital information, an online database where today, in the twenty-first century, anyone can pore over the correspondence and discover the insights that even Schuff would know little about.

Then again, he had made his money; perhaps he would not care.

21

Schuffenwreckers

Given that both versions of *Wheat Field with Cypresses*, those of the Metropolitan Museum of Art and London's National Gallery, had passed through Emile Schuffenecker and the first grand retrospective Vincent van Gogh exhibition, set up by the forger's friend Julien Leclercq, more experts should have looked at those two paintings and questioned their relationship and authenticity. The fact that they have never truly been examined, except at each of their respective museums, makes one wonder about the process of vetting a van Gogh.

To return to the idea of the National Gallery canvas being owned by Père Tanguy, let us look at the surviving records and beyond, to the man who owned his art-paint shop and gallery until he died in 1894.

With the A. B. List coming up empty for the painting, an entry of "cypresses" in the online Van Gogh Letters database reveals a dozen letters pertaining to the asylum period from June 25, 1889, when the drawing subject was first discussed, until the end of that year. Over those six months, there were twelve letters associated with "Cypresses" (from the *Wheat Field with Cypresses* title) and of those, only eight refer to the painting specifically.

The following are the letters from 1889 where the painting's name is found:

- 783—June 25
- 784—July 2
- 800—September 6
- 803—September 19
- 806—September 28
- 808—October 5
- 811—October 21
- 821—October 21
- 822—November 26
- 823—November 26
- 824—December 7
- 829—December 19[216]

That search also produces ten more letters from 1890 that relate to the word but do not link to the subject, extending to the end of Vincent's stay at the asylum and final months of his life at Auvers-sur-Oise.

Given that the written record comes up empty on anything having to do with the National Gallery's Final version being given or sold to Tanguy, who was the man Père Julien Tanguy?

In his book *Pleasure Wars: The Bourgeois Experience: Victoria to Freud*, Peter Gay provides insight into Tanguy's manner and personality, writing:

His large canvases sold for 100 francs and the small ones for 40—this was the tariff set by Julien Francois Tanguy, that hospitable, almost proverbially benevolent dealer in art supplies whom the Impressionists frequented in Paris. An average laborer, assuming he had any money for art, could have managed a small Cézanne for three, perhaps four weeks' work, but there is no record of any potential buyer from that class making his way to Tanguy's shop . . .

Père Tanguy was wiser than they; he took paintings in payment for the colors he sold to his impecunious customers. For years his unpretentious shop, crowded with artists who came to admire—at times to jeer—was the only Parisian gallery where Cézannes were on view.

Van Gogh more than once captured père [sic] Tanguy's benign, bearded face and stocky frame for posterity. Born in Brittany in 1825, an uncompromising political radical, Tanguy all his life skirted the edge of penury, working as a plasterer and after he moved to Paris in 1860, as a color grinder.

Theo paid Tanguy for the rare pigments and paints that he made and shipped down to Vincent, as the young sibling supported his older artist brother for years. That fact can also be found populating the van Gogh letters, stretching from Vincent's time in London, Holland, and down in Paris and the south of France. These payments show up in the account book that Theo kept, which included records related to Vincent's artwork and the dates and purchases of supplies. The book was then used by his widowed wife, Jo, for another decade after his death.

In 2002, the Van Gogh Museum made the account book of Theo van Gogh and Jo van Gogh-Bonger public for the first time. We can see the written records of purchases of supplies and, later, the monthly fees for storing Vincent's growing collection of paintings. Like the van Gogh letters, this too comes up empty for any gift or sale of the painting to Père Tanguy, so his shop and gallery can be ruled out as ever being the owner of the National Gallery's *A Wheatfield, with Cypresses* at any point in the 1890s.

Thus, all signposts point back to only one version going through Schuffenecker's hands in December 1900 after Jo van Gogh-Bonger's sale of eight paintings to the minor artist.[217] One *Wheat Field* painting was put on exhibit at Bernheim-Jeune, but two versions showed up after the exhibition and were sold five years apart.

Did Schuff need the thick imitation impasto brushstrokes to thoroughly dry? Did he want to age the painting a little bit before putting it on the market, the way the 1990s forgers of seventeen Jackson Pollock lost paintings accelerated that effect by making "the paintings look older with tea and dirt"?[218] Verily, tea and dirt existed in abundance in Schuffenecker's world in Paris at the turn of the century.

Speaking about a number of other paintings, authors Born and Landais noted in *Schuffenecker's Sunflowers*:

> The Berlin picture was nothing but a reduced copy, but Vincent's "Wheat Field with Reaper" also inspired Schuffenecker to do harvest scene "adaptions," which after the 1901 Bernheim exhibition, he successfully peddled as "van Goghs."
>
> It was a tall order for Schuffenecker to try to match Vincent's very yellow and very clear wheat field, his simple and beautiful motif. Not only would he never be able to share the intensity of Vincent's emotions and the depth of his thinking, but harvest scenes were just not his thing. He was, as Gauguin said, a denizen of Paris with little feeling for work in the fields.[219]

What the authors show is that the artist-turned-forger was already practicing the art of the con by the time the Bernheim-Jeune Exhibition went live in 1901, that he was already doing mockups of van Gogh-style landscapes, and that problems of copying van Gogh came down to the absence of Tanguy's paints, custom-made pigments that Schuffenecker couldn't reproduce at the turn of the century.

———

R. Alexander "Alex" Boyle—the son of a *Field and Stream* and *Sports Illustrated* writer, a marine who served in World War II and went on to found Riverkeepers, an environmental organization that set out

in the 1960s to keep big industry from polluting the Hudson River above New York City—didn't follow his father's footsteps into either journalism or the military. But Alex Boyle did take his passion and expertise for nineteenth-century art to the Hudson Valley. Boyle worked for the Metropolitan Museum of Art in the 1980s, and in 2002 he collaborated on a PBS art history film with Bill Moyers on an exhibition of Hudson Valley nature artwork at the Hudson River School, in which he "paired twenty famous Hudson River School paintings to images of the Modern Day."[220]

In examining the Met's *Wheat Field with Cypresses* from an artistic perspective, Alex Boyle has long suspected the painting is a forgery, albeit an old forgery.

In our discussion in summer 2013 about the likelihood of the painting being a fake, Boyle looked beyond the lack of "impacted impasto" and clear cracking that looked like a dry riverbed in the National Gallery version. He called out the amateurish shadow in the mountaintop of Les Alpilles, and the smeared brushstrokes of the clouds in the Met's canvas, which do not resemble the iconic swirls of van Gogh's Saint-Rémy landscapes, the halo-like stars in *Starry Night*, and the clouds in *Mountainous Landscape Behind Saint-Paul Hospital*.

During this series of interviews conducted over the phone and face to face in Westchester County, New York, Boyle said, "The Metropolitan Museum of Art example not only has zero 'impacted impasto,' in side-by-side comparisons to the London example it looks like a crude copy by another hand. Perhaps the work of Emile Schuffenecker was one guess. Fleeting cloud shadows in the UK work [*A Wheatfield, with Cypresses*] seem instead in the Met to sink like 'blue blobs' atop hills delineated if only by crude outlines; the differences in draftsmanship border upon the staggering."

Not content only with subjective issues (even though the brush-work is clearly vulgar by van Gogh standards), Boyle also said there was plenty of other evidence showing that painting to be a fake. (He

would end up writing about it, after this author published the article "Hacking van Gogh: Is the Master's 'Fingerprint' Missing from a Met Painting?" in the *Huffington Post* on July 10, 2013. Alex Boyle would publish his detailed exposé about the painting in *Art, Antiques & Design*, an online art magazine, on August 2, 2013, titled, "The Met van Gogh Story Trains Keep Rolling By.")

He also pointed out:

> Vincent's favorite color, emerald green, copper-acetoarsenite, a.k.a. Malachite, is one I am uniquely familiar with as a result of having co-authored a book on "Acid Rain" years ago. As Professor Richard Bopp of Rensselaer Polytechnic Institute explained to me when I asked him why copper gates dissolved around ornate marble mausoleums, or even in New York Harbor, the way the Statue of Liberty did (indeed to such an alarming state it was in dire need of its famous 1986 restoration), he said, "Alex, copper does not want to be a shiny brown piece of metal, it wants to carboxylate and turn into liquid green slag. In short copper in its pure form is unstable, and malachite (emerald green) is a transitional state en route to decomposing."
>
> Vincent's choice of his favorite green color and its eventual chemical fate is a part of how to determine if the one at the Met is right. I don't think it is, but given the exhaustive table of chemicals and elements Anthony Reeve listed in his 1987 Technical Report on the UK work, well maybe the Met has good reason not to show you what the one in New York is made out of. Not only is it in atypical condition, perhaps it is made out of entirely a different set of pigments.

Boyle then shifted to canvas types, pointing out that Vincent "experimented with different canvas types in his search for the one that absorbed well" after he primed the canvas with his lead white paint. "Vincent was dissatisfied with the local supplier, with the first

consignment of a finer type of canvas from Tasset et L'Hôte. In July 1888, he decided to work only on their Toile Ordinaire, which, with a few exceptions, he did until the end of his life," Boyle explained.

He added, "The Toile Ordinaire came shipped in a roll, in a raw state," with its thread count, or warp/weft, described in Van Gogh Museum van Gogh expert, Louis van Tilborgh, et. al.'s *Weave Matching and Dating of Van Gogh's Paintings: An Interdisciplinary Approach,* which explained in detail:

> The various types are distinguished by slightly different average thread counts (warp by weft) per square cm: 11.5 by 18 (fifty-six paintings), 11.5 by 17 (twenty-seven) and 12 by 15.5 (twenty-three). At present there are eight canvases with an average thread count of 11.5 by 15.5 per square cm., which could indicate the use of a fourth type of toile ordinaire from Tasset et L'Hôte. However, in view of the small number of works involved and the fact that the dates of execution extend over the period August 1888 to July 1890, we are assuming for the time being that the canvases actually belong to the match clique with an average of 12 by 15.5 threads per square cm, although they have not been counted among the twenty-three pictures in that group.[221]

"The funny thing about Toile Ordinaire shipped in rolls," Boyle continued,

> was that very state made it easier to take off the stretchers, once dry, roll right back up into a tube and ship the completed work north to Theo in a crate via rail post train, or as the French would say, *Chemin de Fer.* Tasset had other canvases with a higher thread count called 'Fine' and 'Très Fine.' Likely though, these had higher thread counts per centimeter, similar to a nice shirt that has been starched and pressed, must have been much more difficult to roll up, so there was a method to his madness as Vincent navigated

the logistical problems shipping completed canvases via French rail post. The Van Gogh Museum report has taken this analysis of fabric to such a level that they can identify which paintings in their collection were cut from the same bolt of fabric, which helps date a work to February 1890 in Saint-Rémy rather than an earlier erroneous description of June 1890 Auvers-sur-Oise, as was the case in one work cited.

————

The Van Gogh Museum has previously looked at Emile and Amedée Schuffenecker's restoration work and published its findings in the museum's 2001 *Journal*:

> They also retouched the edges and even added a wide strip at the top. Moreover, similar additions to the picture area are found in three other works from the collection of either Emile or Amedée: in the first version of van *Gogh's Daubigny's garden* (F 777 JH 2105), his *Portrait of Camille Roulin*, and in Gauguin's *Human miseries*. Altering the format of 19th-century paintings does not appear to have been common practice, but seems instead to have been a personal predilection of the paint-restorer's.[222]

Another van Gogh example they examined in the same report came from Schuffenecker's friend Julien Leclercq and was the Annenberg-acquired *Cypresses*, which the philanthropist donated to the Metropolitan Museum of Art after his death in 2002:

> Van Gogh's "Cypresses" (F 613 JH 1746), which belonged to Julien Leclercq, has a similar canvas addition at the top, with associated overpainting. However, in this case the addition is quite small, some 1.5 cm wide. More research is required to confirm that this addition is of later date.[223]

There was a story in 1934, related by the assistant of the renowned Swiss art collector Otto Ackermann—who attended the 1901 art exhibition in Paris and knew the Schuffenecker brothers—that in the autumn of that year, "Ackermann had brought together the pictures" for a van Gogh exhibition in Berlin,

> among them some were owned by Amedée Schuffenecker. When, at the time of the exhibition, he happened to visit Mr. Schuffenecker, he saw, hanging on the wall a repetition of one of the pictures that was in Berlin. When he inquired about its provenance, Amedée Schuffenecker explained that he had had the painting copied as a "souvenir," in case of a sale in Berlin! Supposedly the copyist of these pictures had not been the dealer's brother, the painter Emile Schuffenecker, as is often claimed today, but a young painter, who shortly after he had been involved in a court case took his own life.

Amedée's fairy tale did not convince Ackermann.[224]

22

Avant-Garde Berlin

According to the Met's provenance, as listed on its website, the timeline of ownership for the *Wheat Field with Cypresses* runs as follows:

1889: the painting is sent to Theo by the artist
1891–1900: the painting is sold by Theo's widow through Julien Leclercq to Schuffenecker
1900–at least 1901: Emile Schuffenecker
ca. 1906–1910: Louis-Alexandre Berthier, Prince de Wagram, Paris
1910: Paul Cassirer (sold to him through Galerie Barbazanges, Paris)
1910–1935: von Mendelssohn family, Germany, later Switzerland
1935–1951: von Mendelssohn family
1951–1956: Emil Bührle (to whom it was sold through Fritz Nathan by the von Mendelssohns)
1956–93: Dieter Bührle, Zurich

But is this timeline plausible?

The 100-year flood came to Paris on January 21, 1910, and the rain would continue to pour through January 28, with the River Seine cresting to a record twenty-eight feet above spring level.[225] The widespread flooding submerged streets, cafes, apartments, and offices. It forced citizens to walk on elevated wooden planks just to cross the street or travel down a long alley, using the sides of the buildings for balance and support. A photo of a policeman being ferried in a gondola-like boat with a bicycle made the scene look more like Venice than the City of Lights.

The only apparent good news came from the art world. Most galleries and museums of the day didn't have basements or at least didn't store the artwork in the cellars. In fact, Musée d'Orsay, the large museum that today runs parallel to the Seine and receives three million visitors a year, the third most in France,[226] didn't exist in 1910. At the time, that location belonged to Gare d'Orsay, a railroad station built between 1898 and 1900.[227] That January, the Gare station was flooded to street level, stranding commuters, yet not destroying works of art.

Emile Schuffenecker sold *Wheat Field with Cypresses* in 1906 to Louis-Alexandre Berthier, Prince de Wagram, who in turn would sell it to the Galerie Barbazanges, Paris. That took place in 1910, after the Great Flood of Paris, according to the Metropolitan Museum of Art's detailed provenance of the painting. But this timeline doesn't add up for several reasons.

The sale to the Galerie Barbazanges couldn't have taken place in 1910. Why? The answer is simple. The Galerie Barbazanges didn't open on 109, rue du Faubourg Saint-Honoré, until a year later, in 1911.[228, 229] The painting clearly couldn't have been sold to Galerie Barbazanges in Paris ahead of its 1911 opening, or to Paul Cassirer in Berlin in November 1910, or to Franz von Mendelssohn in December 1910—if these sales are supposed to have gone through the Galerie Barbazanges.

The bigger question is why the Metropolitan Museum didn't do the necessary research on the actual chain of custody owners of their First version, the way this author did, that would have uncovered the myriad inconsistencies with dates and timelines of who owned the painting and when. It could have been either in 1993, when the painting was bought by Walter Annenberg for $57 million and gifted to the Met, or five years later, in 1998, when then Met Curator Gary Tinterow—who was the point man for the Met in the late 1980s when it ultimately pulled out of exhibiting *The Passionate Eye* tour—was on a mission to resolve the "suspect" provenance of the painting.

What about a decade after that, when Susan Alyson Stein's team was doing the deep-dive research on who owned *Wheat Field with Cypresses*—and when, and where—for her co-edited book on the Annenberg Collection at the Met?

One must ask why so many art and van Gogh experts outside of the Metropolitan Museum didn't pick up the forgery before. Why is one version within the same series light years better than the other? If one of the paintings was supposed to be superior, one would think it would have been the earlier one from June 1889, since the *drawing* of same landscape was dead on in terms of detail and penmanship, since a great masterpiece, *Starry Night*, was produced while Vincent was confined to his bedroom at the asylum two weeks earlier, and since *Cypresses* and other great landscape "Wheat Field" paintings were done in the lead-up to that scene.

———

The history of Galerie Barbazanges began in 1911, when "Paul Poiret leased part of his property located on the Faubourg Saint Honoré 109 to his friend Henri Barbazanges"; "the Barbazanges Gallery for contemporary modern art started with money from L.C. Hodebert . . . Poiret spoke well, that he could hold two exhibitions a year."[230] The two exhibitions they did hold were in 1911.

Since Galerie Barbazanges couldn't possibly have purchased the painting in either 1909 or 1910, then who bought the painting during that time period? Did Henri Barbazanges buy *Wheat Field with Cypresses* and hold onto it for less than a year? It's possible. But why would Henri do that when he was going to open his own modern art gallery in Paris the following year?

Wouldn't Galerie Barbazanges need paintings, such as a few van Goghs, to fill the halls of the gallery with bold light and bright color that was avant-garde chic and had name recognition? Of course it would. Did someone tip off Henri that Schuffenecker was the quiet owner of the painting from 1901 to 1906, before selling it? It could have happened.

When it did open in 1911, Galerie Barbazanges, over the next fifteen years of its operational life, would cut a huge swath through the avant-garde art scene in Paris and in Europe as a whole. Henri's gallery exhibited Bernard Naudin and the Russian-Jewish artist Marc Chagall in 1924 with a retrospective exhibition of Chagall's magnificent works;[231] the year before Henri bartered Manet's masterpiece *The Old Musician* "in exchange for two other French paintings: a portrait by Camille Corot and a nude by Auguste Renoir."[232]

The idea of Paul Cassirer being the owner of the painting at some point does make sense, since he saw some version of that painting among van Gogh's dazzling, seventy-one-piece art exhibition in 1901 at the Bernheim-Jeune.

Naturally, it would be Cassirer, who had championed van Gogh's form of Post-Impressionism for a decade, who purchased it in Paris and took that painting back to his art gallery in Berlin, since the avant-garde art scene in 1910 had just taken off like a luminous streak of fireworks. It also makes sense that some art dealer, such as a Henri Barbazanges or some other Parisian gallery owner, had bought and sold the van Gogh "masterpiece" to Paul Cassirer in Paris in or around late 1910.[233]

At the start of the decade, Berlin was the fastest growing city in Europe. From 1871, when Vincent van Gogh was eighteen years old and still several years away from embarking on his career as an artist, Berlin's population exploded from 827,000 people to nearly 2.1 million people by 1910.[234] "Berlin also became the most important railway node in Europe with no less than twenty-two railway stations."[235] Prior to the start of World War I, Berlin had more than 100 daily newspapers, which seems an astounding flow of information in a pre-computer, pre-Internet, and pre-smartphone era.[236]

Berlin was hot. Berlin was the place to be. And its avant-garde wave of modern paintings began in 1910 and lasted until 1932, just as the Aryanization of Hitler's Germany descended on the populace like an icy mist of poison gas.

At the start of 1910, *Der Sturm* magazine was established, "devoted to promoting expressionist art; the term *Sturm* ("storm") soon assumed the character of a trademark. This kicked off the new age, the advent of modern art. Two years later, the Sturm Gallery would open in Berlin."[237]

The time, 1910. The place, Berlin. The nouveau city, coming of age amid its smoke-spewing factories, was the right place to be at the right time to sell a van Gogh or the work of any other major artist of the day. Paul Cassirer ended up selling the Met's *Wheat Field with Cypresses* to German-Jewish industrialist and banking magnate Franz von Mendelssohn in Berlin in December 1910. The art dealer owned it for less than a month, while he owned other van Goghs for years. Why? Did he, too, like a Parisian art dealer before him, notice an oddity about the canvas, something that told Cassirer that it was likely a fake?

In late 1910, Franz, together with his cousin Paul von Mendelssohn-Bartholdy, ran the most prominent private and oldest

bank in Germany, founded in the second half of the 1700s, when United States of America had broken off as a colony from England to become an independent country.

The cousins' business skills were only one trait of a talented and passionate family. Before them came world-renowned classical music composer Felix Mendelssohn. As Franz played the violin, so too did his children gravitate toward art and music.

An even more famous ancestor, who perhaps left an even greater impact, was the German-Jewish philosopher Moses Mendelssohn.

Born in 1729, a son of a Torah scribe, by his mid-twenties Moses befriended philosopher Immanuel Kant and journalist and playwright Gotthold Lessing.[238] Moses would publish books defending Judaism in print, yet at the same time use rational thought and reason to reform his religion to assimilate in Germany by recognizing "multiple religions and respected each one," as he wished to lift the Jewish people out of the ghetto.[239]

"Moses Mendelssohn not only set in motion the Hebrew Enlightenment of the 19th century, but his classic *Letters on Sentiment*—considered the foundation of German philosophic-aesthetic criticism—and *Phaidon,* about the immortality of the soul, proved that one could be both a practicing Jew and an enlightened German."[240]

From a robust family tree, with a mixture of solid business underpinnings, intellectual prowess, and an affinity for the arts, Franz and Paul were in a golden era during the rise of Berlin in 1910, an ideal time and place to operate, to lend money to entire industries, to network with business leaders, and to be the financial caretakers of tens of thousands of people, particularly Jewish citizens like them. While becoming rich, they tapped into that family vein of art and culture to become major buyers in modern art.

As they bought dozens of paintings well into the 1920s, Franz would own four van Goghs with "suspect provenance," as family heir and historian Dr. Julius Schoeps explained in a September 2013

telephone interview, while "Paul owned six van Gogh paintings with clear provenance." Dr. Schoeps's reference to "suspect provenance" has only one possible meaning. That one, two, three, or all four of Franz's van Gogh paintings were either faked or copied before 1910. The First version of the *Wheat Field with Cypresses* was one of those four paintings with suspect provenance, as the Met's former art expert Gary Tinterow admitted in his 1998 interview with the *New York Times*.

Today, Dr. Julius H. Schoeps is the director of the Moses Mendelssohn Center for European-Jewish Studies at the University of Potsdam and the managing director of the Moses Mendelssohn Foundation. Prior to that appointment, Dr. Schoeps was the first director and cofounder of the Solomon Steinheim Institute.[241] As a political scientist and Jewish historian, and heir to the Mendelssohn bloodline, Schoeps brought about a decade-long case in the US courts against the Museum of Modern Art (MoMA) and the Solomon R. Guggenheim Foundation in 2007: "The heir, Julius H. Schoeps, a grandson of one of Paul von Mendelssohn-Bartholdy's sisters, has claimed that two of the Picassos—*Le Moulin de la Galette,* done in 1900, and *Boy Leading a Horse,* from 1906—were sold under duress during the Nazi regime, and thus, belong to him."[242]

The lawsuits were an attempt to spur the museums to do the right thing and return the two priceless Picasso paintings that the Nazis had confiscated during the run-up to World War II, forcing Paul von Mendelssohn-Bartholdy to sell those artworks at below market value. Unfortunately for Schoeps and his family's esteemed legacy, on January 18, 2016, the US Supreme Court rejected the appeal to hear how the Nazis forced Mendelssohn-Bartholdy to sell the art amid the Aryanization of Germany in 1934.[243]

Those attempted "clawbacks" of artwork that belonged to the von Mendelssohn family took Julius Schoeps on a long, arduous journey through the US and German court systems to recover a total of

five Picasso paintings, while fighting powerful art institutions like MoMA, Guggenheim, and the Munich Museum.[244]

As was the case with the German Jewish art dealer Paul Cassirer, who would become very successful as chairman of the Berlin Secession, from 1912–1915, the Mendelssohn cousins would grow in wealth and fame in German society, as would their art collection. Franz, Paul, and their families would hit the apex of their lives in Germany in the late 1920s, as their nation was battered by the cold defeat in World War I and the hard reparations of the Versailles Treaty; the emergence from the defeat of war must have reminded them of their ancestry and the postwar rebuilding they did in their day. "Moses's eldest son, Joseph . . . [was] . . . responsible for managing France's reparations after the Napoleonic Wars, financing railroad development across Eastern Europe and controlling the Tzar's investments."[245]

Whatever optimism had swept through Europe in the 1920s, and with Germany climbing out of its inflationary death spiral, avant-garde art was still a hot investment for collectors looking to expand their collections in the Roaring Twenties. Being on the front lines of banking, dealing with businesses and citizens alike, must have forewarned the Mendelssohn cousins that dark clouds were forming on the nearby horizon that would soon loom over the art world, the Jewish people, and the continent.

23

Aryanization

The business partnership between art dealer Paul Cassirer and Johanna Cohen-van Gogh-Bonger dissolved at the start of the First World War, when Cassirer, the gifted director of the Berlin Secession, who had published dozens of translated van Gogh letters and acquired 151 works of art from the Dutch master, was called up to fight for his native Germany in August 1914.[246]

As for Johanna Cohen-van Gogh-Bonger, widowed a second time two years earlier in 1912, the same year the Titanic struck an iceberg on its maiden voyage and sank, she published the first volume of Dutch edition letters in the spring of 1914. The following year, she moved to New York and began translating van Gogh's letters into a fourth language, English.[247] "At her death, September 2, 1925, she had reached letter 526. She had been back in Holland since 1919. During her lifetime a second printing of the Dutch edition was required, which meant a great success for a small country; she rejoiced in it very much."[248]

Without Johanna van Gogh-Bonger's passion and dedicated work ethic, Vincent van Gogh might have become an overlooked relic of the nineteenth century. Together with many art dealers, especially

Paul Cassirer and later on collectors, "such as Helene Kröller, a wealthy art history major from Essen, and an American born pharmaceutical magnate, Alfred C. Barnes, the first American to own a van Gogh,"[249] she spread the iconic talent and daring artwork of her late brother-in-law in Europe and across the Atlantic.

A year after Johanna's death in 1925, workaholic Paul Cassirer's relationship with his wife had come to an end. The one work of art he didn't attend to, the relationship with his wife, left him heartbroken, at a loss. He committed suicide in 1926.[250]

With the deaths of Jo van Gogh-Bonger and Paul Cassirer, the experts who could have identified a fake van Gogh were gone. Thus, the timing of the Otto Wacker affair—the first of two van Gogh fakery scandals—is an event of historical significance. For someone to come out of the woodwork in 1926 with thirty-three never-seen-before ("new") van Gogh paintings—purchased by a secret "Swiss collector"—the timing was either miraculous or planned by design.[251]

Otto Wacker was a working-class son of Hans Wacker, an artist, who grew up in Berlin. Otto's brother Leonhard was a restorer of paintings and had his own art studio. Like Vincent van Gogh, who failed at most professions during his young life before becoming an artist, Otto also dabbled unsuccessfully in several professions, from cabaret singer to dancer, using the alias Olinto Lovael. In 1925, Otto apparently found his calling as an art dealer in Berlin. That was the same year that Johanna van Gogh-Bonger died and Paul Cassirer's marriage unraveled, leading to his death the following year.

Otto Wacker needed the real experts dead. He got them. All that was left was a group of wealthy collectors owning dozens of van Goghs, but no real experts other than Emile Schuffenecker. The collectors couldn't tell the difference between the artwork on a German marc and the swirling impasto strokes that vibrated a halo of light around Venus in *Starry Night*. Or so Wacker believed.

In putting on a van Gogh exhibition with the "new" paintings in 1927, Otto had sent a dozen paintings—about a third of the new, out-of-thin-air van Goghs with no provenance, other than a claim of their coming from a secret Russian collector through a more private Swiss one—over to the Paul Cassirer Gallery. It was the first of several of Otto's miscalculations. During the unpacking of those canvases, Cassirer's team of trained artists had become familiar with Vincent van Gogh, since the Dutch painter had been famous in Berlin since 1912. Despite Paul Cassirer's death a couple of years earlier, his employees knew the artist and the Post-Impressionist style, brushwork, and techniques, and thus were able to see suspect paintings stand out from real ones at first glance. In pulling out five of the first nine paintings, Cassirer's team noticed something odd. The handful of paintings looked as if several different hands had painted them, with at least one of them being a poor copy of a real van Gogh.

Otto Wacker had created his own trap, instead of buzz for a new Vincent van Gogh exhibition. The market for van Gogh paintings, among others, was red-hot in Berlin. But there still were enough people in the know, in addition to the Cassirer team, who were alive and had insight on the Dutch master, and who had attended enough past exhibitions that might question the provenance on some, if not all, of the thirty-three paintings exhibited.

As fate would have it, the day before the exhibit was set to open, a second major question on the authenticity of the new van Goghs emerged. Twenty-nine of the thirty-three "new" van Goghs hung on the walls of the gallery. The remaining four paintings were placed on the floor in front of the wall they were supposed to hang on. Timing was Wacker's strategy, but it wasn't on his side. Had those four van Goghs been delivered earlier, and had they already been hanging on the walls alongside the other 29 paintings, perhaps Otto Wacker would never have been caught. But fate had other plans.

The Wacker bust went down as follows:

When the last four arrived, they were placed next to their assigned positions on the floor. At that moment, Grete Ring, the general manager, saw the paintings and stopped dead. Something about them didn't look right. Could these pieces be forgeries?

Ring and Walter Feilchenfeldt, the managing director of the firm holding the exhibit, agreed that all four were fakes. The paintings were removed from the exhibit just in time. But then, Ring and Feilchenfeldt wanted to take a closer look at the other 29 paintings.

For the next 5 years, art experts, art dealers, museum curators, and others carefully studied the 33 paintings attributed to van Gogh. In 1932, Wacker was found guilty of fraud and sentenced to 19 months in prison.[252]

As in most countries, then and now, the long arm of the law moved slowly. The police would end up raiding Wacker's studio and confiscating the artwork in late 1929. It would be another three years before Otto Wacker would go to trial for the forgeries.[253]

An account of the trial stated:

Otto Wacker had tried various professions before becoming an art dealer in 1925. He succeeded in establishing a sound reputation with dealers and experts in the Van Gogh field, and De la Faille and Meier-Graefe constantly stressed their faith in his integrity.' Grete Ring, one of Paul Cassirer's closest business partners, puts the time much earlier: 'One day, a youthful dancer, Olindo Lowael [sic], alias Otto Wacker, the son of a Düsseldorf painter, made his appearance in the Berlin art trade. At first—it was around 1922—he offered relatively small dealers comparatively modest pieces, works of the Dutch and Düsseldorf schools, and sometimes major works, an Israëls, an Achenbach, Schuch, Uhde, Trübner.[254]

Art experts during the trial and since then believed that Otto's brother Leonhard had painted most, if not all, of the forgeries.

Like Amedée Schuffenecker, who switched careers midstream, Otto Wacker jumped on the bandwagon of the easy-money, parasitic salesman-cum-art dealer, not to find his passion but to exploit an opportunity in a hot bubble market that would have brought huge profits—had he not been caught.

The 1932 Wacker Trial marked the end of the German avant-garde era. The rise of Nazi Germany and its Aryanization of the country that year saw the death to modern art. Adolf Hitler, the leader of the Nazi Party and future chancellor of Germany, made sure of that, since he was attracted to Greek and Roman classical art from the past.

Hitler and the Nazis rode on the coattails of reelected German President Paul von Hindenburg on March 13, 1932. In the Weimar Republic, under its system of political rule, Hindenburg was forced to reluctantly appoint Adolf Hitler as the chancellor of Germany.[255] The fateful decision set in motion the Aryanization of the country; Hindenburg would soon regret his catastrophic decision.

In 1933, the first wave of anti-Semitic laws took effect. Jewish students were barred from several schools and colleges, Jews were barred from state service positions, and Jewish lawyers and Jewish tax consultants were either diminished or had their licenses revoked.[256]

The Nazis would also implement laws that would remove Jews from offices and board seats in public companies, institutions, and banks. That was the first step to liquidate the financial assets and holdings of the banks. Franz and Paul's Mendelssohn and Company bank sat at the center of the bull's-eye for the Nazi Party, which would plunder their assets like wild dogs over the next five years: "Nazi policies to eradicate Jewish-owned banks and bankers had reduced his [Paul's] income to only about fourteen percent (14%) of what it had been only two years earlier and . . . [f]aced with escalating Nazi predation directed at his real estate property—and with no reasonable expectation of receiving any sustainable future income from Mendelssohn and Co.—in October 1934 Mendelssohn-Bartholdy began liquidating his

singular private modern art collection to protect his residual estate from Nazi seizure and to offset his precipitate deficit."[257]

The same hard blow struck Franz von Mendelssohn. When his financial transactions became frozen, artwork was used as trade for money, services, goods, food, and for some family members provided a chance to flee as the Nazi seizures of Jewish property ran unchecked and unabated.

Forced to make some difficult choices for their families leading up to World War II, Franz and Paul began to figure out which paintings to keep and which ones to sell (at below-market value) in order to survive.

———

In his 2006 memoir on the von Mendelssohn family, *Looking Back,* Fritz Kempner, a cousin of Dr. Peter Witt, who was a grandson of Franz von Mendelssohn, wrote about his travails in surviving after the fall of Germany to the United States and Russia in Berlin at the end of World War II on the European continent:

> When I drove up to this Shangri-La in my Army jeep in the middle of a fine day in July 1945, I had no idea what I was going to find. A farmhand directed me to the manor house, a two-story modern stone building occupying one side of a huge yard. Upon entering by the front door I found myself in a large vestibule with a marble floor, an open stairway to the second floor and on the wall—to my amazement—both a Van Gogh and a Cézanne that I recognized from my grandparents' house in Berlin. Leading off the vestibule were four wooden doors, all closed, suggesting secrecy. I had a flash recall that Germans keep interior doors of private houses closed. With a pounding heart I opened a door closest to the sound of people talking. For a moment there was total silence as they were wondering what this soldier was doing interrupting their lunch and I was staring at them, looking for a familiar face. Out of the crowd

of some fifteen people I suddenly recognized my mother's sister and said: Tante Emma (Witt), Fritz Kempner.

I shall never forget the shouts of joyous recognition that this simple statement elicited.[258]

Coming to that farmhouse and reconnecting with family members was only the first step in rebuilding one's life. A country like Germany that was going to rebuild, deal with food rations, and bear the fallout of war was no place to begin a new life. Since Peter Witt was young at the time, his life and career lay in front of him—but he had to get educated first.

In 1949, Dr. Peter Witt, together with his new wife, would take *Wheat Field with Cypresses*, along with twelve other von Mendelssohn-owned paintings, over the German border near their summerhouse into Switzerland, as Dr. Witt's daughter Elise Witt recalled in a 2013 telephone interview, adding, "He was going to start a family." Emil G. Bührle acquired the painting soon after.

In 1998, articles in the *New York Times* and *Wall Street Journal* noted the provenance issues of the Met's recently acquired van Gogh, a part of Walter Annenberg's 1993 donation. Was the landscape painting stolen by the Nazis and used as barter with arms dealer Emil G. Bührle during the war, some wondered. Finally, the Met's Gary Tinterow was able to reach out to the heir of Franz von Mendelssohn, Dr. Peter Witt, who would become the missing link in the story of what had happened to the van Gogh masterpiece during and right after the war.

Dr. Witt and Gary Tinterow spoke by telephone. Tinterow asked Dr. Witt, who lived in North Carolina at the time, to come to New York City, offering to take him out for lunch to hear his story. But that day never came to pass, since Peter Nikolaus Witt would die later that September.[259]

Dr. Witt represented the intellectual side of the Moses Mendelssohn triangle of family traits: talent, business acumen, and philosophy. After the war, he would coauthor and produce more than 150 studies, most of them on spiders and their webs, from the "possible genetic component in web building" to LSD's alteration of web-spinning spiders. His talent didn't go unnoticed; he was recruited, rumor has it, by the predecessor of the Central Intelligence Agency. By the late 1950s, Dr. Witt took his family to America, where they settled in the south, and he continued his research.

Wheat Field with Cypresses was one of sixty paintings in the Franz and Paul von Mendelssohn collections. But unlike three-quarters of the artwork, *Wheat Field* was never used as barter for goods or money—at least the cousins didn't lose or have to sell all of their artwork.

It's a marvel that the heirs kept the remaining paintings out of the hands of Nazi General Hermann Göring and his lust to loot European-master art from Jewish art dealers and compromised art collectors—all despite Adolph Hitler labeling the French Impressionists and Post-Impressionists "degenerate art."

Paul von Mendelssohn-Bartholdy would die in May 1935 at sixty. The liquidation of the fifth generation family bank, Mendelssohn and Company, was too much for him to bear. One month later, Franz died in Berlin. He was seventy years old. He, too, could be said to have died of a broken heart.

They both were consumed by a Germany they no longer recognized.

The deaths of Franz and Paul von Mendelssohn and the takeover four years later of their banking dynasty foreshadowed horrific days for German-Jewish people.

24

A Deal with the Devil

Before Emil G. Bührle enriched himself with the spoils of war, purchasing the majority of his art collection (including *Wheat Field with Cypresses*, acquired from Dr. Peter Witt) right after the European conflict up until his death ten years later, the richest man in Europe during World War II was a major armament manufacturer supplying both sides with arms and munitions.

Because he was operating out of neutral Switzerland, Bührle's business-first approach allowed him to not choose sides during the fighting. Like many people at the start of World War II, he didn't know which side would come out victorious. Would it be Hitler's Germany? Stalin's Russia? Or America and its allies? Without choosing sides, Bührle kept his German roots in check while the "Brown Sauce" poisoned German citizens and troops with nationalist fervor, exploited by Adolf Hitler.

Emil Bührle focused on enriching himself at the expense of others, no matter the moral implications, blood spilt, or lives lost. In the end, it didn't mean anything to him, as long as he and his family business survived and kept growing. But few people really knew who Emil Bührle was and whether he looted art from Jewish art

dealers, owners, or collectors. That would only become clear in the years and decades after World War II, when the CIA declassified "Project SafeHaven."

The secret US operation to track Nazi gold after the war was first revealed to the public in the mid-1990s, though rumors had existed for years. With the declassification of "Project SafeHaven" came Switzerland's own end-of-the-century investigation into such war crimes. Switzerland launched the Independent Commission of Experts (ICE), which published its final report in 2002. That, in turn, led to the Simon Wiesenthal Center's publishing its 165-page report on the Nazi looting of art—*The Hunt Controversy: A Shadow Report*, researched and written by Erin Gibbons in 2006.

Not one of those documents painted a favorable portrait of Bührle. That led to a change of perception—some of the paintings in the arms manufacturer's possession were not just "suspect"; they were also "tainted."

From the ICE report, it is crystal clear which company dominated business in "neutral" Switzerland over the five years of the war. Oerlikon-Bührle & Co. had 490.5 million francs in export permits; the next closest company, Tavaro SA, Geneva, brought in one-fifth of that amount at 105.6 million francs. To give real perspective on how well Bührle's company did during the war as an arms supplier, it suffices to mention that it outperformed the next thirty-eight companies on that list combined, including Tavaro, which cumulatively grossed 455.5 million francs, or 45 million francs less than Oerlikon-Bührle's dominant, monster-sized company.[260]

But when Oerlikon-Bührle, Switzerland's largest arms exporting company, went on the record long after the war stating that its annual reports went missing from 1939 to 1945, the entire duration of World War II, it showed that Emil could still cast a long shadow over his company a half-century after his death.[261]

In its investigation of the looting or buying of stolen European art during the war, the ICE Report raised several issues with Emil G. Bührle. In Table 9, "Restitution claims involving cultural assets before the Chamber of Looted Assets," it pointed to the Vincent van Gogh drawing, *Paysage—Landschaft* in German, *Landscape* in English—as being looted during the war from Alexandrine de Rothschild, perhaps the only family with more combined wealth than Emil Bührle. It was taken from Alexandrine de Rothschild's home on 2 rue Léonard de Vinci, Paris, by agents of Hermann Göring during the war, who sold it directly to Emil Bührle.[262]

The date of action in Switzerland for that drawing was November 13, 1947; the restitution of the object "as per judgement" came the following year, on July 5, 1948.[263]

Bührle, as the three investigations would show, was no saint. In fact, he was a known buyer of looted Nazi art.

Could Vincent have imagined that one of his masterpieces would run through two world wars? Or that the biggest European arms dealer after the war would own one version, some version, of his magnificent *Wheat Field with Cypresses* landscape painting?

In the Simon Wiesenthal Center–sponsored report, an entire chapter—"Herr Buhl and his associates in Lucerne"—was dedicated to Emil Georg Bührle. Herr Buhl, whose identity remains otherwise elusive, was identified as an art trafficker who both sold and commissioned a number of forgeries during the war. The report rhetorically asked whether this Swiss art dealer's name, "Herr Buhl," was in fact mistranslated from the original source material by Irish military intelligence officers.[264] With clues such as "an unreliable dealer who sells forgeries," who isn't a "prompt payer in money matters and is unreliable as well,"[265] one starts to see Buhl as Bührle when all of his other moral, ethical, greedy, and power-hungry issues are looked at in concert.

Another thoroughly researched, well-documented source points to the Göring-Bührle connection of stolen Nazi art. It comes from

the 2013 book *Hermann Göring and the Nazi Art Collection,* written by Kenneth Alford:

> Three French Impressionist paintings were also included as well two or possibly three pictures bought by the Swiss arms manufacturer Bührle from Dequoy in Paris.
>
> Wendland claimed to be unable to remember the method by which Bührle's pictures were transmitted so conveniently from Paris, but it is possible that Wendland had begged this favor his good friend and powerful protector [Göring.]
>
> When the Impressionist pictures arrived in Lucerne late in 1941, Wendland noted that four of the finest pictures he had chosen were missing.
>
> In 1943 Wendland accompanied Bührle and a Zurich lawyer to a bank vault in Zurich for the purpose of viewing some paintings, which according to the lawyer who was the custodian of the key of the vault, were being offered for sale by a Dutch firm.
>
> The paintings were recognized by Wendland as the four missing paintings which were supposed to be adorning Göring's bedroom walls, as he advised Bührle against buying them.
>
> Göring himself never went to Switzerland. Hofer and Angerer were the only two agents active there and, of the two, Hofer was the more significant as he had lived there and was closely associated with the two most important figures, Fischer and Wendland.[266]

After the war, Hermann Göring was tried and sentenced to be executed at the Nuremberg Trial for war crimes against humanity (he committed suicide on the eve of his execution). With the loss of Göring, Emil Bührle needed new agents to search, locate, and secure the best artworks across Europe. (After the war, only seventeen art historians emigrated to Switzerland, while the rest of the experts left Europe and emigrated abroad, about 85 percent of the total before the war. Among them was Paul Rosenberg, who moved to New York City.)[267]

Dr. Fritz Nathan, one of the leading Jewish architects before the rise of Adolf Hitler, moved to Holland, the land of van Gogh, in 1938.[268] He would become the de facto go-between on several acquisitions made by Emil Bührle after the war, since art deals between wealthy buyers like Bührle needed a trusted broker, a middleman who would find the sellers, vetting the works of art for sale, their condition, the names of the artists, whether the paintings were authentic or crude forgeries, and whether there was a paper trail of past owners.

Dr. Fritz Nathan would represent Dr. Peter Witt on more than one sale, with Nathan's name on the Met's provenance and not that of Peter Witt himself.

———

As discussed earlier, Peter Nikolaus Witt, the Mendelssohn family heir, carried Schuffenecker's *Wheat Field with Cypresses* across the Swiss border to freedom in the aftermath of Nazi Germany. His scholarship eventually enabled him to move to America, which he saw as the land of opportunity. In order to move his family there, he needed money. It so happened that both he and Emil G. Bührle, whose wealth and love of art were well known, lived in Switzerland.

In 1951, Peter Witt gave two inherited Vincent van Gogh paintings to Dr. Fritz Nathan to broker a sale to Bührle: *Blossoming Chestnut Branches*[269] and the well-traveled *Wheat Field with Cypresses*.[270]

In the 1998 interview with the *New York Times*, in the months before his death, Dr. Witt revealed his reason for selling the van Goghs: "'We needed money, and he was the only person who had the cash in his pocket,' Dr. Witt recalled. He said he could not remember how much Bührle had paid, except that 'it was quite a large sum.'"[271] That "large sum" of money allowed Peter Witt to leave Europe with his family and continue his stellar career for the next three decades.

As for Emil G. Bührle, he got what he wanted—more price-less van Goghs—for what would become easily the best and most impressive private collection in Europe, as Charles Moffett, Walter Annenberg, and NGA Director J. Carter Brown would see first-hand. But without the expertise to detect a forgery or the ability to identify the real version by comparing and contrasting the condition and quality of the different versions of *Wheat Field with Cypresses*, Bührle had no idea that he had been sold a forgery. There was no way of telling.

Visiting the E. G. Bührle Foundation online, one reads that the arms dealer to the Nazis had bought three-quarters of his vast col-lection of artwork from 1951 to 1956. Not a bad haul for the start of the Cold War. Did he really do that? That would have been 75 percent of the final tally of 155 paintings, two gothic altarpieces, and two dozen medieval sculptures. With a grand total of 181 works of art, it meant that he had purchased 136 of those pieces over the scant last six years of his life. The more likely scenario is that Bührle acquired most of his paintings during or right after the war. And just like the Oerlikon's financial records, which magically disappeared, any records Bührle might have kept on the purchase, barter, or theft of the paintings were long gone.

25

The Holocaust Clawback

On September 18, 1946, the US Office of Military Government for Germany, Economics Division, Restitution Branch Monuments, Fine Arts, and Archives Section, together with the US Art Looting Investigation Unit (ALIU) in Washington, released a detailed report on art dealer Dr. Hans Adolf Wendland. He was a key figure in Nazi-looted art during the war and was connected to the regime. Knowing this, the ALIU team knew it would be imperative to interrogate him if they were to swiftly and successfully recover the art stolen from mostly Jewish dealers, owners, and collectors after the war.

In September 1946, ALIU investigators brought in Dr. Wendland and interrogated him over a ten-day period. During those grilling sessions, they uncovered his ties with Göring art spook Hofer, stating he was part of a

> complex web of art looting and acquisition spun by the Nazis, the most important German figure whose base of operations was a neutral country—Switzerland. He was one of the most agile and informed contacts of Walter Andres HOFER, "Director of the Art

Collection of the Reichsmarshall." He figured, whether wittingly or not, as the receiver of confiscated art in the first exchange of paintings from French private collections effected by the Einsatstab Rosenberg, and subsequently participated in three other exchanges with GOERING's agent, playing an important role in the importation of these works of art into Switzerland.[272]

The declassified brief went on to state, "Wendland was arrested in Rome by the American Forces on July 25, 1946, at the request of the American Legation, Berne." He was subsequently sent to the Wannsee Internment Camp near Berlin.[273]

During the joint interrogation, Wendland admitted that he had become a "moral outcast in Switzerland" and that he feared to be linked in a deeper investigation with Theodor Fischer of Lucerne.[274] But he and Fischer had met in Berlin in 1920 as part of the rising avant-garde art scene, even as Germany was licking its wounds from the fallout of World War I.

Before and during the war, Theodor Fischer was one of the greatest and wealthiest art dealers in Switzerland. "In an auction in June 1939 in Lucerne gallery owner Theodor Fischer auctioned approximately 125 paintings and sculptures by great modern artists such as Picasso, Braque, Van Gogh, Klee, and Kokoschka."[275] ALIU investigators were keenly aware that Hans Wendland and Theodor Fischer knew each other as far back as 1920. With that insight, the ALIU investigation continued to challenge Wendland's assertion that he was merely a "consultant," that he aided Jews, and that Fischer did not incorporate his business until January 1, 1945.[276]

ALIU came back and laid out the facts to Dr. Wendland, pointing out that he had traveled to France six times between 1941 and 1943. The first trip was to secure his belongings, which had been blocked; he admitted to making three trips "between occupied and unoccupied France during the occupation."[277]

In the fourth section of the ALIU report, "Business Ethics," Wendland admitted to producing false receipts and then submitting them for payment that would be made by Hofer to him—a clever trick for the books. Some of those paintings sold by Wendland to Hofer would find their way into the hands of Hermann Göring. Those receipts enabled Hofer to receive payment from Göring in Swiss francs, which he would settle for French francs.[278]

ALIU's probe further uncovered that in the first exchange with Herr Hofer, "the chief reason for the exchanges on Göring's side was the lack of foreign currency." The investigators could then connect the dots from Hans Wendland to Herr Hofer; from then, the looted art made its way into Göring's hands or to Emil Bührle by way of Dr. Fritz Nathan, who as far back as 1942 was already the arms dealer's art advisor and specialist on modern art. [279]

The ALIU report also delved into the "Four Missing Pictures" that were supposed to hang on Göring's bedroom wall, but somehow ended up with Emil G. Bührle. They included van Gogh's *Landscape* drawing (*Paysage, Landschaft*), his painting *Green Wheat Field*, Jan Steen's *Marriage of Cana*, and a pair of Cézanne portraits, Nos. 67 and 69, all on the Allied list of looted artworks.[280]

Why was this important? It showed the line from Wendland-Hofer through Nathan to Bührle as a long-established conduit for looted art during the war. It becomes clear why Emil Bührle destroyed his company records of business transactions, cash flow, and account balances from 1939 to 1945. Had those records ever been found by ALIU, Bührle would have certainly joined Hermann Göring at Nuremberg. Had that happened, who knows where Peter Witt's version of *Wheat Field with Cypresses* would have ended up— perhaps somewhere other than hanging in the hallowed halls of the Metropolitan Museum of Art in New York.

The ALIU report concluded with the personal assets and property that Hans Adolf Wendland owned, might have owned, and might have hidden in stealth bank accounts in Switzerland.

Had brothers Vincent and Theo van Gogh, or even Jo van Gogh-Bonger for that matter, been around in the aftermath of World War II and borne witness to the wholesale destruction of a race of people, its rich culture and heritage, they would have been repulsed. It would have especially disturbed them that at the center of the shadow market of financing the war was the stolen art of Vincent and his Impressionist brethren from the 1880s into the early decades of the twentieth century.

It wasn't until the mid-1990s, four decades after the war ended, that the clawbacks pursued by the likes of Mendelssohn family heir Dr. Julius Schoeps began to track the fates of the missing heirloom artwork sold under extraordinary duress during the Nazi liquidation of Jewish-run and Jewish-owned businesses in Germany before the war, and in the occupied countries of Western Europe, particularly France, during the war. The rapid growth of the World Wide Web had accelerated the ability of the families whose art was looted to communicate more globally, doing quicker and deeper research that simply wasn't available in the 1960s, 1970s, and 1980s.

The Internet explains why many of the court cases and legal challenges are still being heard in 2016, especially since it takes such a long time for cases to be heard, decisions to be made, appeals filed, and so on, going up through the higher courts both in the United States and Germany, among other European nations where the victims lived and operated their art galleries.

It also explains why the Simon Wiesenthal Center, with its 2006 report on Nazi-looted art, continues the fight for restitution, and why Jewish organizations forced Switzerland to finally act, not just on the art theft front with the 2002 ICE investigation report, but also through the courts and the United Nations to expose all the secret Swiss bank accounts and Swiss banks and other institutions that aided the Germans during the war by hiding, fencing, and financing stolen property.

On Monday, November 30, 1998, the US State Department and the US Holocaust Memorial Museum held a four-day summit— the Washington Conference on Holocaust-Era Assets—that focused on Nazi-confiscated art during the 1930s and World War II. The "government-organized, international meeting of forty-four govern- ments and thirteen non-governmental organizations (NGOs) . . . sought to address the issue of assets confiscated by the Nazis during the Holocaust (1933–45), specifically art and insurance, as well as communal property, archives and books, and to conclude any re- maining gold issues."[281] It was built off the success of the London Nazi Gold conference, which had been held the year before.

The Holocaust-Era Assets conference developed eleven guiding universal principles, though admitting that many of the speakers in attendance, from the United States to France, Germany, and East- ern European countries, operated in different legal systems. [282]

Dr. Konstantin Akinsha, Research Director, Project of Docu- mentation of Wartime Cultural Losses, United States, opened his session by stating:

> The establishment of different databases, collecting information about art works looted during WWII, is now a popular topic within the circle of scholars and representatives of organizations and groups involved in the search for the "disappeared" cultural property of the victims of the holocaust. There are many plans and ideas to create a "total" database, which will include all possible claims and informa- tion about nearly every artwork looted during the war. Unfortu- nately, such an undertaking doesn't appear very realistic.

In 2010, German authorities intercepted an elderly man, Cornelius Gurlitt, on a train from Zurich to Munich. He was "carrying a large amount" of cash on him, so they went to his apartment and found

more than 1,000 works of art by Chagall, Renoir, and a missing Mat-
isse—*Seated Woman*—stashed away. The combined value of the art-
work exceeded $1 billion. What was an old man, living in apartment
that resembled a hovel, doing with a trove of missing World War II
pieces of art with a value more than that of the building block he lived
in? It turned out that his father had worked as an art broker for the
Nazis.[283] *Seated Woman* was a painting that had belonged to art dealer
Paul Rosenberg before he was forced to flee from the Nazis, leaving
behind his art. Rosenberg would subsequently spend years trying to
recover the pieces that were looted, and his story is just one of many.

There would be subsequent conferences that were born out of the
1998 Holocaust-Era Assets summit, including a four-day confer-
ence held in Prague in June 2009, which produced a report of over
a thousand pages on the proceedings, and a Milan conference in
2011, carrying the title of Restitution Experience Since The Wash-
ington Conference (1998), which discussed major achievements
since that first summit and what the updated "Washington Prin-
ciples" called "provenance research on national collections" for the
more than forty participating nations.[284]

At the 2009 conference in Prague, in a story called "Retaining
van Gogh," it came to light that a New York City attorney had sent
a letter to the Detroit Institute of Art (DIA) about Vincent's Saint-
Rémy painting *Two Diggers Among Trees* (December 1889), which
was transferred from the estate of art collector Robert Hudson Tan-
nahill in 1970 to DIA. The letter went on to explain that the paint-
ing, along with one other van Gogh, belonged to the estate of Mrs.
Hugo Nathan (no relation to Dr. Fritz Nathan), as she was forced
to sell it in the liquidation of her assets by the Nazis in 1937, all
because she was Jewish.

As of February 2016, van Gogh's *The Diggers*, as DIA calls the
painting, can still be seen at the Detroit Institute of Art.[285]

More problematic than the resolution of a single particular
case is the entrenched mentality, the human keeper mentality, the

mentality that led the Germans and the Soviets to fight over every brick of Stalingrad to produce a bloody stalemate. In other words, the behavior of the museum heads to choose to fight, in most cases, rather than to resolve many of the provenance and restitution issues. The authors of "Retaining van Gogh" wrote about the issue:

> Our research team repeatedly found the keepers of various archives unwilling to accommodate them, or willing to respond to only the most tightly focused enquiries, behavior that reinforced the need for regulations allowing greater freedom of access in the area of Nazi-looted art.[286]

Translation: good luck to the victims in getting your looted artwork, or art sold on the cheap under the Nazi threat, returned to you. They also wrote about the purpose and scale of the looting:

> Many of them were used to enrich the collections of Göring or other Nazi elites. Others were siphoned off to Switzerland, for example, to the Fischer Gallery in Lucerne, while an estimated 500 were destroyed in the symbolic N.S. bonfire at the Jeu de Paume in July 1943, so vividly described by French curator Rose Valland.
>
> In terms of art looting, the ERR's most blatant claim to the status of war criminals was the seizure of over 20,000 works of art from over 200 private Jewish collections in France and Belgium. That whole process was instigated by Reichsmarschall Herman Göring in part to enrich his own collection.[287]

(ERR refers to Einsatzstab Reichsleiter Rosenberg, which was the special task force set up and overseen by Hitler's chief ideologue, Alfred Rosenberg.)

Pushback in response to the demands for restitution of Nazi-plundered art came from all directions, and from top institutions in the United States and Europe. The Metropolitan Museum of Art's

Director Philippe De Montebello, who at the 1998 conference also sat on the board of the United States Association of Art Museum Directors Task Force, was one director who was not going to cave to demands for either the suspected looted art to be returned to the rightful owners or for financial compensation.

During his "Break-out Session on Nazi-Confiscated Art Issues: Principles to Address Nazi-Confiscated Art," in the ten minutes he was allotted to address his art museum peers, members of Congress, and US Holocaust Memorial Museum executives, De Montebello said: "Principally, the task force report called on American art museums to begin to conduct a comprehensive review of their collections to ascertain if any works may have been unlawfully confiscated during the Nazi/World War II era, and never subsequently returned."[288]

He went on to discuss guidelines for museums, and then he managed to waste some of his allotted ten minutes by deflecting away from the core subject of the conference, stating:

> The fact is, museums proudly announce acquisitions—the Met has joyously recorded in recent weeks the purchase of works by Jasper Johns and Van Gogh—and frankly, if my press office had not generated considerable press attention, internationally, someone would now be looking for other work! And of course, museums display new acquisitions prominently in their galleries, indeed all new acquisitions at the Met have a special and highly visible blue sticker on the label.[289]

When will all the questions of the looted World War II art, the art with suspect or tainted provenance, be resolved? How many more conferences on Holocaust-era assets need to take place to get close to getting it right?

My guess . . . on the hundred-year anniversary of the end of World War II.

In the year 2045.

26

Van Gogh's Missing DNA

In 1982, CBS investigative journalist Morley Safer of *60 Minutes* thought he had a hot story to pursue with a painting by Georges de La Tour potentially being "branded a fake." Safer had "produced four English art professionals who attacked the authenticity of *The Fortune Teller*, believed to be painted by the 17th-century French artist between 1632 and 1635, and purchased by the Met in 1960 at a cost of $675,000."

The Met swatted aside Safer's request for an independent art expert to examine the authenticity of the artwork and denied him copies of the X-rays and results of tests that the Met had done on the painting. The Met art representative used a flimsy excuse not to appear on *60 Minutes*, claiming that because the story was more British-centric, he would only be interviewed by the BBC. As the *New York Times*'s Grace Glueck saw it, "the failure of anyone from the Met to appear on the program did the museum a real disservice."[290]

This author faced a similar stonewalling by the Met in July 2013, when requesting a copy of the museum's condition report for *Wheat Field with Cypresses*. When repeated requests to review the Met's condition report on *Wheat Field with Cypresses* were denied, editor

Stephen Gregory, publisher of the *Epoch Times* newspaper, wrote a Freedom of Information Act (FOIA) letter requesting the condition report; that request was also denied.

Months later, this author learned through a former employee at the Metropolitan Museum, who will remain nameless, that the Met has an unwritten policy when it comes to paintings with questionable backgrounds and provenances:

- If the painting was purchased by the Met and later proven to be a fake, the Met would, in most cases, remove it from its walls and store it in a cellar vault alongside many other such fakes that the museum had bought over its nearly 150-year history.
- If the painting was given as a "gift" to the Met, however, the museum was under no obligation to examine the object's history to find out whether it was genuine or a forgery.

Wheat Field with Cypresses fits the second case. The painting was gifted to the Met by Walter Annenberg after he bought it for $57 million (it would be "the most expensive purchase" acquired by the museum).[291] Thus, following the Met's own internal logic, it was under no obligation to verify whether the van Gogh was real or a fake. With that twisted logic, the Met also felt it wasn't obligated to provide the condition report to a newspaper, even under a FOIA request. So the Met, in its own view, under its so-called unwritten policy, believes that it has no obligation to do what's right for world-famous, iconic master artists like Vincent van Gogh and for the museum's visitors.

The Met's refusal to release the condition report—which would reveal the analysis of physical condition, aging, repairs, touch-ups, weave counts, pencil sketching or outlining of the subject under the paint, chemical analysis of the pigments and vanishes or sealers, and whether any dirt or pollen made it into the paint if it was painted outdoors—is in stark contrast with the approach taken by the National Gallery.

Of course, even if the Metropolitan Museum ever does release the condition report, could the document be trusted? This is not to accuse the Met of anything. But after a cascade of denials, rejected FOIA requests, and a raft of major errors of attribution in its 2009 Annenberg Collection art book on *Wheat Field with Cypresses*, a skeptic would be wary of anything the Met put forth concerning this painting.

But if the Met had released the real condition report, which would have shown the two previous major owners of the painting—the Bührle family and Franz von Mendelssohn's family—the following items would prove it to be an outright forgery:

1. **Canvas weave count**. With a van Gogh self-portrait suspected of being a fake, two siblings who inherited the painting in 2000 wanted it authenticated. They brought it to Maria-Claude Corbeil, a chemist at the Canadian Conservation Institute of Ottawa. In mining the van Gogh letters, she was able to deduce that the canvas was supposed to be "asymmetrical." In other words, it contained a "different number of horizontal and vertical threads." Under X-ray imaging, Corbeil proved the "canvas contained the same number of threads in the horizontal and vertical directions." Conclusion: the portrait was a fake.[292]

 Note: Van Gogh's *The Langlois Bridge* (May 1888, Arles) at the Wallraf das Museum, Cologne, Germany—the museum conducted a condition report on the painting, which uncovered a weave count of "vertical 12, horizontal 13 threads per cm, very fine, open, almost netlike weave, pale in color."[293] It other words, it is asymmetrical—a genuine van Gogh.

 Question: Does Schuffenecker's (the Met's) *Wheat Field with Cypresses* canvas have the same asymmetrical weave properties? If it's a square, it's a fake.

2. **Colors and pigments**. As has been stated throughout this book, Vincent van Gogh was very particular in the paints he used. Van Gogh's custom-made colors and pigments, mixed and ground by Père Tanguy, from the special greens to the lead whites, are one of a kind. In the National Gallery Technical Bulletin for *A Wheatfield, with Cypresses*, it is stated that van Gogh used "chrome yellow" (lead chromate).

Note: By 1901, when Schuffenecker forged the *Wheat Field with Cypresses*, Père Tanguy had been dead for seven years, with no understudy or apprentice in his shop to reproduce those special pigments.

Question: Does the Met's *Wheat Field with Cypresses* contain the special paints for the wheat field (chrome yellow), cypresses (green), and the lead white to "prime" the canvas, and perhaps use for the white clouds? If the yellow was "cadmium," or any of the other special paints that don't match pigments used during the Saint-Rémy period, then it's a fake.

3. **X-rays and impacted impasto.** X-rays have been used to detect or confirm certain colors and pigments, weave counts, chemical analysis, and final condition of paints under varnish used by van Gogh in his paintings from the French period.[294] If those French-era paintings were from the South of France, then stresses would be detected from age, poor storage, and impacted impasto.

Note: The National Gallery Technical Bulletin didn't show any varnish being used on the Final version of the painting. That likely suggests that the other twin, the Small version of *Wheat Field with Cypresses,* wasn't treated with varnish either, which would have been out of character for the usually meticulous

van Gogh. Yet in September 1889, Vincent was coming off his bender of depression, so perhaps he either forgot this step of preservation or didn't have the materials at the time to seal the painting.

Question: What would the Met's version reveal under X-rays, with respect to canvas condition, paint colors, and special pigments used? If the X-ray revealed a painting atypical from other pictures van Gogh painted during his thirteen-month stay at the asylum, then it's a fake. If the Met's version wasn't sealed with varnish when other June 1889 landscape paintings were, then it's likely a fake.

4. **Brushstrokes.** Van Gogh's brushstrokes, athletic and fast, separated him from other painters of his era and following generations. They were "strongly rhythmic" and "tightly arranged, creating a repetitive and patterned impression"; they were "special to van Gogh."[295]

Question: Are the painting's brushstrokes characteristic of van Gogh's style? If the "blue blob" on the Alpilles mountains and the spiraling cloud, which looks like the white paint had been sucked through a straw on the canvas in the upper left hand of the Met's version, are not typical van Gogh brushstrokes and were painted by a different hand, then the painting is a fake.

5. **Cracking.** A study by Louis von Tilborgh of the Van Gogh Museum, which examined the weave patterns of van Gogh's canvases, found: "It is known from Van Gogh's letters that he preferred rolls of canvas to ready-made, pre-stretched canvases, and information about their weave structure might make it possible to reconstruct painting locations on those rolls."[296]

Note: Van Gogh's paintings in the South of France, whether done in Arles or Saint-Rémy, all have the same exact characteristic: being rolled for transport. National Gallery's *A Wheatfield, with Cypresses* was "rolled" with the physical evidence being more than simple wear and tear or poor storage. That painting suffered from being rolled, showing "impacted" impasto, cracking in the blue sky in the upper right-hand corner of the picture, while the Met version is totally free from any such cracking or impacted thick applications of paint.

With no such physical blemish in the paint aging that resembled cracks in a clown's makeup or that of a dry riverbed, the Met's *Wheat Field with Cypresses* is a fake.

Deep analysis by scientific experts would prove the Met's *Wheat Field with Cypresses* as an old Schuffenecker forgery (circa 1901). An X-ray would reveal that Schuffenecker didn't draw the contours, as Vincent would have done. The "known van Gogh aid," which the Dutch artist himself had described as a "perspective frame" in pencil, would be absent from the Met masterpiece. Would the experts find canvas pre-primed with lead white paint, another van Gogh trademark?[297] And when X-rays would reveal the absence of asymmetrical weave counts— there would be nothing for the Met to hide or refute anymore.

Van Gogh Museum's leading art expert, Louis von Tilborgh, in his 2012 study *Weave Matching and Dating of Van Gogh's Paintings*, addressed the claims that van Gogh, who at times lost his faculties and could be idiosyncratic, wouldn't have been so exact with his materials, such as the special paints and canvases. As Tilborgh et al. noted: "Thanks to the correspondence we simply know more about the way he worked with his painting materials than about almost any other artist of his period, although that mainly applies to the years 1888–90."[298] Van Gogh remained precise and kept track of what he used.

Finally, during a November 2013 interview, former FBI special agent and founder of the FBI's Art Crime Unit Robert Wittman weighed in on what would be, for him, the unequivocal proof that the Met's *Wheat Field with Cypresses* is a fake van Gogh. He pointed specifically to the material characteristics of the painting. Knowing that the picture was painted outdoors in June 1889 leads one to expect that there would have been pollen or dirt in the paint.

Wittman added, "Paint chip analysis, if it doesn't detect pollen, then it's a clear fake. That would be definitive," since the landscape would be shown to have been painted indoors as opposed to being outside, in front of his subject, as van Gogh did with his sketch and then detail drawing of *Wheat Field with Cypresses* in June 1889.

Unfortunately, such an analysis is not an option, outside of attempting to steal a chip of paint off the painting inside the Met. (The thought has crossed this author's mind.) Regardless, the overwhelming circumstantial evidence points to their picture being painted by another hand, that belonging to Schuffenecker.

27

Failing van Gogh

"Where do I start?" I asked an exasperated Susan Alyson Stein. It was the second time she had called that Monday after the Fourth of July weekend in 2013. Monday is the one day of the week the Metropolitan Museum of Art is closed.

Stein, a middle-aged, well-educated woman with short, spiky raven-black hair and a narrow face made narrower by small wire-framed glasses, was the curator of nineteenth-century European art at the Metropolitan Museum.

To her credit, "Susie" Stein rushed back from her vacation on the east end of Long Island to deal with the questions I raised on the questionable authenticity of a major van Gogh. She came back to the city to answer a detailed email I had sent to the museum's press office the day before the holiday.

The email stated that I had evidence—albeit circumstantial—there was a suspected fake van Gogh painting hanging in the museum. It wasn't any painting, mind you, that was in question, but the Met's ultimate prized acquisition.

In 2013, Gary Tinterow was the director of the Museum of Fine Arts in Houston, Texas. I reached out to Mr. Tinterow to comment

on the broken provenance of the Met's painting. I received a reply from his assistant Mary Haus by email: "I forwarded your query to Gary Tinterow; he requested that you direct your inquiries instead to the Metropolitan, as he is no longer with the Met."

Nice dodge, I thought.

Alas, it turned out, Susan Stein wasn't actually in the mood to answer questions—certainly not from me. No way. She wanted to "enlighten" this reporter. So instead of reviewing the PowerPoint I had sent her, showing the six points of dissimilarity—which would grow to two dozen points—between two identical van Gogh landscapes, both purportedly painted in the same summer of 1889 at the Saint-Rémy asylum, Ms. Stein felt the need to educate me on the complexities of van Gogh's art.

What could I possibly know about Vincent van Gogh? I did disclose that he was my "favorite" artist, going back twenty-five years to when I lived and worked in Philadelphia in that watershed year of 1987, when Impressionist art sales blew through the stratosphere, forever in a new orbit and remaining a key investment today for billionaires.

Having visited the Philadelphia Museum of Art—a good place to take a date—and the magnificent Barnes Collection of Impressionist art frequently, I dove deep into the world and brushstrokes of van Gogh, Monet, Gauguin, and many others. Back then, all of the paintings in the Barnes Collection were crammed—an ensemble—onto the walls and halls of its mansion off City Line Avenue. The artwork housed several van Goghs, including a couple from the Saint-Rémy period, along with other European artists.

Susan, just go over each point I sent you and answer them one by one. That would be the logical way to proceed, I thought.

Susan Stein had other ideas, so she wanted to address other matters, like the pronunciation of Saint-Rémy.

But I, James Ottar Grundvig, am stubborn, like the Norse fjords carved in granite that are part of my roots. I am persistent to a fault.

It comes in handy when facing an adversary such as Ms. Stein. So I pushed back, telling her, "The museum was built for people like me, the common folk, and not for the elite like you."

"I agree. We are a public institution—that's why I came to the museum today to respond to your email," she said. And yet the Met doesn't consider itself a public institution when having to answer to a FOIA letter request. Stein went on to suggest that instead of chasing answers or "go fishing" for a fake van Gogh, I should travel to Europe and meet with van Gogh experts and enjoy the scenery.

"I did," I claimed. "I interviewed one of the leading van Gogh experts in the world—Louis van Tilborgh at the Van Gogh Museum in Holland. You have heard of him, haven't you?"

"Of course," she said.

"Why don't you answer the six points I sent you on *Wheat Field with Cypresses*?"

"Our *Wheat Field* was painted late June, early July in 1889," she stated.

"What about the *A Wheatfield, with Cypresses* painting in the UK National Gallery of Art in London? That work was painted in September as written in Vincent's letter," I continued.

"That one was a copy of ours that Vincent did," she claimed.

Not believing her for a second, I forged on, stating, "Both paintings have the same exact cloud formation. They have the same secondary image embedded in the same cloud, the same shading, and the same yellow-brown wheat field. They can't have been painted a season apart given the similarity of all these characteristics. The color of your wheat field shows harvest season, which is in the fall. I know that because my father grew up on a farm in Norway."

I noted that at the start of late June the wheat field at Saint-Rémy would have been green, as the *Green Wheat Field with Cypresses* painting in Prague attests to, along with another wheat field painting called *After the Storm* that was mentioned in Vincent's letter of June 9, 1889. If those two paintings of wheat fields are deep green

with the spring rains of June, then why is the Met's version the amber-brown of autumn?

Not wanting to be specific in either of those two phone calls that day or in email, Stein moved on, holding the line that the UK *Wheat Field*—sometimes referred to as *Cornfield*—was a copy (Final version) done by van Gogh of the Met's original painting (claimed First version). Not likely. (In fact, according to the National Gallery's own *Technical Bulletin*, its picture is the Final version painted from a previous study. No copy, but the best and final version of three.)

I pointed out, "You have some other problems with your painting. There's the *Green Wheat Field with Cypresses* in the Narodni Galerie in Prague." Ms. Stein knew of it. "That painting," I continued, "with its 'blue' and 'multicolored Scottish plaid' sky resembles the July 2, 1889, passage Vincent wrote in a letter to his brother Theo, and not the gray, cloud-covered sky in your painting."

During the phone call, I too had attributed that very specific line from the van Gogh letter to the wrong painting. I would come to learn that my simple, non-art expert mistake was right on the hunch but wrong on the painting. Two years later, I would discover that the "multicolored Scottish plaid" was a reference to another of the Met's van Gogh painting, the vertical *Cypresses*.

"There are three *Wheat Fields*. We have one of them," she insisted.

But that conversation was in 2013. Now, with the deep-dive investigation complete, we learned several things that apparently the experts at the Met, from Gary Tinterow in the 1990s to Susie Alyson Stein in the twenty-first century, didn't know or uncover.

We know two of the van Goghs, including *Wheat Field,* traveled with Dr. Peter Witt, who sold them to Emil G. Bührle in 1951 in a deal brokered by Dr. Fritz Nathan.

Dr. Schoeps wrote about the suspect van Gogh painting in his 2009 German-language book *The Heritage of the Mendelssohns* and knew the Met version was a painting with "shaky provenance."

When addressing the possibility of the Met's *Wheat Field* not being painted in June 1889, Ms. Stein asked, "So what happened to the other one?"

It didn't get lost during either of the two world wars. Emile Schuffenecker manufactured it just before or right after the 1901 Bernheim-Jeune van Gogh retrospective exhibition.

So this leads to a compelling question for the Metropolitan Museum: Is the painting worth tens of millions of dollars, the $57 million price tag from two decades ago adjusted for inflation to an estimated value of $95 million in 2016?

Or did the Swiss arms dealer's son, Dieter Bührle, dump the fake on the Met knowing full well he could never sell it at auction, as there would be no takers once the painting was thoroughly vetted by forensic science, chemical analysis, X-rays, and a team of experts, as was done with the Final version of the original painting in the National Gallery in 1987?

Is the Met's version only worth the cost of materials, canvas and stretchers, brushes and paints, and the labor it took Claude-Emil Schuffenecker to make the knockoff copy?

During the second phone call with Ms. Stein that day, I asked her if I could see a copy of the *Wheat Field with Cypresses* condition report. She responded "No," adding, "I don't know which curator has the condition report. But they are away on summer vacation."

I would later discover that the curator who wrote the latest version of the condition report at the Met was Charlotte Hale in 2006. Susan Alyson Stein notes that in her book *Masters of Impressionism and Post-Impressionism: The Annenberg Collection.*

"I did ask specific questions earlier today on whether the Met has done any modern-day testing with X-rays and other technology, like the museums in Europe have done," I reminded her.

"You can find the answer to that in the footnotes I sent you earlier on the book that I edited," she replied.

The irony is that this book, which is sold in the Metropolitan Museum's store and online, has the *Wheat Field with Cypresses* on its cover. Yes, just like *The Passionate Eye* brochure, which lured the big-whale art collector Walter Annenberg to step into the honey trap and acquire the painting for the Met. Of all the thousands of paintings done by the "eighteen master artists" profiled in *The Annenberg Collection* book, she put the fake on the cover.

Confounding.

What Susan Stein and the Met don't realize is that the world has since changed. Thanks to big data, cloud analytics, and other technologies, we live, work, and operate in an open-source, shared-economy, transparent society of the twenty-first century. The new generation of millennials, who continue to enter the work force, have a different view on secrecy, opacity, and deception.

Open source means the average person has free access to all of the van Gogh letters in the online searchable database, as well as the use of Google Images to examine close-ups of a painting in great detail in high-definition images, or Google Earth to zoom down on the asylum as it still stands today and see Vincent's wheat field, which has been replaced with grass and some trees, and the Alpilles mountain range to the south still visible to the southeast along the way the morning sun shines on the mountains in summer.

Vincent van Gogh will live forever.

Do you hear that, Claude-Emile Schuffenecker?

Do you hear that, Emil Bührle?

Van Gogh's paintings will be transferred from one owner to the next, from the dead to the living, from parent collector to an heir or a donation to a museum. Van Gogh will live on far into the future, to be experienced by new ardent fans and curious people who will wonder what made him great and why his iconic bright, dazzling colors and brushstrokes were so unique to him and special to all of us.

Long live Vincent van Gogh.

IV
THE AGE OF
TRANSPARENCY

28

Van Gogh's Fragmented Oeuvre

The forgers who fenced dozens of paintings through the once-venerable Knoedler Gallery, established in the nineteenth century, could only commit their crime knowing that artists such as Rothko, Pollock, and Motherwell had been dead a long time. When we see the profits one stands to reap—"Preet Bharara's office indicted Ms. Rosales on being the front for the paintings that were sold to Knoedler Gallery for more than $30 million, and then flipped for $80 million to wealthy investors"[299]—we can understand why people of all stripes forge paintings. This particular series of crimes started in the mid-1990s and went well into the twenty-first century, before Getty, the owner of the gallery, pulled the plug on the historic gallery. Before that happened, however, "the profits were huge. In total, 63 fake paintings were listed as produced and laundered. They included iconic names of Jackson Pollock, Mark Rothko, and Robert Motherwell, but they had an 'odious' air about them."[300]

The August 2013 article this author wrote on that art-crime conspiracy explains the mindset of the thief: "For art forgery to work, the artist must be dead so he can't spot a fake. Take the abstract

expressionist Jackson Pollock, who died in 1956. Last year, the Knoe-dler Gallery was shut down for having a 'forged' Pollock. There's one problem with copying his work. Pollock used lead-based paints that were banned in the 1970s.

"Another problem with Pollock: 'The whites are no longer whites, they are now yellow, due to aging,' said a top art restorer and a watchdog to the New York City auction houses when I met him at his studio. 'There are two ways to detect fakes. The good ones can spot the odious crap right away. If it's a period piece, you flip over the painting and check the frame and canvas to see if it's an original from that time period,' he explained."[301]

At the start of the twentieth century, doubts began arising about suspect van Goghs that had moved beyond a single fake, or even two or three. The question grew with time. In 1997, an article came out claiming that there could be as many as one hundred fake van Goghs, with at least "forty-five doubted in the canonical Hulsker catalogue, sixteen are in the Van Gogh Museum, Amsterdam; lead-ing scholars Dorn and Feilchenfeldt consider another twenty-one dubious, and there is skepticism also about some drawings. But there is good news as well: over the last ten years, twelve new works have been accepted as being by Van Gogh."[302]

Talk about a broken oeuvre from a major artist. One hundred fakes? *Mon dieu!* Even if the number were whittled down to forty-five fakes, the van Gogh controversy is clearly alive and well more than a century after his death.

But instead of going to bat and trying to hit a home run, why not try to hit a single, as in a single fake? More startling than the number of fake van Goghs in the market is that this particular one, the Met's *Wheat Field with Cypresses*, has never shown up on any of those fake-forged-Schuffenecker lists. It's an outlier. It is also a clear fake. A butchered copy. So if that painting has never been examined as one of the dozen or more suspect fakes by the art experts that came before this book, what does that say about Vincent's true oeuvre?

Let's start with what we do know about which van Goghs are true *van Nogh* paintings.

1901—Julien Leclercq removes two van Goghs from the seventy-one paintings that were exhibited at the Bernheim-Jeune Gallery on day one of the show, making a nice diversionary tactic to get Jo van Gogh-Bonger to look in another direction.

1932—Then there were the four confirmed fakes in the Otto Wacker Trial, which didn't turn up the weave count issue then, but have been confirmed by modern X-rays for one of them. In his miraculously discovered trove from a "secret" Swiss collector, how many of the thirty-three paintings are actually *van Nogh*s?

2000—Maria-Claude Corbeil, a chemist at the Canadian Conservation Institute of Ottawa, proves through deep X-rays that the weave counts were not asymmetrical for painting *Cypresses* (different than the Met's original), which has a provenance that ran through convicted art forger Otto Wacker.

2014—Swiss investigative journalist Hanspeter Born and French art expert Benoit Landais dismantle the Yasuda *Sunflowers* in their thoroughly researched book *Schuffenecker's Sunflowers,* proving beyond a doubt it was forged by the minor artist in 1901.

2014—Not to be outdone by their own work, Born and Landais make another strong case in their book by looking at another Met van Gogh; this time they examine *L'Arlésienne: Madame Ginoux with Books*; the authors show that Madame's elbow is floating above the table, not resting on it as it does

in the real painting with nearly the same name, *L'Arlésienne: Madame Ginoux with Gloves and Umbrella*, which hangs in Musée d'Orsay in Paris.

2016—James O. Grundvig, with plenty of help from the experts—particularly art expert Alex Boyle, who shined the light in the right direction—proves beyond question that the Metropolitan Museum of Art's version of *Wheat Field with Cypresses* is a clear fake, a bad Schuffenecker forgery. By the way, no condition report is needed from the Met to solve this case.

Without breaking a sweat, the above list shows there are ten—*ten*—major van Goghs that are fakes. Since we are talking about ten, and not one or two, one begins to wonder how many more are actually out there. We may never know. But then, we should know. In the opinion of this author, and I do not stand alone, the Van Gogh Museum, which is the ultimate arbiter of all things related to the Dutch master artist, should do a lot more to confirm the fakes that are out there and investigate those with questionable provenance. It seems that museums are more interested in protecting their self-serving interests, revenue, and reputations than checking the authenticity of their paintings.

However, in the Digital Age, someone, some organization, or a group of art lovers, art historians, art researches, or an investigative journalist like myself can shame those museums that have been and continue to be unwilling to cooperate, unwilling to be transparent, and unwilling to serve the public as they claim to do. Perhaps interested parties could join together and apply some shame and more pressure en masse by singling out those museums that claim to seek the truth but in reality sweep it into a dark corner of their storage vault.

At the top of that list should be the Metropolitan Museum of Art.

A recent book, the 2001 *Behind the van Gogh Forgeries: A Memoir*, which reprints a fragment of a Schuffenecker obituary published by Dutch newspapers in 1934, sheds more light on the circumstances surrounding his life:

> With reference to the death of the painter Emile Schuffenecker, deceased in Paris at the age of eighty-three, the 'Deutsche Allgemeine Zeitung' reminds us that his name was repeatedly mentioned in relation to paintings erroneously ascribed to Van Gogh. He was a friend of Van Gogh and belonged to Gauguin's circle in Pont-Aven. Van Gogh had a great influence on him. Copies of Van Gogh's paintings which came on the market were probably by his brother Amedée, a wine dealer who was also an art dealer. There are most likely in various collections a number of works ascribed to Van Gogh that were painted by Amedée Schuffenecker. [303]

It appears the Dutch editors believed that the Schuffenecker brothers had gotten away with committing the ultimate fraud, copying sixty paintings, most of them van Goghs.

So the ultimate number of the van Gogh fakes remains a mystery, and one certainly worth a closer look.

Van Gogh / *Van Nogh* Check List

The *van Nogh* Checklist is meant more for the art fan, the van Gogh enthusiast, and not necessarily for the art experts, art editors, art historians, and art scholars at the Metropolitan Museum of Art, the Van Gogh Museum, London's National Gallery, or other museums. We know these institutions will do whatever it takes to protect their inventory and priceless artworks, but their maneuvering ultimately won't help any attempted cover-ups as technology improves and the research goes from analog archival documents to, one day, a living database of letters, facts, images, metadata, and other available and multifaceted information.

Vincent van Gogh's art career can be seen in stages of development over ten years. First, we find him perfecting his technique, initially as a doodler, sketcher, and drawing artist, and later with his breakout painting *The Potato Eaters*, created in Nuenen, Netherlands, in 1885. But if one takes that painting, or any of the paintings he did during that period, and compares it to his iconic artwork created in Paris—influenced by the French Impressionists—the works will almost look like they came from different artists. Once Vincent journeyed to the South of France, with his dream of starting an artist

colony derailed by his mental breakdown in Arles around Christmas 1888, he developed his iconic brushstrokes and a dazzling array of colors. Most of Vincent's top ten or top twenty masterpieces on anyone's list are likely to come from among the paintings created in the last three years of his career as an artist—those spent in Arles, Saint-Rémy, and Auvers-sur-Oise—and not his first seven.

Knowing this great creative development and the subsequent gap in the quality of his artwork, one can set out on their own and begin to look for things that might not add up for a typical van Gogh painting. Thus, the date of the artwork is the first critical juncture in determining and defining a van Gogh.

When separating the van Gogh oeuvre by time and region, set apart works from his earlier years. Thus the first part of his massive oeuvre covers his early years as an artist, when he created in Holland, England, The Hague, and Paris when he first arrived in France. The next batch of creativity dates to the period in Arles and Saint-Rémy. Most of van Gogh's bright, colorful, vibrant, and iconic paintings came from the later period, 1888 to 1890. The last seventy or so canvases, created over the final two to three months of his life in Auvers-sur-Oise, in northern France, the farming community outside of Paris, fall partly into both groups. From a virtuosity point of view, the Auvers paintings are firmly placed in South of France group. But because those paintings never suffered the stresses of being rolled, stacked on one another, crammed into crates, and shipped by goods train to Paris, their physical condition falls into the first category of his earlier works.

This is important because the paintings that were created in the South of France hold physical "signatures" that van Gogh's other paintings do not, including time and place.

Second, look to the extant correspondence, especially between the artist and his brother. Vincent and Theo's letters have been parsed, reviewed, deciphered, dissected, sourced, and analyzed like few documents over the same period of time, when Jo van Gogh-Bonger,

Paul Cassirer, and others began publishing limited and full editions, eventually in Dutch, French, German, and English. Today, with the Van Gogh Letters database available online, free to use, and easy to navigate, with keyword searches, one can easily dive deep and quickly into any single painting, event, person, period of time, or other specific queries. That wasn't possible in 2000. So technology of this century has already had a huge impact on research, killing off the static and archaic typed or handwritten card catalogues in the libraries of the world.

Lastly, because the light and bright colors from the south influenced Vincent so dramatically, he meticulously relied on certain hues, paints, and pigments from the Tanguy shop. The letters from that period back up what the experts at museums around the world have learned and confirmed—that van Gogh had special, custom-made paints that were unique only to him.

Thus, the Arles and Saint-Rémy paintings give an investigator a lot more avenues to explore in searching for a fake van Gogh. That all starts with how the paintings were stored, dried (insufficiently in many cases), rolled, and transported from the Arles train station on the goods train up north to Theo's apartment in Paris. And because van Gogh was so prodigious during his years in the south, Theo and Jo's flat soon ran out of places to store his paintings. By the time Theo got married and Vincent was halfway into his Saint-Rémy stay at the asylum, Theo had leased space from Père Tanguy to store more of his brother's paintings as they arrived each month.

When I interviewed Van Gogh Museum Senior Researcher Louis van Tilborgh in June 2013 for the "Hacking Van Gogh" article I was researching for the *Huffington Post*, he agreed that the van Gogh paintings from the Saint-Rémy year were "rolled" and shipped north, as the van Gogh letters state. The signature trait of stress, combined with thick impasto brushstrokes that led to the paints being "impacted" with signs of cracking and other stress microfractures,

are wholly different than other van Goghs painted before and after the artist's Arles–Saint-Rémy period.

In 2014, Dr. van Tilborgh was appointed professor of art history at the University of Amsterdam.[304] Van Tilborgh's 1986 doctoral thesis was on Vincent van Gogh. In the "Social Responsibility" section of the press release, we read: "This scientific mission is the reason why the Van Gogh Museum provides the University of Amsterdam with the professorship of Louis van Tilborgh. Van Tilborgh—senior researcher of the museum—has been appointed as professor of Art History, more particularly Van Gogh at the Faculty of Humanities."[305]

Van Tilborgh's passion and expertise for van Gogh extends beyond Amsterdam and the Netherlands, and beyond speaking to journalists like myself overseas. Months after the June 2013 interview, Louis van Tilborgh was busy authenticating a long-missing, but ultimately genuine van Gogh, *Sunset at Montmajour* (1888), a painting from Arles. [306]

====

An autumn 1986 Metropolitan Museum of Art exhibition of eighty van Gogh paintings from the Arles–Saint-Rémy period left quite an impression on *New York Times* art writer Michael Brenson on the eve of the March 1987 *Sunflowers* auction. After seeing the exhibit showing some of the best artwork from that period, Brenson wrote: "At Saint-Rémy, and then to a lesser degree in the north French village of Auvers, where he spent the last three months of his life, van Gogh's powers of discernment and organization are unmistakable."[307]

Six weeks earlier, Brenson elaborated on that special period in van Gogh's life as an artist, writing:

> Van Gogh changed art. He took the complementary colors of Impressionism and made them not so much expressions of light as symbols of a fiery, pantheistic imagination.

There is a lot in these paintings that defies rationalistic method and language. The cosmic imagery of "The Starry Night"—in which van Gogh seems at the same time to be charting and riding the chariots of the gods—is one of them. The maternal cloud shape in "Olive Trees With the Alpilles in the Background" is another. The "secondary imagery"—facial configurations in trees and clouds . . . mitting such ghostly authority that once recognized they do not stop exercising a haunting power—is as prominent in the St. Rémy paintings as it is in landscapes of Cézanne.

In Auvers, the palette changes and the pictorial audacity continues, but there is less identification with place, more interest in the kind of decorative possibilities suggested by Puvis de Chavannes, and most of the paintings now seem first of all like paintings. The double-square canvases—roughly 19 by 38 inches—gave van Gogh a way of exploring friezelike composition. It also enabled him to work within a peaceful format; horizontality has long been identified with the calm of the horizon. There are fascinating works here, hallucinatory dances of flowers and wheat, landscapes scurrying about under heavy skies. Van Gogh was heading someplace new.[308]

From the details of this book, one can produce what this author calls the Van Gogh/ *Van Nogh* Checklist:

- **Time and Place:** Arles/Saint-Rémy period.
- **Physical Condition:** Impacted impasto, cracking, paint stress from being rolled and kept in rough storage at Theo's flat and Tanguy's shop.
- **Canvas/Weave Count:** Asymmetrical weave count, such as twelve horizontal, thirteen vertical threads per square centimeter. If the weave count is square from Arles onward, it's a clear *van Nogh*.
- **Colors:** There were at least three unique colors that Père Tanguy created for van Gogh: lead whites to prime the canvas;

chrome yellows, for the hot effects of the southern sun, golden wheat, and shining stars; and those special greens for the fields. There are a lot of studies and literature in this area. Twentieth-century forgers simply wouldn't have had access to these special paints, since Tanguy died in 1894. Any one of those colors of paints that deviate from other van Goghs from the same era and place tell us it's a true *van Nogh*.

- **Brushstrokes:** Again, this has been examined by art experts, as well as electrical engineers who mapped those strokes hidden beneath the surface. Using X-rays, electrical engineers from New Jersey ran the bits of data through machine-learning data analytics to confirm that Vincent van Gogh had a one-of-a-kind, unique brushstroke. To examine non–van Gogh brushwork, look at the ten fake van Goghs and compare them against genuine Vincent artwork to detect poor, varying brushwork of an inferior hand for a *van Nogh*. Vincent van Gogh was a very deliberate painter.

- **Letters:** The Van Gogh Letters database, found at http:// vangoghletters.org/vg/. This great online resource empowers anyone to rapidly and efficiently scan hundreds of Vincent's letters by region, time, person, object, or keyword (e.g. wheat, cypress, starry, river, rolled, train, etc.) in minutes, 24/7.

 In the letters, there is a column on the right side for sources, attributions to correct paintings, and other interesting facts about the life and artistry of van Gogh. This allows the user to check and verify the sources used.

- **Museums:** Those museums that own or exhibit van Gogh paintings are good sources of information. Even the Met, which doesn't share its condition reports, keeps valuable details online.

 Each museum does it differently; that's why it's important to fact-check artwork in multiple sources.

30

Blockchain Fine Art

In 1997, investigative journalist Hector Feliciano published *The Lost Museum: The Nazi Conspiracy to Steal the World's Greatest Works of Art*. Feliciano captured many of the provenance issues that plagued the works of art caught up in the Nazi swarm over looted and confiscated art.

When Feliciano's book came out, *New York Times* columnist Richard Bernstein wrote: "The Swiss, criticized these days for providing a safe haven for the gold and jewelry taken from the Jews, come off badly in Feliciano's account. Swiss dealers aided the Nazi effort and profited from it. More important, perhaps, after the war the Swiss government made very little effort to return looted works to their rightful owners. One celebrated collection, that of the Emil G. Buehrle Foundation, Feliciano concludes, 'contains paintings that were confiscated during the war, paintings whose story is not fully told in its catalogues.'"[309]

To combat the obscure dealings of the Metropolitan Museum of Art, which still refuses to aim for transparency, one can rely on emerging new technology to gain access to suppressed information. In particular, blockchain technology—an online ledger with

exchanges that verify transactions—which has been the basis for Bitcoin and other cryptocurrencies, is set to become the underlying foundation that will revolutionize the art world. This is not some whimsical dream or farfetched idea. There are real companies that are currently using the next generation of blockchain technology, a digital distributed ledger that tracks and monitors the transfers of licensing or ownership of assets.

Why is that important? The blockchain system is global. It's electronic. It's open 24/7 from any Internet access point in the world. And it requires clearinghouses to confirm the transfer of an object or property to make that transaction valid.

CoinTelegraph, a website that focuses on digital currency and blockchain, interviewed Masha McConaghy, a curator and cofounder of Ascribe, a Berlin-based startup that uses blockchain technology to register digital medium of all kinds.

On blockchain being applied to art, McConaghy said, "In the physical art world there is a great need in clean provenance. Here [is] where blockchain technology will play an important role. In Germany, especially after the discovery of Gurlitt Collection the provenance research became the most important topic. The unregulated art market is in need for transparency and regulation and blockchain can address a lot of issues."[310]

It's a simple but powerful way to authenticate artwork and art projects and track their history of ownership, from creation to current owner.

On December 7, 2015, I attended a panel discussion in New York City on the technology applied to the art world. The evening forum, *Fine Art and the Blockchain: Provenance, Authentication and Value Creation*, was hosted by Rik Willard and his blockchain-centric organization, the Agentic Group.

The speakers included Judy Pearson, president of Aris Title Insurance Corp.; Ji Jun Xian, partner Emigrant Bank Fine Art Finance; Jeffrey Smith of Tradable Rarities Exchange, Inc.; and Brooklyn-based

Jesse Grushack, blockchain strategist at Consensys, a venture production studio "building applications and end-user tools for blockchain ecosystems."

Almost two years earlier, on February 18, 2014, Alexander Boyle and I attended a special lecture on art crime by Robert Wittman at the Frick Museum in New York City. In covering that evening's discussion on how to identify the various forms of art crime, theft, and forgery for *Art, Antiques & Design*, an online magazine based in the United Kingdom, Boyle wrote:

> [Wittman] started out with statistics, estimating the worldwide annual art trade at $200 billion, but of that 3% or $6 billion was of illicit cultural property. That ranges from fakes and forgeries to smuggled items and outright theft. The Federal statutes that enabled Agent Wittman and his team to take action include Interstate Transportation of Stolen Property, Theft of Major Artwork, Hobbs Act, Smuggling, and Mail Fraud and Wire Fraud."[311]

In the economically anemic world we live in today, where billionaires look for other vehicles for investing their money beyond bonds, commodities, equities, and real estate, priceless art by the masters has become more important than ever. We have to vet and verify whether a Pollock was created by Jackson Pollock, or a van Gogh painted by the real Vincent. With $200 billion of art traded annually, blockchain ledgers will become more critical in business, even if museums like the Met or others don't like the transparency that comes with the technology.

The museums will soon have to play by the same new rules as everyone else, as blockchain will likely become the only way to conduct such multimillion-dollar transactions in the near future.

In a separate interview with Coindesk, Stephen Vogler, a German artist, told the online digital currency magazine that he thinks "the blockchain may be the answer to the art world's perennial problem,

authenticity." He added, "The blockchain is the first decentralized trustable database, which can track the ownership of virtual properties in a reliable way."[312]

Blockchain technology, which will let an artist or a writer register a digital "work," assigns the number of editions for a particular piece and then allows for the electronic transfer and tracking of editions, which future buyers can then authenticate.

Naturally, blockchain or other digital authentication systems could not have prevented masked gunmen from robbing the Emil G. Bührle Foundation's museum in 2009, escaping with $163 million worth of Emil Bührle's handpicked art. The four stolen paintings were by Degas, Monet, Cézanne, and of course Vincent van Gogh.[313]

The *Washington Post* article that covered the brazen, daylight theft said, "Daniel Heller, author of *Between Company, Politics and Survival: Emil G. Buehrle and the Machine Tool Factory Oerlikon, Buehrle & Co. 1924–1945*, said Buehrle repurchased seventy-seven paintings after the war from a Jewish dealer, after the Swiss high court ruled the works had been stolen."[314]

Who says karma doesn't have a sense of humor? Looting the looter has a certain ring to it, a certain panache.

In 2012, European authorities recovered the last of the stolen art from the Swiss heist with the Cézanne painting, recovered in Belgrade, Serbia. Bührle's pride and joy, van Gogh's *Blooming Chestnut Branches*, was "discovered undamaged in a car outside a psychiatric hospital in Zurich soon after the robbery."[315]

In 2015, the Emil G. Bührle Foundation closed its museum doors and will move into a new museum in downtown Zurich, where Oerlikon-Bührle AG held its offices and tool works from the 1930s through the 1950s. The building is currently undergoing renovation with plans to be open to the public in 2020. But the Bührle history is more complicated than one can see, so who knows how karma will treat the renovation and grand opening of the new

exhibit? When it does finally open, the paintings should be enjoyed. There are no fakes left.

In 2015, Lucia Foulkes, at Boston College Law School, wrote a twenty-five-page brief titled *The Art of Atonement: How Mandated Transparency Can Help Return Masterpieces Lost During World War II.* She made a convincing argument, from a legal standpoint, that "the United States government should act unilaterally to transform the moral responsibility of government bodies and museum officials into an enforceable legal duty."[316]

What would the battery of lawyers who represent MoMA and the Guggenheim think about dropping their staunch defense of artwork sold under duress? And what about the Metropolitan Museum of Art? Would the arrogant, stonewalling institution play ball?

Not of their own accord, they wouldn't. They have proved that time and again. How would the Met feel about a unilateral decision to restitute all Nazi-confiscated art? How would the Met's board of directors feel if the federal government stepped in and forced the museum to open its doors of secrecy and share its condition reports—on genuine and fake paintings—with journalists and art experts alike?

Since that is unlikely to happen, investigative journalists need to probe other suspect artworks at the Met and elsewhere themselves, especially those created by the masters. *Wheat Field with Cypresses* isn't the first van Gogh to be examined as a forgery, and it won't be the last.

One recommendation this author can make to the Van Gogh Museum is for it to take up the blockchain system on a trial basis, use it for a couple of its van Gogh paintings with clear provenance, and go back in time and register those artworks as if the past owners were alive today. Such a mockup might demonstrate to the directors and experts of that museum the benefit of using the online distributed ledger technology. It could then be used for loans of artwork to other museums, tracking the paintings' movements around the world until they return home.

If the Van Gogh Museum likes the technology, then perhaps it can reach out to other museums around the world and begin a trend, digitally putting their artwork online in a series of past-dated transactions, while using the blockchain method to record the details of their art's travels on future tours and exhibitions, each step of the way.

Now that would be a brighter, more transparent future. Something I believe the brothers van Gogh would approve of, were they alive today in the twenty-first century.

═══

I have spent three years of solid research on this one painting, *Wheat Field with Cypresses,* a process that was similar to dropping a rock in a pond and watching the ripples race out from the center. There were many paths to examine along the way.

What should the Met do with its *van Nogh* painting, *Wheat Field with Cypresses,* that hangs today in the Annenberg Gallery? It will never leave the museum again, but not because of some old, stale agreement with Walter H. Annenberg that the Met promised to honor. No, it can't leave now because this book has clearly outed it as a work of art created by another hand.

The Met is under no obligation to be transparent. But that, I suspect, will change. The Met does not have to share the painting's true history, or embarrass the Annenberg Foundation by announcing that Walter bought a fake van Gogh in 1993 for $57 million. The IRS, however, might be interested in looking into that massive tax write-off, and whichever insurance company is insuring that painting might have a different opinion than that of the Metropolitan Museum of Art.

What should the Met do with *Wheat Field with Cypresses?*

In my opinion, they should leave the fake where it is, trapped in its gallery, hanging on the wall, and honor Walter Annenberg's wishes. He did, after all, donate $1 billion worth of genuine art to

the Met. Let the fake van Gogh be a learning tool and experience for visitors, whether art students, art rookies, art experts, tourists, art professors, or art enthusiasts like me.

Let people compare the real van Gogh brushstrokes found in the same gallery at the same museum, in Vincent's *First Steps* and *Cypresses*. Let them compare, whether by going online or by visiting the National Gallery in London in person and comparing its great example of *A Wheatfield, with Cypresses* against the Met's *van Nogh*.

When that happens, perhaps the Met will throw up its hands and become a little more transparent. Then the staid, crusty old museums of the twentieth century can embrace the future of art meeting technology in this century, and Vincent van Gogh will look down on us and smile one more time with the sun emblazoned in his favorite color—chrome yellow.

ENDNOTES

1. Western European Report, Switzerland. Foreign Broadcast Information Service, April 10, 1987: 53–59.
2. Ibid.
3. Ibid.
4. Ibid.
5. Ibid.
6. Ibid.
7. John F. Burns, "Scandal Imperils Mulroney's Hold," Special to the *New York Times*, January 25, 1987.
8. Hanspeter Born and Benoit Landais, *Schuffenecker's Sunflowers and Other Van Gogh Forgeries*, Self-published, Switzerland, 2014.
9. "Marietta Gets $1.7 billion Army Contract," Associated Press, Washington, DC, December 1, 1987.
10. René Elvin, "Collector Extraordinary: The Bührle Collection and the New Zurich Kunsthaus," *Studio Magazine*, Zurich, Vol. 158: 50–4, August 1959. File Bührle, *The Passionate Eye* Exhibit, National Gallery of Art, Washington, DC, Gallery Archives, accessed December 2, 2015.
11. Ibid.
12. Ibid.
13. Hortense Anda-Bührle, Letter to Charles S. Moffett, National Gallery of Art, October 30, 1987. File Bührle, *The Passionate Eye* Exhibit, National Gallery of Art, Washington, DC, Gallery Archives, accessed December 2, 2015.
14. Charles Moffett, NGA Memorandum to Director J. Carter Brown, June 3, 1988. File Bührle, *The Passionate Eye* Exhibit, National Gallery of Art, Washington, DC, Gallery Archives, accessed December 2, 2015.

15. Ibid.
16. Ibid.
17. J. Carter Brown, NGA Letter to Hortense Anda-Bührle, June 7, 1988. File Bührle, *The Passionate Eye* Exhibit, National Gallery of Art, Washington, DC, Gallery Archives, accessed December 2, 2015.
18. Ibid.
19. J. Carter Brown, Memorandum for the File, June 15, 1988. File Bührle, *The Passionate Eye* Exhibit, National Gallery of Art, Washington, DC, Gallery Archives, accessed December 2, 2015.
20. Ibid.
21. Charles Moffett, *The Passionate Eye, Vincent van Gogh 1853–1890*, No. 62, *Wheat Field with Cypresses, June 1889*, Essay, Zurich, Artemis, 1990.
22. Frances P. Smyth, Memorandum for the File, February 13, 1983. File Bührle, *The Passionate Eye* Exhibit, National Gallery of Art, Washington, DC, Gallery Archives, accessed December 2, 2015.
23. Ibid.
24. Ibid.
25. 1990 Annual Report, National Gallery of Art, Washington DC, 1990, 82.
26. Frances P. Smyth, Memorandum of Telephone Conversation, "Bührle Exhibition," February 13, 1989. File Bührle, *The Passionate Eye* Exhibit, National Gallery of Art, Washington, DC, Gallery Archives, accessed December 2, 2015.
27. Elizabeth A. C. Weil, Memorandum to Martin Marietta, "Notes from Our Meeting," NGA Corporate Relations, September 11, 1989. File Bührle, *The Passionate Eye* Exhibit, National Gallery of Art, Washington, DC, Gallery Archives, accessed December 2, 2015.
28. "Collections," accessed December 10, 2015, http://www.sunnylands.org/page/20/art-collection.
29. Rita Reif, "Van Gogh's 'Irises' for $53.9 Million," *New York Times*, November 12, 1987.
30. Tim Kane, "The Passionate Collectors and the Billion-Dollar Gift (fourth in an eight-part series)," *Palm Springs Life*, Palm Springs, May 2011.
31. Brochure. File Bührle, *The Passionate Eye* Exhibit, National Gallery of Art, Washington, DC, Gallery Archives, accessed December 2, 2015.
32. Neil Harris, *Capital Culture: J. Carter Brown, the National Gallery of Art, and the . . .* (Chicago: University of Chicago Press, 2013) 426–27.
33. Ibid.
34. "Walter Annenberg Study Archive," accessed December 12, 2015, http://www.jewwatch.com/jew-leaders-annenberg-walter.html.
35. J. Carter Brown, Memorandum to Ruth Kaplan, NGA External Information Officer, April 30, 1990. *The Passionate Eye* Exhibit Files, National Gallery of Art, Washington, DC, Gallery Archives, accessed December 2, 2015.
36. Ibid.
37. Ibid.

38. Ibid.
39. Ibid.
40. Ibid.
41. "Times Appoints Chief Art Critic," *New York Times,* January 11, 1990.
42. Press Facts, *The Passionate Eye* Exhibit, National Gallery of Art, Washington, DC, Gallery Archives, accessed December 2, 2015.
43. Hortense Anda-Bührle, Press Breakfast Speech, *The Passionate Eye* Exhibit File, National Gallery of Art, Washington, DC, Gallery Archives, accessed December 2, 2015.
44. Richard Sanders, "Merchants of Death Conference," *Peace Magazine,* Vol. 05, No. 6, November 1989: 8.
45. Michael Kimmelman, "ART VIEW; Was This Exhibition Necessary?" *New York Times,* May 20, 1990.
46. Ibid.
47. Ibid.
48. Ibid.
49. Charles Moffett, Memorandum to Files, "Re: Kimmelman/ Bührle Collection." File Bührle, *The Passionate Eye* Exhibit, National Gallery of Art, Washington, DC, Gallery Archives, accessed December 2, 2015.
50. Ibid.
51. J. Carter Brown, Memorandum to the Art and Education Committee of the Trustees, "Re: Kimmelman Piece on Bührle Show." File Bührle, *The Passionate Eye* Exhibit, National Gallery of Art, Washington, DC, Gallery Archives, accessed December 2, 2015.
52. Arianem Gigon, "A New Look at Bührle Art Collection's Shadowy Past," SwissInfo.Ch, Zurich, October 9, 2015.
53. Piers Rodgers, "Letter to the Editor to New York Times," Secretary Royal Academy of Arts, May 24, 1990. File Bührle, *The Passionate Eye* Exhibit, National Gallery of Art, Washington, DC, Gallery Archives, accessed December 2, 2015.
54. Neil Harris, *Capital Culture: J. Carter Brown, the National Gallery of Art, and the Reinvention of the Museum Experience* (Chicago, University of Chicago Press, 2013), 432.
55. Ibid.
56. Ibid, 432.
57. John Russell, "Annenberg Picks the Met for $1 Billion Gift," *New York Times,* March 12, 1991.
58. Ibid.
59. Walter H. Annenberg obituary, accessed December 15, 2015, http://articles. philly.com/2002–10–02/news/25353073_1_art-collector-pneumonia-museums.
60. Michael Kimmelman, "ART VIEW; From Strength to Strength: A Collector's Gift to the Met," *New York Times,* June 2, 1991.

61. Michael Kimmelman, "Annenberg Donates a van Gogh to the Met," *New York Times*, May 25, 1993.
62. "The Art of the Deal," accessed December 15, 2015, http://krieger.jhu.edu/magazine/F05/pages/alumni_mazoh.htm.
63. Michael Kimmelman, "Annenberg Donates a van Gogh to the Met," *New York Times*, May 25, 1993.
64. Ibid.
65. Ibid.
66. Lukas Gloor, Emil G. Bührle Foundation, email to James O. Grundvig, November 13, 2013.
67. Letter No. 626, Vincent to Willemien van Gogh, Arles, June 20, 1888.
68. Letter No. 736, Vincent to Theo van Gogh, Arles, January 17, 1889.
69. Letter No. 728, Vincent to Theo van Gogh, Arles, January 2, 1888.
70. Ibid.
71. Letter No. 732, Vincent to Theo van Gogh, Arles, January 7, 1889.
72. Ibid.
73. F. Javier González Luque and A. Luis Montejo González, "Vincent van Gogh and the Toxic Colours of Saturn: Autobiographical Narrative of a Case of Lead Poisoning," paper, University of Salamanca, 2004.
74. Ibid.
75. F. Javier González Luque and A. Luis Montejo González, "Vincent van Gogh and the Toxic Colours of Saturn: Autobiographical Narrative of a Case of Lead Poisoning," paper, University of Salamanca, 2004.
76. Paul Wolf, *Creativity and chronic disease Vincent van Gogh (18531890)*, University of California, San Diego, VA Medical Center, San Diego, BMJ Publishing Group, 2001.
77. http://vangoghletters.org/vg/documentation.html#id2September1889. Accessed December 20, 2015.
78. Letter No. 762, Theo to Vincent van Gogh, Paris, April 24, 1889.
79. Letter No. 769, Frédéric Salles Theo to Vincent van Gogh, Arles, May 5, 1889.
80. Letter No. 767, Theo to Vincent van Gogh, Paris, May 2, 1889.
81. Letter No. 776, Vincent to Theo Vincent van Gogh, SaintRémy, May 23, 1889.
82. Ibid.
83. Ibid.
84. Ibid.
85. Letter No. 777 Vincent to Theo van Gogh, Saint-Rémy, May 31, 1889.
86. Letter No. 773, Railway Postman Joseph Roulin to Vincent van Gogh, Marseille, May 13, 1889.
87. Letter No. 775, Railway Postman Joseph Roulin to Vincent van Gogh, Marseille, May 22, 1889.
88. Letter No. 777, Vincent to Theo van Gogh, Saint-Rémy, May 31, 1889.
89. "Vincent van Gogh Biography," accessed December 22, 2015, http://www.biography.com/people/vincent-van-gogh-9515695#synopsis.

90. K. Shabi, "Starry Night: Meaning of the Vincent Van Gogh Landscape Painting," Legomenon, June 3, 2013, http://legomenon.com/starry-night-meaning-of-vincent-van-gogh-painting.html.

91. Albert Boime, "Van Gogh's Starry Night: A History of Matter and a Matter of History," *Arts Magazine*, December 1984.

92. Ingo F. Walther and Rainer Metzger, *Van Gogh: The Complete Paintings* (Cologne, Germany: Taschen Bibliotheca Universalis, Original Edition 1990, 2015), 511.

93. Letter No. 783, Vincent to Theo van Gogh, Saint-Rémy, June 25, 1889.

94. Letter No. 797, Vincent to Theo van Gogh, Saint-Rémy, August 22, 1889.

95. Letter No. 784, Vincent to Theo van Gogh, Saint-Rémy, July 2, 1889.

96. Letter No. 782, Vincent to Theo van Gogh, Saint-Rémy, June 18, 1889.

97. Letter No. 784, Vincent to Theo van Gogh, Saint-Rémy, July 2, 1889.

98. Ibid.

99. Ibid.

100. Ibid.

101. Letter No. 785, Vincent to Willemien van Gogh, Saint-Rémy, July 2, 1889.

102. Ibid.

103. Letter No. 789, Vincent to Theo van Gogh, Saint-Rémy, July 14, 1889.

104. Letter No. 790, Vincent to Theo van Gogh, Saint-Rémy, July 14, 1889.

105. Letter No. 792, Theo to Vincent van Gogh, Paris, July 16, 1889.

106. D. W. Olson, "Vincent Van Gogh and Starry Skies Over France," *Celestial Sleuth: Using Astronomy to Solve Mysteries in Art, History and Literature* (New York: Springer-Praxis, 2014), 54.

107. Ibid, 56–57.

108. Vincent Van Gogh and Colta Feller Ives, *Vincent Van Gogh: The Drawings* (New York: Met Publications, 2005), 316.

109. Ibid.

110. Ashlee Farraina, "Self-Portraits: Vincent Van Gogh #12," February 21, 2011, accessed December 30, 2015, http://ashleemariesinspiration.blogspot.com/2011/02/self-portraits-vincent-van-gogh.html.

111. Letter No. 797, Vincent to Theo van Gogh, Saint-Rémy, August 22, 1889.

112. Ibid.

113. Ibid.

114. Letter No. 779, Vincent to Theo van Gogh, Saint-Rémy, June 9, 1889.

115. Eric Gelber, "Van Gogh: Drawing Media and Techniques," *Making a Mark Blog*, February 22, 2007, accessed December 30, 2015, http://makingamark.blogspot.com/2007/02/van-gogh-drawing-media-and-techniques.html.

116. John Leighton, et al., "Vincent Van Gogh's 'A Cornfield, with Cypresses,'" National Gallery of Art, London, Technical Bulletin Vol. 11, 1987, 52.

117. Ibid, p. 57.

118. H. W. Janson, *The Modern World: A Basic History of Art* (New York: Harry N. Abrams, 1971), 308.

119. Letter No. 805, Vincent to Theo van Gogh, Saint-Rémy, September 20, 1889.
120. Letter No. 806, Vincent to Theo van Gogh, Saint-Rémy, September 28, 1889.
121. Ibid.
122. John Leighton, et al., "Vincent Van Gogh's 'A Cornfield, with Cypresses,'" National Gallery of Art, London, Technical Bulletin Vol. 11, 1987, 44.
123. The Vincent van Gogh Gallery, accessed January 1, 2016, http://www.vggallery.com/.
124. John Leighton, et al., "Vincent Van Gogh's 'A Cornfield, with Cypresses,'" National Gallery of Art, London, Technical Bulletin Vol. 11, 1987, 45.
125. Ibid.
126. Ibid.
127. Ibid, 49.
128. Ibid.
129. Ibid, 52.
130. Ibid, 44.
131. Letter No. 814, Joseph Roulin to Vincent van Gogh, Marseille, October 24, 1889.
132. Letter No. 845, Jo Bonger to Vincent van Gogh, Paris, January 29, 1890.
133. Letter No. 845, Jo Bonger to Vincent van Gogh, Commentary, Paris, January 29, 1890, http://vangoghletters.org/vg/letters/let845/letter.html.
134. Ibid.
135. "The Red Vineyard," accessed January 1, 2016, http://annaboch.com/theredvineyard/.
136. Ibid.
137. Frances Spalding, "How Van Gogh's Sunflowers Came into Bloom," *The Guardian*, London, January 17, 2014, https://www.theguardian.com/books/2014/jan/17/how-van-gogh-sunflowers-bloom.
138. Ibid.
139. "The Red Vineyard," accessed January 1, 2016, http://annaboch.com/theredvineyard/.
140. Letter No. 853, Vincent van Gogh to Albert Aurier, Saint Rémy de-Provence, February 9–10, 1890.
141. Ibid.
142. Letter No. 868, Vincent to Theo van Gogh, Saint Rémy de Provence, May 4, 1890.
143. Letter No. 870, Vincent to Theo van Gogh, Saint Rémy de Provence, May 11, 1890.
144. Letter No. 872, Vincent to Theo van Gogh, Saint Rémy de Provence, May 13, 1890.
145. "Auvers," *Van Gogh: Paintings and Drawings, A Special Loan Exhibition*, The Metropolitan Museum of Art (New York: Met Publications, 1949), 90.
146. "Vincent van Gogh & Auvers-sur-Oise," accessed January 1, 2016, http://www.tfsimon.com/auvers-sur-oise.html.
147. Wouter van der Veen, *Vincent van Gogh in Auvers*, Institut Van Gogh, Amsterdam, January 2015, 3.

148. Letter No. 899, Vincent to Anna van Gogh-Carbentus and Willemien van Gogh, Auvers-sur-Oise, July 14, 1890.
149. Letter No. 902, Vincent to Theo van Gogh, Auvers-sur-Oise, July 23, 1890.
150. Ibid.
151. Simon Dickinson, *Vincent Van Gogh: L'Enfant* à l'Orange (London: Dickinson), 23, accessed January 5, 2016, https://www.tefaf.com/media/tefafmedia/Van%20Gogh%20booklet%20(7).pdf.
152. Ibid.
153. Chris Stolwijk and Han Veenenbos, *The Account Book of Theo van Gogh and Jo Van-Gogh-Bonger,* Van Gogh Museum, Amsterdam, 2002.
154. Andries Bonger, *Catalogues des Oeuvres de Vincent Van Gogh*, Van Gogh Museum, Amsterdam, accessed January 5, 2016, http://www.europeana.eu/portal/record/92034/GVNRC_VGM01_b3055.html.
155. Theo Van Gogh (Art Dealer), "Death," World Heritage Encyclopedia.
156. Ibid.
157. "Gay Nineties," Wikipedia, accessed January 9, 2016, https://en.wikipedia.org/wiki/Gay_Nineties.
158. Dickinson, Simon, *Vincent van Gogh: Moulin De La Galette* (London: Dickinson), 12.
159. Bogomila Welsh-Ovcharov, "Emile Bernard, an Extraordinary Collector of Vincent Van Gogh," The Morgan Library online, New York, accessed January 9, 2016, http://www.themorgan.org/collection/vincent-van-gogh/letter/1/page/1.
160. "The First Publication of the Letters," Van Gogh Museum Journal 2002, Van Gogh Museum, Amsterdam, 29.
161. Ibid.
162. Simon Dickinson, *Vincent van Gogh: Moulin De La Galette* (London: Dickinson), 12.
163. Ibid.
164. Simon Dickinson, *Vincent van Gogh: Le Moulin d'Alphonse Daudet à Fontvieille,* (London: Dickinson, June 1888), 29, accessed January 10, 2016, https://issuu.com/simoncdickinsonltd/docs/vg_final_issuu__2_.
165. Van Gogh Museum Journal 2002, Van Gogh Museum, Amsterdam, 125.
166. Ibid.
167. Van Gogh Museum Journal 2001, Van Gogh Museum, Amsterdam, 23.
168. Belinda Thompson, "Gauguin," Thames & Hudson World of Art, New York, 1987, 36.
169. Colta Ives and Susan Alyson Stein, *Exhibition, Vincent Van Gogh: The Drawings,* The Metropolitan Museum of Art, Met Publications (New York: Van Gogh Museum, Amsterdam, Yale University Press, New Haven and London, 2005), 64.
170. Ibid, 65–66.
171. Ibid, 66.

172. "Portrait of Julien Leclercq and His Wife," accessed January 10, 2016, http://museum.cornell.edu/collections/prints-drawings/19th-century-drawings/portrait-julien-leclercq-and-his-wife.
173. Beth Saulinier, "Eye of the Beholder," *Cornell Magazine*, Ithaca, New York, June 1998, 36.
174. Anteneum Banafsheh Ranji, " The Heart and Soul of Finnish Art," *Helsinki Times*, Finland, February 14, 2013.
175. "Exposition Universelle," accessed January 10, 2016, http://www.expomuseum.com/1900/.
176. C. Homburg, *The Insane Artist or Genius at his Best: Vincent van Gogh, Case in Point*, Translated Google, University of Groningen Press, Netherlands, 1990, 85.
177. "Sorting out the Sunflowers," Editorial ArtNews.com, November 1, 2007, accessed January 10, 2016, http://www.artnews.com/2007/11/01/top-ten-artnews-stories-sorting-out-the-sunflowers/.
178. Ibid.
179. "Vincent van Gogh," Artble, accessed January 10, 2016, http://www.artble.com/artists/vincent_van_gogh.
180. Born and Landais, *Schuffenecker's Sunflowers and Other Van Gogh Forgeries*, 189.
181. Cynthia Saltzman, *Portrait of Dr. Gachet: The Story of a Van Gogh Masterpiece, Money, Politics, Collectors, Greed, and Loss* (New York: Penguin, 1999), p.9.
182. Charles S. Moffett, *The Passionate Eye, Vincent van Gogh 1853–1890*, No. 62, *Wheat Field with Cypresses, June 1889*, Zurich, Artemis, 1990.
183. Sotheby's Impressionist & Modern Art Evening Sale, New York, May 5, 2015, http://www.sothebys.com/en/auctions/ecatalogue/2015/impressionist-modern-art-evening-sale-n09340/lot.18.html.
184. "Die Seine mit der Pont de Clichy," accessed January 10, 2016, https://commons.wikimedia.org/wiki/File:Van_Gogh_-_Die_Seine_mit_der_Pont_de_Clichy.jpeg.
185. "Prisoners Exercising (After Doré)," accessed January 10, 2016, http://www.vggallery.com/painting/p_0669.htm.
186. "Wheat Field with Cypresses," Metropolitan Museum of Art, accessed January 12, 2016, http://www.metmuseum.org/collection/the-collection-online/search/436535?=&imgno=0&tabname=object-information.
187. Beth Saulinier, "Eye of the Beholder," Cornell Magazine, Ithaca, New York, June 1998, 40.
188. Walter Felichenfeldt, "Van Gogh Fakes: The Wacker Affair, with an Illustrated Catalogue of the Forgeries," accessed January 10, 2016, http://www.vggallery.com/misc/fakes/wacker.htm.
189. Van Gogh Museum Journal 2001, Amsterdam, 2001, 17.
190. Ibid, 20.
191. Ibid, 30.
192. Ibid, 37.

193. Born and Landais, *Schuffenecker's Sunflowers and Other Van Gogh Forgeries*, 335.

194. Jeanne Willet, "History of the Avant-Garde (Part 14): The German Art Dealers of the Avant-Garde," Heatherwood Institute and Press, accessed January 12, 2016, http://www.heathwoodpress.com/history-of-the-avant-garde-part-14-the-german-dealers-of-avant-garde-art/.

195. "Biography: Paul Cassirer," JewishVirtualLibrary.com, accessed January 12, 2016, https://www.jewishvirtuallibrary.org/jsource/judaica/ejud_0002_0004_0_04037.html.

196. Ibid.

197. "Guide to the Cassirer collection, 19061933," Department of Special Collections, Green Library, Stanford University Libraries, Palo Alto, California, 1999, accessed January 12, 2016, http://www.oac.cdlib.org/findaid/ark:/13030/tf-538nb0pb/entire_text/.

198. Johanna van Gogh-Bonger, *Memoir of Johanna Gesina van Gogh-Bonger*, Amsterdam, 1910, accessed January 12, 2016, http://www.webexhibits.org/vangogh/memoir/nephew/5.html.

199. "Paul Cassirer," Wikipedia, accessed January 12, 2016, https://en.wikipedia.org/wiki/Paul_Cassirer.

200. "A Chronology of Vincent van Gogh's Life, Art, and Early Critical Reception," accessed January 12, 2016, http://www.clevelandart.org/sites/default/files/documents/exhibition-catalogue/6_Chronology.pdf.

201. Jeanne Willet, "History of the Avant-Garde (Part 14): The German Art Dealers of the Avant-Garde," Heatherwood Institute and Press, accessed January 12, 2016, http://www.heathwoodpress.com/history-of-the-avant-garde-part-14-the-german-dealers-of-avant-garde-art/.

202. Ibid.

203. "A Chronology of Vincent van Gogh's Life, Art, and Early Critical Reception," accessed January 12, 2016, http://www.clevelandart.org/sites/default/files/documents/exhibition-catalogue/6_Chronology.pdf .

204. Johanna van Gogh-Bonger, *Memoir of Johanna Gesina van Gogh-Bonger*, Amsterdam, 1910, http://www.webexhibits.org/vangogh/memoir/nephew/5.html.

205. Grisebach, "Towards 'The Potato Eaters' on the Importance of the Brabant Portraits in Vincent van Gogh's Oeuvre," Auction 4 June 2015, Lot Vincent van Gogh, Groot-Zundert, 1853–1890 Auvers-sur-Oise.

206. "A Chronology of Vincent van Gogh's Life, Art, and Early Critical Reception," accessed January 12, 2016, http://www.clevelandart.org/sites/default/files/documents/exhibition-catalogue/6_Chronology.pdf.

207. Claude-Emile Schuffenecker, "Artworks," The Athenaeum, accessed January 12, 2016, http://www.the-athenaeum.org/art/list.php?m=a&s=tu&aid=409.

208. "Wheat Field with Cypresses," Metropolitan Museum of Art, accessed January 12, 2016, http://www.metmuseum.org/collection/the-collection-online/search/436535?=&imgno=0&tabname=object-information.

209. "Louis-Alexandre Berthier," Wikipedia, accessed January 12, 2016, https://en.wikipedia.org/wiki/Louis-Alexandre_Berthier.
210. "A Wheatfield, with Cypresses," PubHist, accessed January 12, 2016, https://www.pubhist.com/w6382.
211. "Octave Mirbeau," Wikipedia, accessed January 12, 2016, https://en.wikipedia.org/wiki/Octave_Mirbeau.
212. "Irises," J. Paul Getty Museum, accessed January 12, 2016, http://www.getty.edu/art/collection/objects/826/vincent-van-gogh-irises-dutch-1889/.
213. Octave Mirbeau, "Artists," accessed January 12, 2016, http://www.vggallery.com/misc/archives/mirbeau.htm.
214. "A Wheatfield, with Cypresses," PubHist, accessed January 12, 2016, https://www.pubhist.com/w6382.
215. Ibid.
216. Van Gogh Letters, "Cypresses," accessed January 12, 2016, http://vangoghletters.org/vg/search/simple?term=cypresses.
217. Born and Landais, *Schuffenecker's Sunflowers and Other Van Gogh Forgeries*, 193.
218. Michael Kaplan, "Inside the $80 Million Scam that Rocked the Art World and Hits Court This Week," *New York Post,* January 24, 2016.
219. Born and Landais, *Schuffenecker's Sunflowers and Other Van Gogh Forgeries*, 330.
220. http://www.art-antiques-design.com/authors/2:robertalexanderboyle. Accessed January 14, 2016.
221. Louis Van Tilborgh, et. al, "Weave Matching and Dating of Van Gogh's Paintings: An Interdisciplinary Approach," *The Burlington Magazine*, Vermont, February 2012, 112–122, accessed July 20, 2013, http://people.ece.cornell.edu/johnson/tilborgh_2012.pdf.
222. Van Gogh Museum Journal 2001, Amsterdam, 44–45.
223. Ibid, 45.
224. Born and Landais, *Schuffenecker's Sunflowers and Other Van Gogh Forgeries*, 311–12.
225. Alan Riding, "Fearing a Big Flood, Paris Moves Art," *New York Times*, February 19, 2003.
226. "Musée d'Orsay," Wikipedia, November 29, 2015, https://en.wikipedia.org/wiki/Musée_d%27Orsay.
227. Alan Riding, "Fearing a Big Flood, Paris Moves Art," *New York Times*, February 19, 2003.
228. Gallery Barbazanges, Paris, "History," accessed January 17, 2016, http://www.kubisme.info/kt271.html.
229. "Galerie Barbazanges," Wikipedia, February 6, 2016, https://en.wikipedia.org/wiki/Galerie_Barbazanges.
230. Gallery Barbazanges, Paris, "History," accessed January 17, 2016, http://www.kubisme.info/kt271.html.
231. Findlay Galleries, blog, *Chagall and the Circle of Jewish Painters of the 20th Century.*

232. Earl A. Powell III, "Shedding New Light on 'The Old Musician,'" *National Gallery of Art Bulletin*, "From the Director's Desk," Washington, DC, Fall 2009, 41:6.

233. Susan Alyson Stein and Asher Ethan Miller, *The Annenberg Collection: Masterpieces of Impressionism and Post-Impressionism*, Metropolitan Museum of Art, Met Publications (New York: Yale University Press, New Haven and London, 2009), 211.

234. Hubert Van den Berg, Editor, et. al, *A Cultural History of the Avant-garde in the Nordic Countries 1900–1925*, Editions Rodopi B.V., Amsterdam, New York, 2012, 201.

235. Ibid.

236. Ibid.

237. "Storm Women. Women Artists of the Avant-Garde in Berlin, 1910–1932," Art History News, November 13, 2015. http://arthistorynewsreport.blogspot.com/2015/11/storm-women-women-artists-of-avant.html.

238. Moses Mendelssohn, https://www.jewishvirtuallibrary.org/jsource/biography/Mendelssohn.html.

239. Ibid.

240. Michael Levitin, "Berlin Bind: Between Neo-Nazis and Mendelssohn," Forward.com/Culture, December 10, 2004, accessed January 17, 2016, http://forward.com/culture/3972/berlin-bind-between-neo-nazis-and-mendelssohn/.

241. Julius H. Schoeps, Wikipedia, Google Translated, accessed September 30, 2013, https://translate.google.com/translate?hl=en&sl=de&u=https://de.wikipedia.org/wiki/Julius_H._Schoeps&prev=search.

242. Alan Feuer, "A Lawsuit Will Determine the Fate of 2 Picassos," *New York Times*, December 18, 2007.

243. "The Supreme Court won't hear an appeal from descendants of famed composer Felix Mendelssohn who want the German officials to return a valuable Pablo Picasso painting that was subject to forced transfer under the Nazi regime," *Associated Press*, Washington, DC, January 19, 2016.

244. Michael Sontheimer, "Art Restitution and Picasso: One Jewish Family's Battle with a Munich Museum," *Das Spiegel*, Germany, October 18, 2011.

245. Michael Levitin, "Berlin Bind: Between Neo-Nazis and Mendelssohn," Forward.com/Culture, December 10, 2004, accessed January 17, 2016, http://forward.com/culture/3972/berlin-bind-between-neo-nazis-and-mendelssohn/.

246. Angelina Giovani, "Happy birthday, Vincent van Gogh! Part Two," *Plundered Art blog*, May 25, 2015, http://plundered-art.blogspot.com/2015/05/happy-birthday-vincent-van-gogh-part-two.html.

247. Johanna Van Gogh-Bonger, Johanna, *Memoir of Johanna Gesina van Gogh-Bonger*, Amsterdam, 1910, http://www.webexhibits.org/vangogh/memoir/nephew/5.html.

248. Ibid.

249. Angelina Giovani, "Happy birthday, Vincent van Gogh! Part Two," *Plundered Art blog*, May 25, 2015, http://plundered-art.blogspot.com/2015/05/happy-birthday-vincent-van-gogh-part-two.html.
250. "Biography: Paul Cassirer," JewishVirtualLibrary.com, https://www.jewishvirtuallibrary.org/jsource/judaica/ejud_0002_0004_0_04037.html.
251. M. Rae Nelson, "Authentic or Not: Chemistry Solves the Mystery," *ChemMatters* magazine, April 2011.
252. Ibid.
253. J. L. Dolice, blog, *Fabulous Fakes* and *A History of Art Forgery*, 2003.
254. Stefan Koldehoff, *The Wacker Forgeries: A Catalogue*, Van Gogh Museum Journal 2002, Amsterdam, 139.
255. "German Presidential Election, 1932," accessed January 18, 2016, https://en.wikipedia.org/wiki/German_presidential_election,_1932.
256. "AntiJewish Legislation in Prewar Germany," US Holocaust Memorial Museum.
257. Kevin Koeninger, "Heirs Sue Bavaria for Nazi-Looted Picasso," *CourtHouseNews.com*, March 29, 2013.
258. Fritz Kempner, *Looking Back*, self-published, Maine, 2006, 98–99.
259. Judith H. Dobrzynski, "Tracing a van Gogh Treasured by the Met," *New York Times*, February 11, 1998.
260. "Independent Commission of Experts Switzerland—Second World War," Final Report, Zurich, 2002, 202.
261. Ibid, 40.
262. Alexandrine de Rothschild, Cultural Plunder by the Einsatzstab Reichsleiter Rosenberg: Database of Art Objects at the Jeu de Paume, http://www.errproject.org/jeudepaume/card_view.php?CardID=12737
263. Ibid.
264. Erin Gibbons, *The Hunt Controversy: A Shadow Report* (Paris: The Simon Wiesenthal Centre, 2002), 63–65.
265. Ibid, 64–65.
266. Kenneth D. Alford, *Hermann Goring and the Nazi Art Collection: The Looting of Europe's Art Treasures and Their Dispersal After World War II* (New York: McFarland & Co, 2013), 116.
267. "Independent Commission of Experts Switzerland—Second World War," Final Report, Zurich, 2002, 350.
268. Frank Mecklenburg, et al., "Guide to the Fritz Nathan (1891–1960) Collection, 1914–2000," Leo Baeck Institute, Center for Jewish History, New York, 2004.
269. Archive of the Foundation E.G. Bührle Collection, Zurich, www.buehrle.ch.
270. Susan Alyson Stein and Asher Ethan Miller, *The Annenberg Collection: Masterpieces of Impressionism and Post-Impressionism*, Metropolitan Museum of Art, Met Publications (New York: Yale University Press, New Haven and London, 2009), 211.

271. Judith H. Dobrzynski, "Tracing a van Gogh Treasured by the Met," *New York Times,* February 11, 1998.

272. U.S. War Department, "ALIU Detailed Interrogation Report: Hans WEND-LAND," Washington, DC, September 18, 1946, 1.

273. Ibid, 3.

274. Ibid, 5.

275. Marianne Feilchenfeldt, "The Case for Theodor Fischer," in a TV interview; she and her husband Walter left the head office of Paul Cassirer Gallery to Amsterdam in 1933.

276. Ibid, 8.

277. U.S. War Department, "ALIU Detailed Interrogation Report: Hans WEND-LAND," Washington, DC, September 18, 1946, 9.

278. Ibid, 11.

279. Ibid, 17–18.

280. Ibid, 22.

281. J. D. Bindenagel, "Message from the Editor," Washington Conference on Holocaust-Era Assets Proceedings, Washington, DC, February 19, 1999.

282. Holocaust Restitution: Washington Conference on Holocaust-Era Assets, Jewish Virtual Library, Washington, DC, November 30–December 3, 1998.

283. Oaklander, Mandy, "Matisse Painting Looted by Nazis Returned to Jewish Art Dealer's Heirs," *Time*, May 16, 2015.

284. Charles A. Goldstein, *Restitution Experience Since The Washington Conference (1998),* Counsel Commission for Art Recovery, Milan, Italy, June 23, 2011, 1.

285. "The Diggers," http://www.dia.org/object-info/127f6f52–58cb-4381-a706-f649d1ee56e5.aspx.

286. Holocaust Era Assets Conference Proceedings, "Retaining van Gogh," Prague, June 26–30, 2009, 803.

287. Ibid, pp. 750–751.

288. "Washington Conference on Holocaust-Era Assets," US State Dept. and the US Holocaust Memorial Museum, Washington, DC, November 30 to December 3, 1998, 554.

289. Ibid, p. 555.

290. Grace Glueck, "Art View; Painting Attribution Sparks an Uproar," *New York Times*, April 4, 1982.

291. "Gary Tinterow Appointed Director of the Museum of Fine Arts, Houston," http://www.prnewswire.com/news-releases/gary-tinterow-appointed-director-of-the-museum-of-fine-arts-houston-134914793.html.

292. M. Rae Nelson, "Authenticate or Not? Chemistry Solves the Mystery," *Chem-Matters* magazine, April 2001.

293. Caroline Von Saint-George, *Vincent van Gogh—The Langlois Drawbridge*, Brief Report on Technology and Condition. Wallraf das Museum, Cologne, Germany, 2008, 3.

294. Geert Van der Snickt, et al., "X-Rays Elucidate Color Change in Van Gogh Painting," *CNRS International Magazine*, France, September 14, 2012.

295. Jia Li, et al., *Rhythmic Brushstrokes Distinguish van Gogh from His Contemporaries: Findings via Automated Brushstroke Extraction*, Institute of Electrical and Electronics Engineers, Piscataway, New Jersey, June 2012.

296. Louis Von Tilborgh, et al., "Weave Matching and Dating of Van Gogh's Paintings: An Interdisciplinary Approach," *The Burlington Magazine*, Vermont, February 2012, 113.

297. Caroline Von Saint-George, *Vincent van Gogh—The Langlois Drawbridge*, Brief Report on Technology and Condition. Wallraf das Museum, Cologne, Germany, 2008, 2.

298. Louis Von Tilborgh, et al., "Weave Matching and Dating of Van Gogh's Paintings: An Interdisciplinary Approach," *The Burlington Magazine*, Vermont, February 2012, 112.

299. James O. Grundvig, "Knoedler Scandal Head Fake, NY Times Swallows the Bait," *The Epoch Times*, August 30, 2013.

300. Ibid.

301. Ibid.

302. Martin Bailey, "At least forty-five Van Goghs may well be Fakes," *The Art Newspaper*, No. 72, July-August 1997, accessed September 30, 2013, http://www.vggallery.com/misc/fakes/fakes2.htm.

303. David L. Grossvogel, *Behind the Van Gogh Forgeries: A Memoir* (New York: Authors Choice Press, 2001), 53.

304. Louis Van Tilborgh, Van Gogh Museum Press Release, "Louis Van Tilborgh," Amsterdam, December 11, 2014.

305. Ibid.

306. Farah Nayeri, "Van Gogh Work Missing for Century on Show in Amsterdam," *Bloomberg News*, September 9, 2013.

307. Michael Brenson, "Art View; The Faces That Haunt Van Gogh's Landscapes," *New York Times*, January 4, 1987.

308. Michael Brenson, "'Van Gogh' at the Metropolitan: Portrait of the Triumphant Artist," *New York Times*, November 28, 1986.

309. Richard Bernstein, "Nazis and Their Allies in Art Theft," *New York Times*, June 18, 1997.

310. Lana Smiley, "The Top Art Projects Applying Blockchain," Altcoin Today, January 4, 2016, accessed January 24, 2016, http://www.altcointoday.com/top-art-projects-applying-blockchain/.

311. Alexander Boyle, "'Priceless' Evening at the Frick Collection, Agent Robert Wittman on Art Theft," Art Blog, May 2, 2014, http://www.art-antiques-design.com/art/384-priceless-evening-at-the-frick-collection-agent-robert-wittman-on-art-theft.

312. Yessi Bello Perez, "How Blockchain Tech is Inspiring the Art World," *Coindesk*, May 14, 2015, http://www.coindesk.com/blockchain-technology-inspiring-art/.

313. John Ward Anderson, John Ward, "Paintings by Four Masters Stolen in Zurich," *Washington Post,* February 12, 2008.
314. Ibid.
315. "Recovered Cezanne Authenticated by Swiss Art Expert," BBC online, April 13, 2012, http://www.bbc.com/news/entertainment-arts-17702198.
316. Lucia Foulkes, "The Art of Atonement: How Mandated Transparency Can Help Return Masterpieces Lost During World War II," 38 B.C. Int'l & Comp. L. Rev. 305 (2015), http://lawdigitalcommons.bc.edu/ iclr/vol38/iss2/6

ACKNOWLEDGMENTS

I want to thank Tony Lyons, CEO of Skyhorse Publishing, for his passion and commitment to bringing books that are off center to the public; thanks are also due to Louis Conte for taking the risk of introducing this material in a field he wasn't familiar with but has now come to look at in a different way, and to my Skyhorse editors for their dedication, eye for detail, and questions that brought out the best in this author.

I am grateful to art experts R. Alexander Boyle, who pointed out the physical differences between Vincent van Gogh's paintings created in the South of France and the rest of his oeuvre from all points north; Benoit Landais for his dedication and expertise in identifying thirty-two likely van Gogh forgeries and tirelessly challenging museum curators and private collectors on authenticity and provenance issues (he is putting those case studies on his platform, www.vincentsite.com); and J. L. "Louis" van Tilborgh, art expert at the Van Gogh Museum in Holland, who helped identify the artist's "missing fingerprints" in style, paint type, and brushstrokes.

I am much obliged to the National Gallery in London and the team behind the 1987 "Technical Bulletin" on van Gogh's *A*

Wheatfield, with Cypresses, as well as to Chris Riopelle, Curator of Post 1800 Paintings, for his thirteenth-hour research into the painting's provenance; to the Van Gogh Museum in Holland and its upkeep of the rich Van Gogh Letters online database; to Michele Willens, Senior Archivist in Gallery Archives, and her staff at the National Gallery of Art in Washington, DC; to van Gogh expert Susie Alyson Stein and the Metropolitan Museum of Art for challenging my position; and to Susan Anderson, the Martha Hamilton Morris Archivist, and Margaret Huang, Digital Archivist, at the Philadelphia Museum of Art, in Philadelphia, Pennsylvania.

My thanks also to the heirs of classical composer Felix Mendelssohn, Dr. Julius H. Schoeps, director of the Moses Mendelssohn Center for European-Jewish Studies at the University of Potsdam and managing director of the Moses Mendelssohn Foundation, and songwriter Elise Witt.

Finally, I am also grateful to Evelyn Campos for her detailed edits and eye for organization that helped me meet critical deadlines; and to Michael Cane, an old high school friend, who introduced me to Alex Boyle—an encounter that got the ball rolling after he answered one simple question: "Are there any fake van Goghs out there?"